YELLOWSTONE VIEW

PHOTOGRAPHS BY THOMAS LEE

FOREWORD BY SCOTT McMILLION

Layout and Design by Geoff Hill

A publication of Big Sky Publishing, a division of Pioneer Newspapers Inc., Stephanie Pressly, publisher

copyright 2008, all rights reserved | first edition | ISBN 978-1-931832-93-9
Printed in Korea

Foreword *By Scott McMillion*

YELLOWSTONE NATIONAL PARK IS A PLACE, SOMETHING YOU CAN FIND ON A MAP. But it's also an image, a symbol, an icon of something very American.

And it's also a process, a slow unfolding of the complex relationships of life: from soil and sunlight come plants and then the animals that eat them, and the animals that eat those animals. All of these things die, and with death comes decay and decomposition, the creation of more soil. And so the cycle continues in Yellowstone, where people mostly stay out of the way, letting Yellowstone go about the business of being Yellowstone.

And then there's the water, which abounds here in all its forms: vapor, fluid, solid chunks. Raindrops gather on pine needles and fall to the forest floor. Some soak deep into the earth, only to rise again as steam, heated by the geothermal fury that cooks the park's bedrock. Other water spends the winter locked in snow or ice, awaiting a summer river ride to the Pacific Ocean or the Gulf of Mexico. Some water bides for a time in lakes, calm and unknowing of its delightful work: reflecting the clouds and sky that gather water and keep the cascade of life flowing.

Every raindrop, every strand of DNA has a part in this process.

Purple geranium near north entrance

And that is what I see in Thomas Lee's remarkable photography: connectedness, a vision of the role of birth and death and rebirth, succor and consumption and decay. Everything has a role. Some players work fast, some move slowly.

Two of Thomas' photographs illustrate the slow process.

The first captures a fire killed tree, as black and shiny as a polished shoe. But look a little closer and on the tree you see lichens, going about the job of dismantling that tree, of turning it into dirt.

The second is of lodgepole pines that have taken on an even bigger job. They have found boulders resting in the Firehole River and shot roots into them, an effort at converting basalt into soil, rendering it into sustenance for plants and animals that lack the tenacity of a lodgepole pine, which, in turn, will fall victim to lichens and mold and bugs, making more soil.

On a more rapid time scale, you see the same struggle for dominance in Thomas' photograph of two bison bulls jousting, their horns locked. One is young, with his eyes open. The other is older, bigger, but with his eyes closed. They fight because they both want to be the boss, do the breeding, take a role in the process that is Yellowstone, even if it costs them their lives.

And the life process moves even more rapidly in the photographs of coyotes tearing apart an elk carcass, turning it into fertilizer that will nourish grass and feed other elk next year.

Thomas' work is possible because a handful of people had the good sense to set Yellowstone aside and protect it, and do so despite the indifference of a nation still recovering from the Civil War. The park has changed a lot since 1872. It has roads now, and hotels and parking lots and millions of visitors, which is not a bad thing. Otherwise, we wouldn't know what we do about the park. We — the owners of the park — wouldn't be able to marvel at its mysteries so easily.

Yellowstone is the world's first national park, but the concept has spread around the world. Protecting what is special and dear and wild has been repeated thousands of times, from Africa to Alaska. Some people say it was America's best idea.

Turning Thomas Lee loose in Yellowstone, armed with just his eye and his camera, isn't such a bad idea either. The fruits of those two ideas are in your hands right now, spelling out the process.

Bison grazing along the Yellowstone River, Hayden Valley

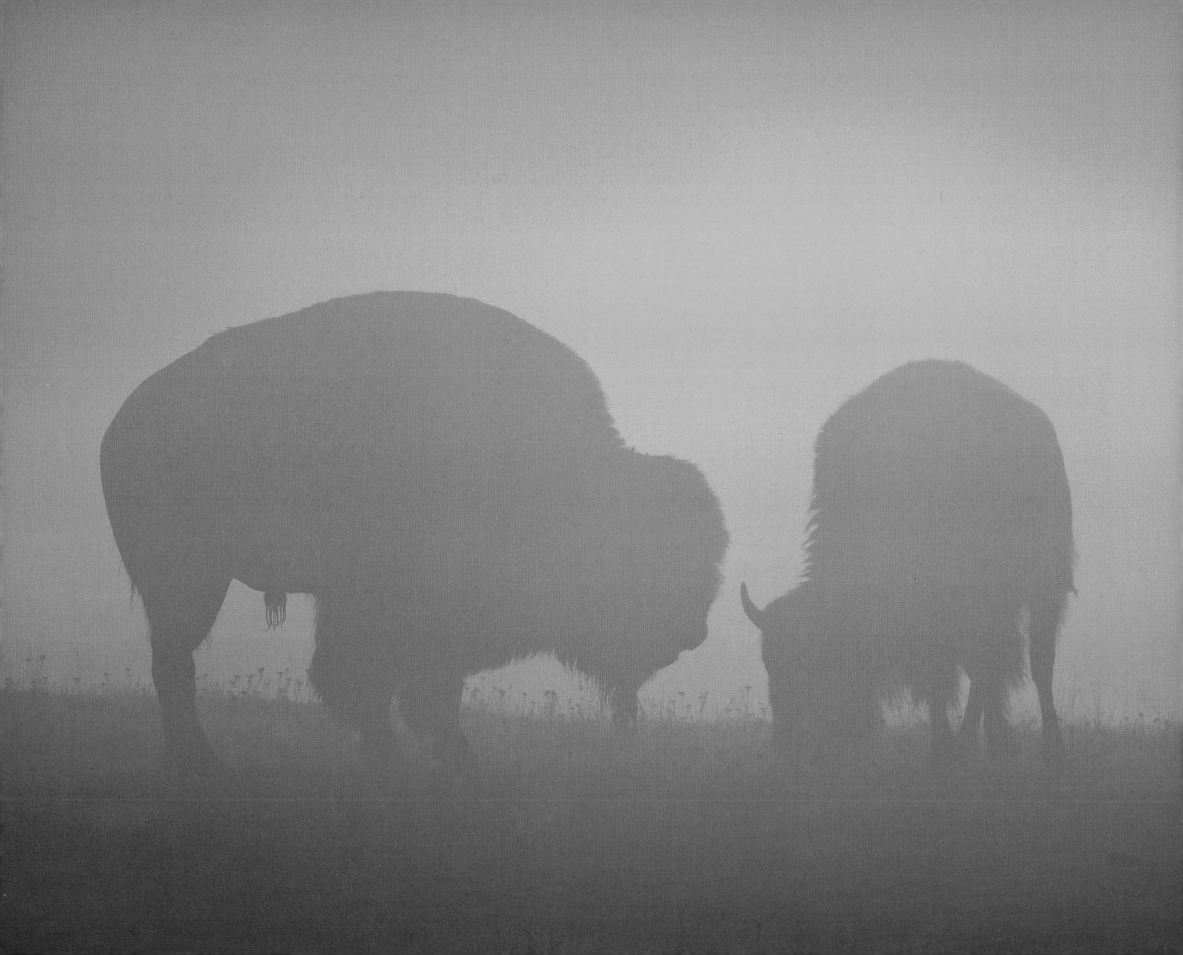

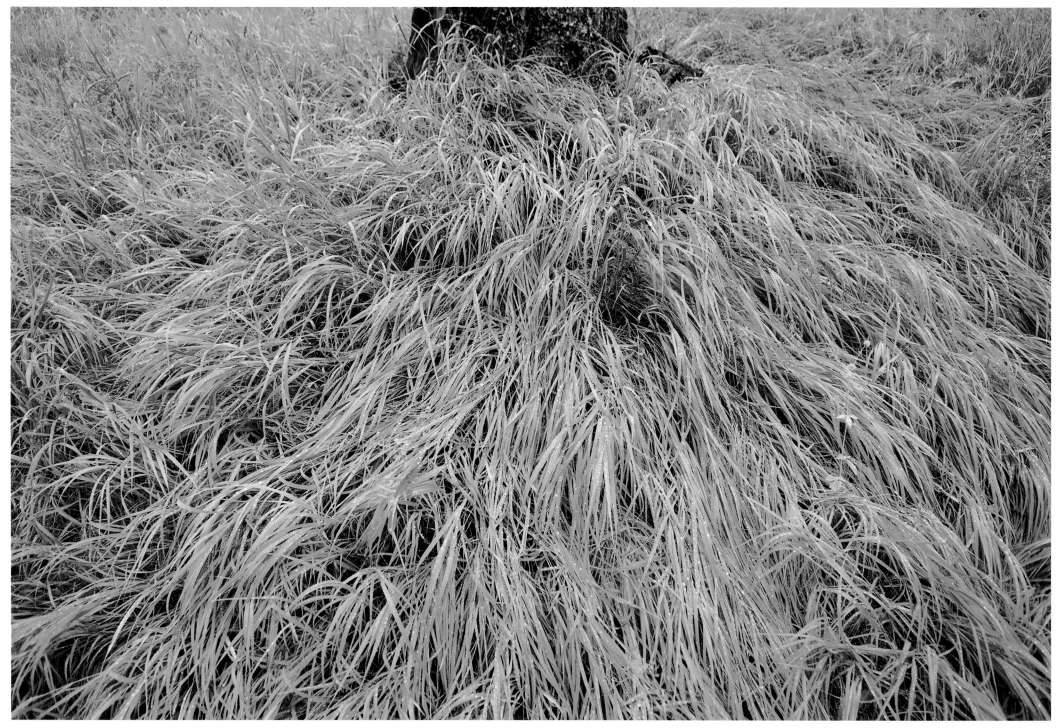

Rain-laden grass near Canyon Village

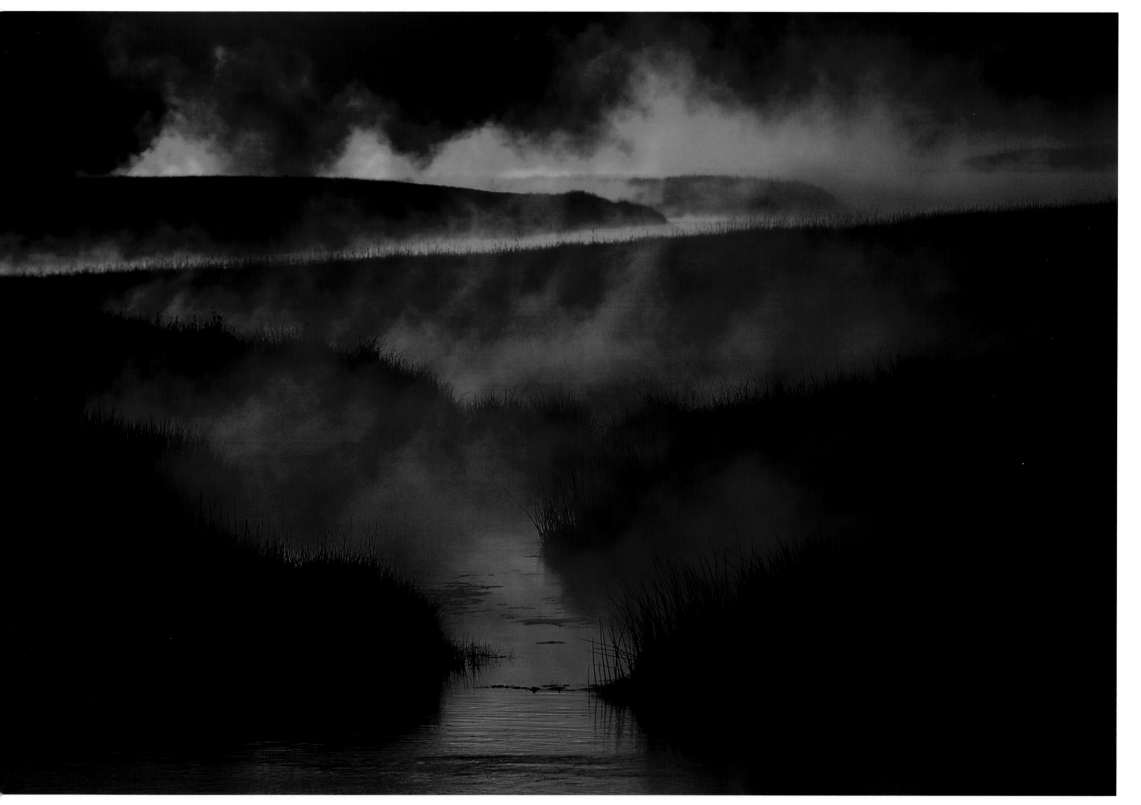

Sunrise, Madison River

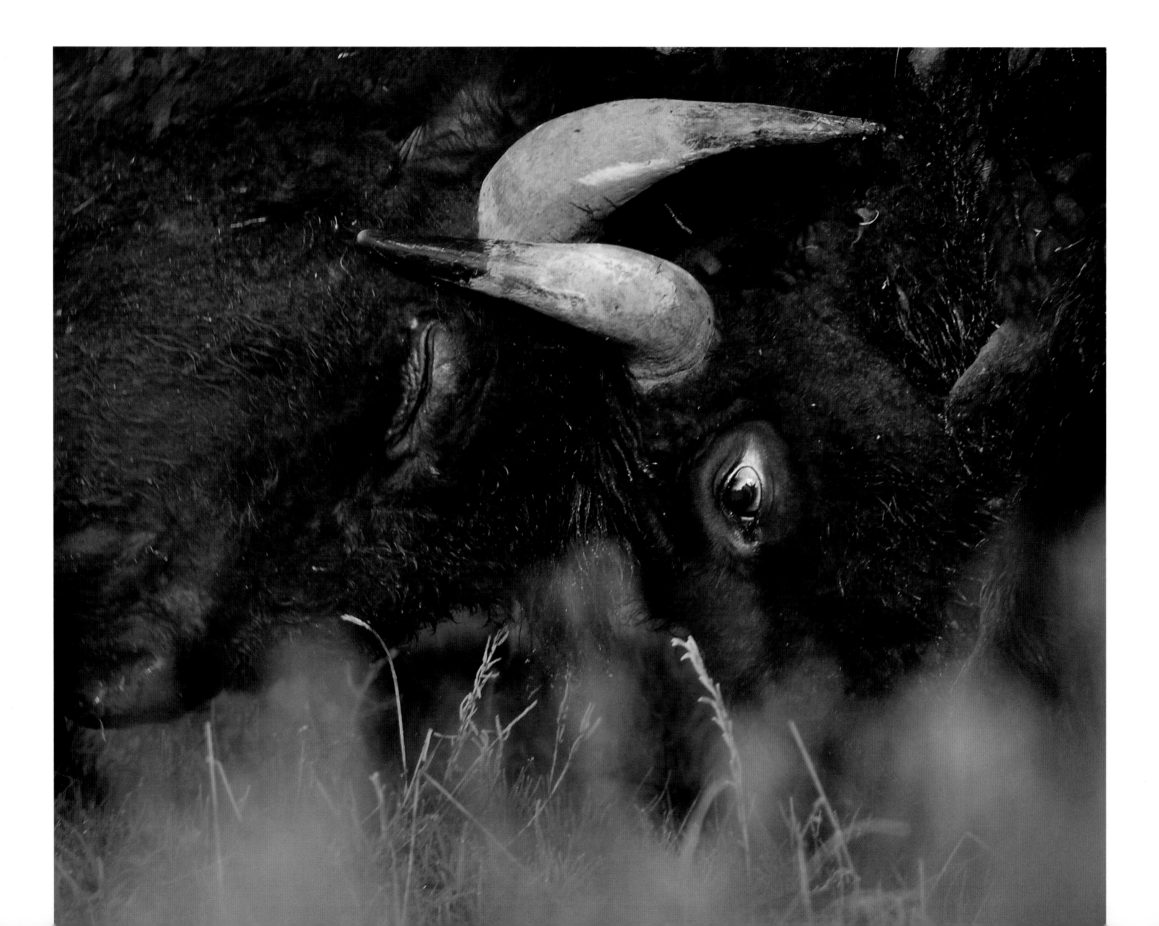

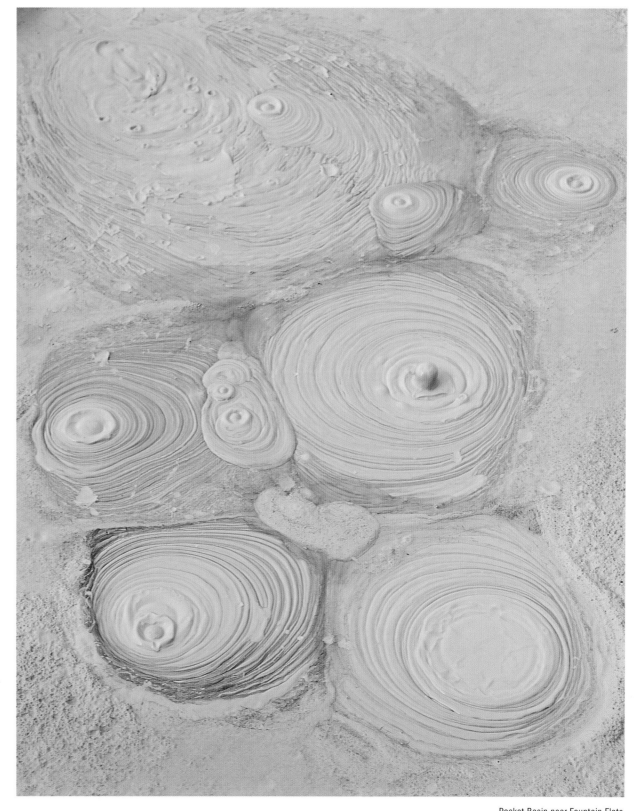

Dueling bull bison,
Hayden Valley

Pocket Basin near Fountain Flats

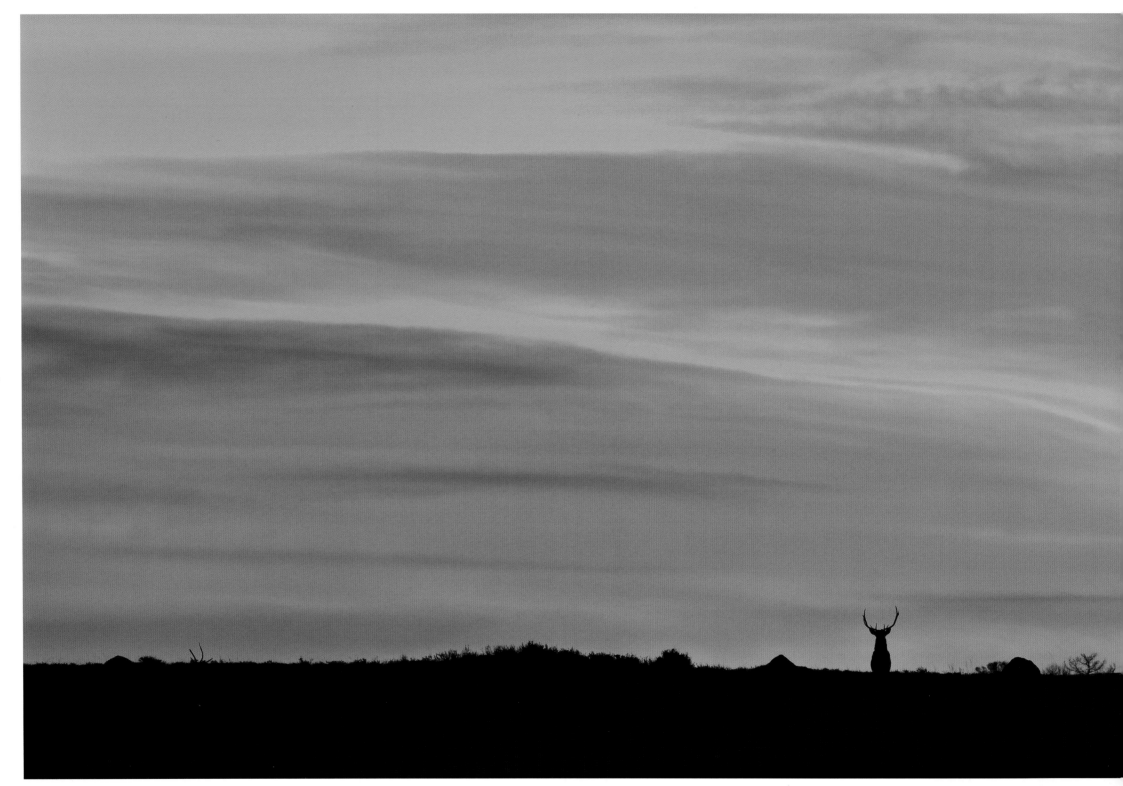

Bull elk atop ridge, east of Mammoth

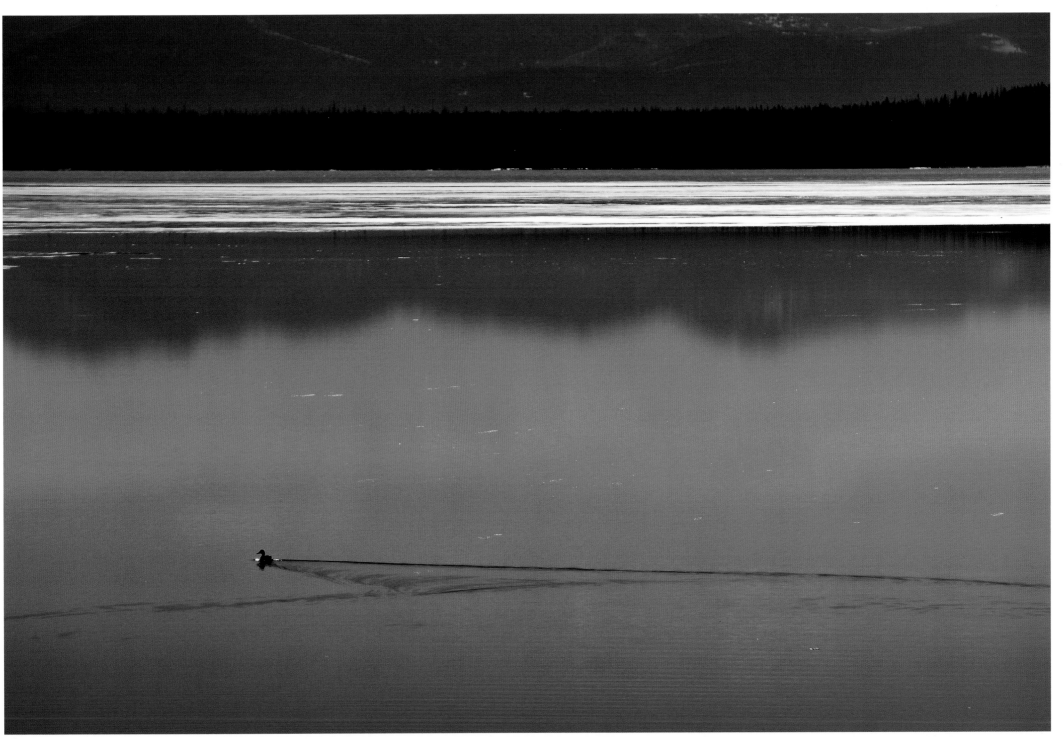

Duck on Yellowstone Lake at West Thumb

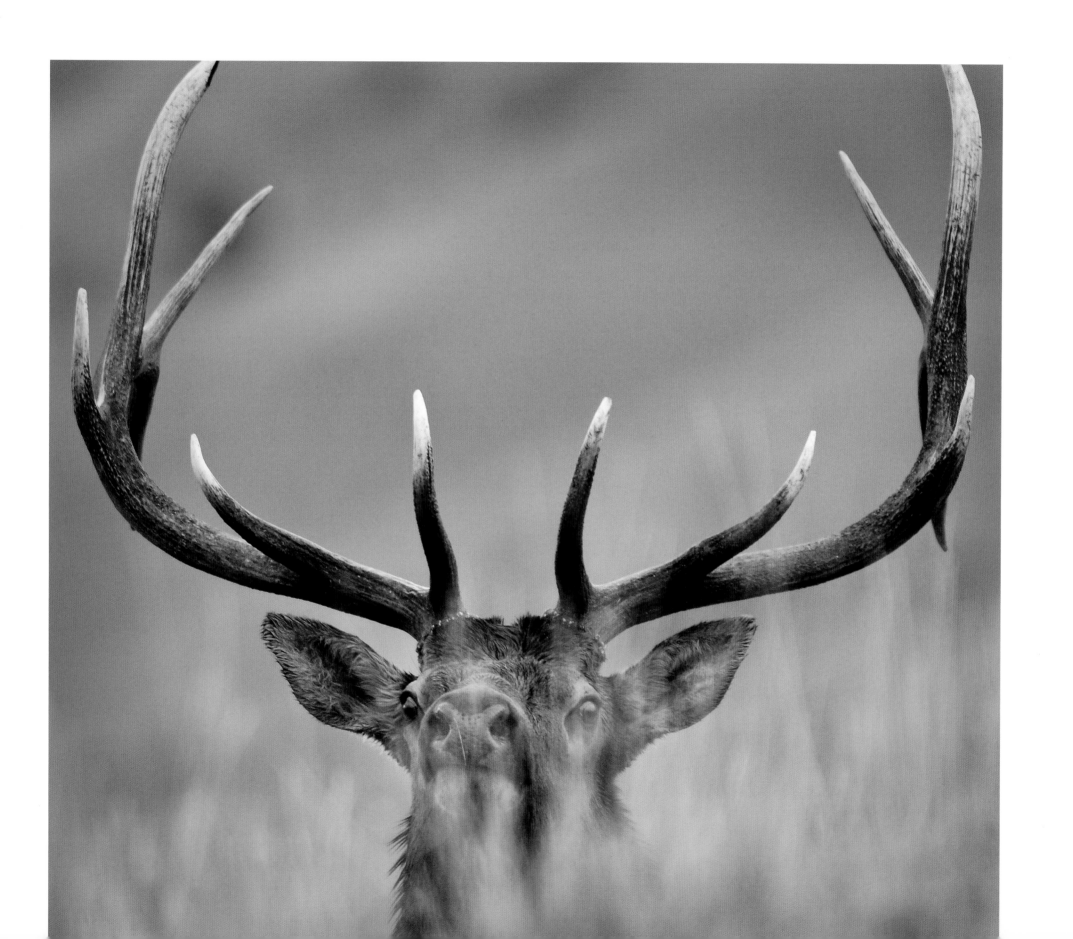

Bridge Creek near Natural Bridge and, at left, bull elk in rut, east of Mammoth

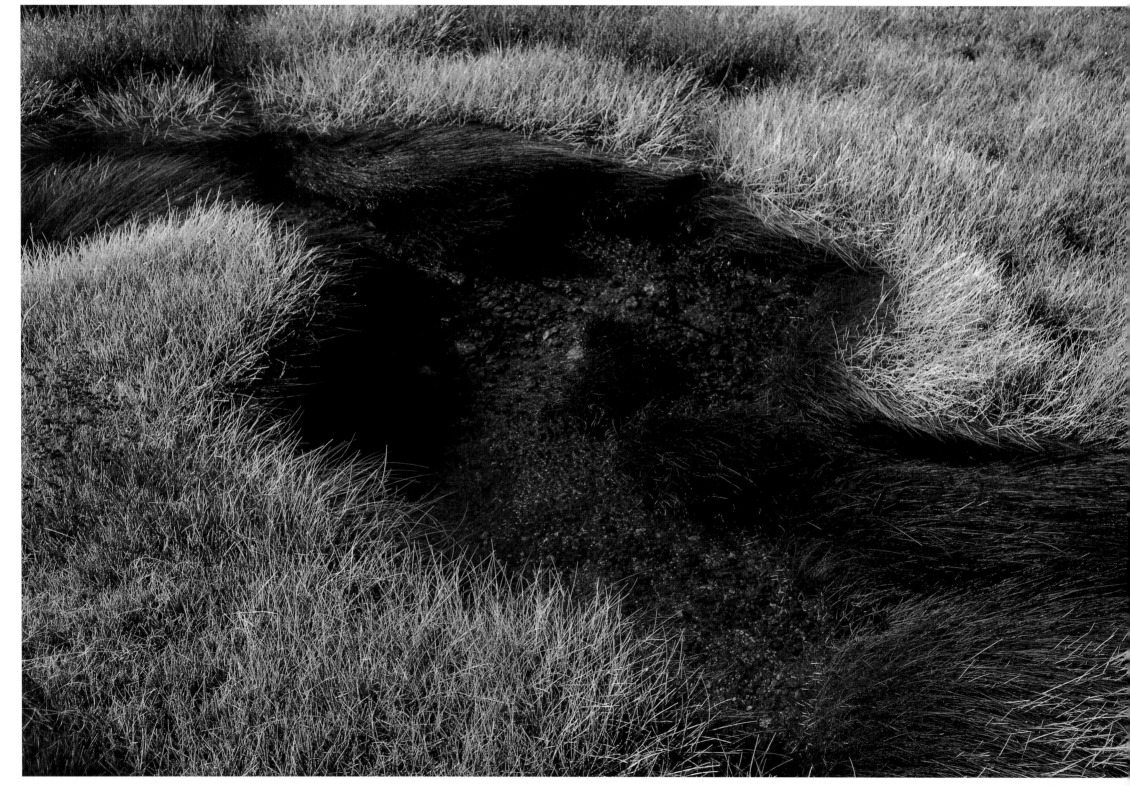

Creek near Norris Geyser Basin

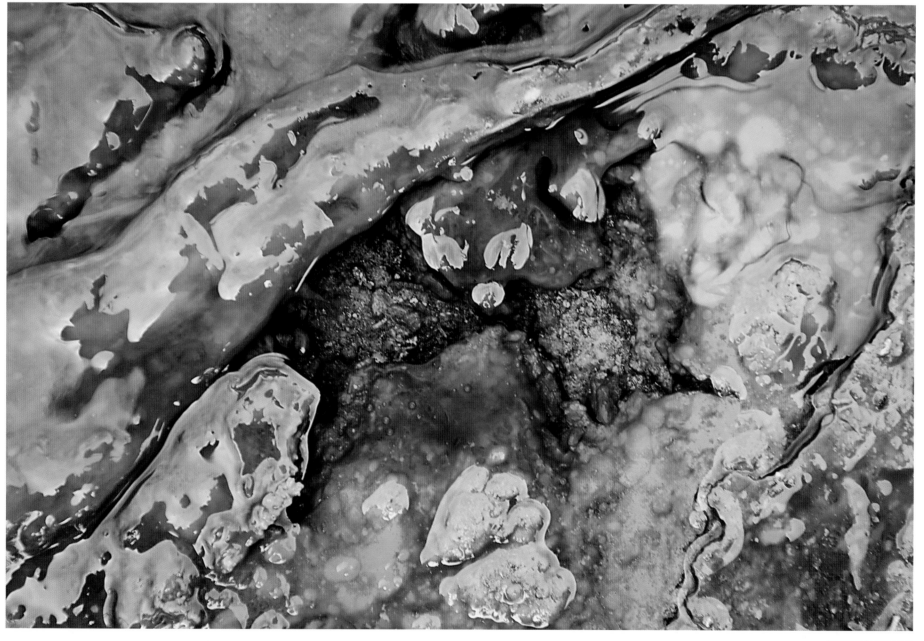

Artemisia Spring detail

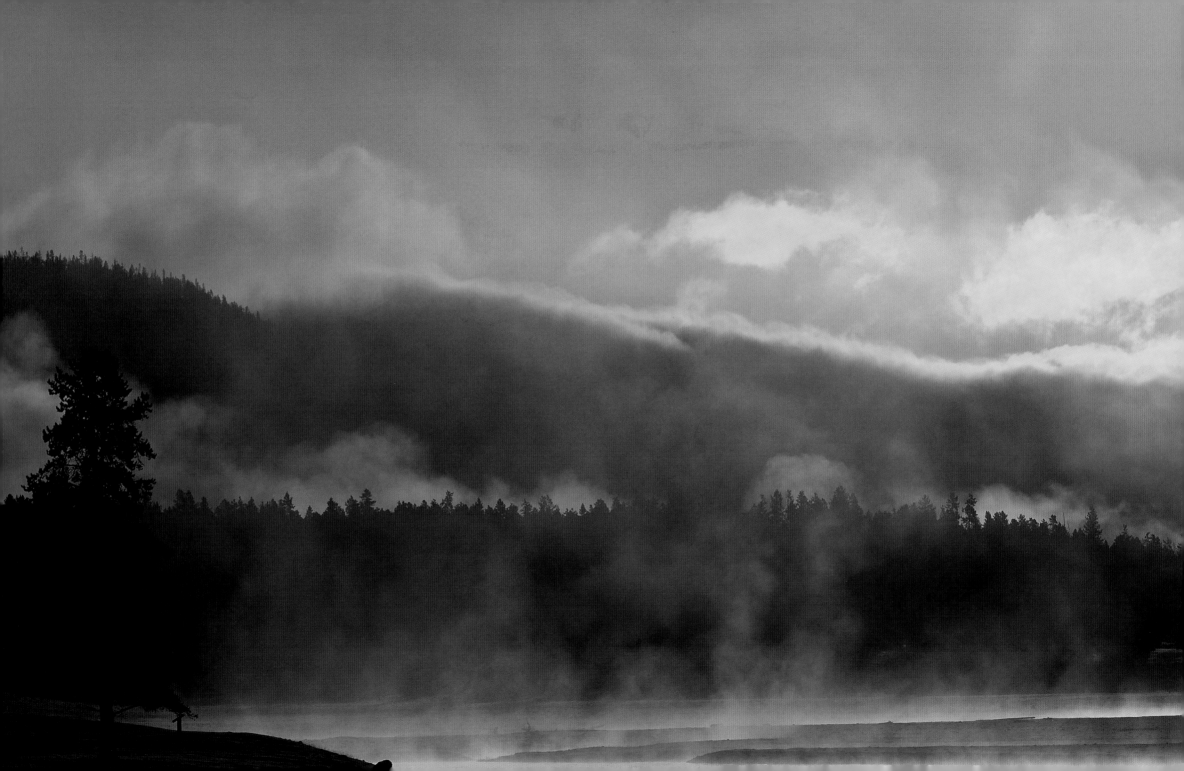

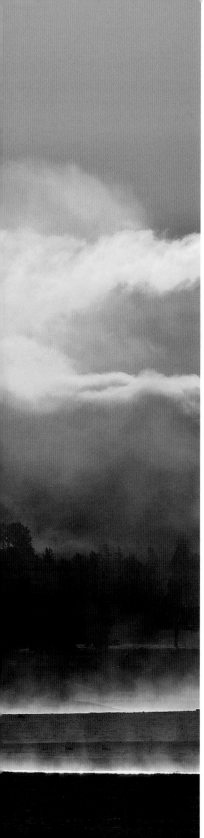

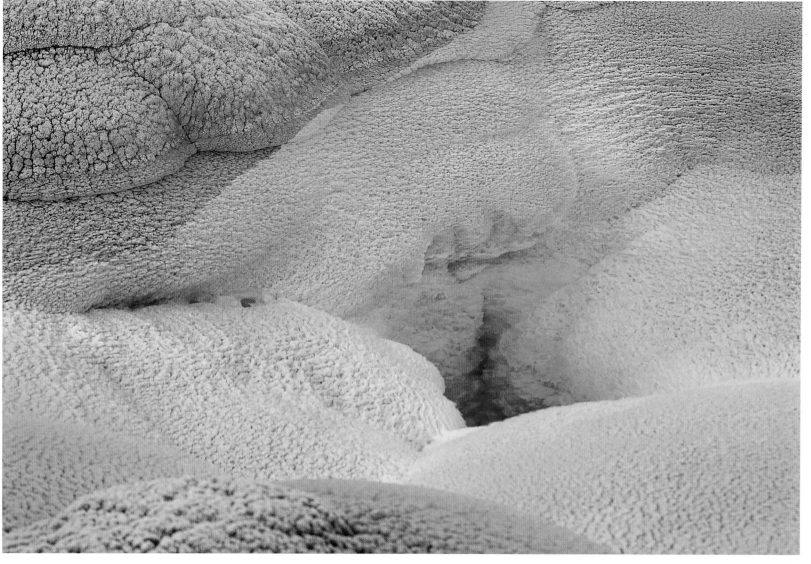

Narcissus Geyser

Elk grazing along Madison River

Soda Butte Creek, Round Prairie

Gibbon River near Madison Junction

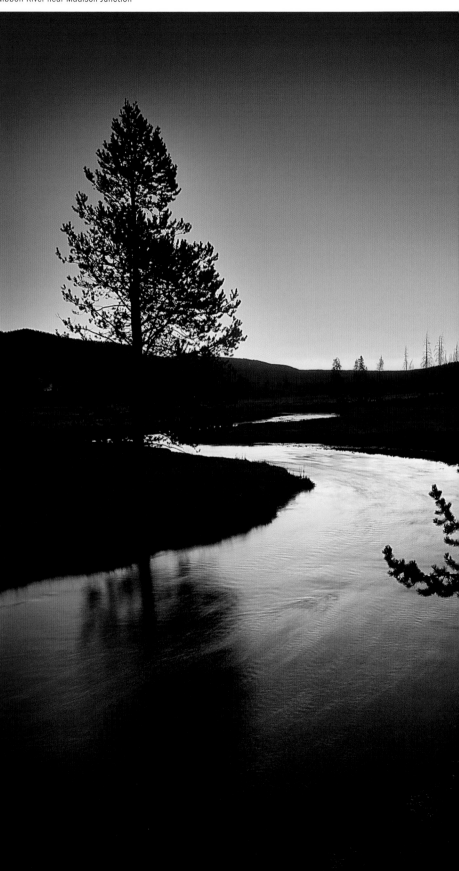

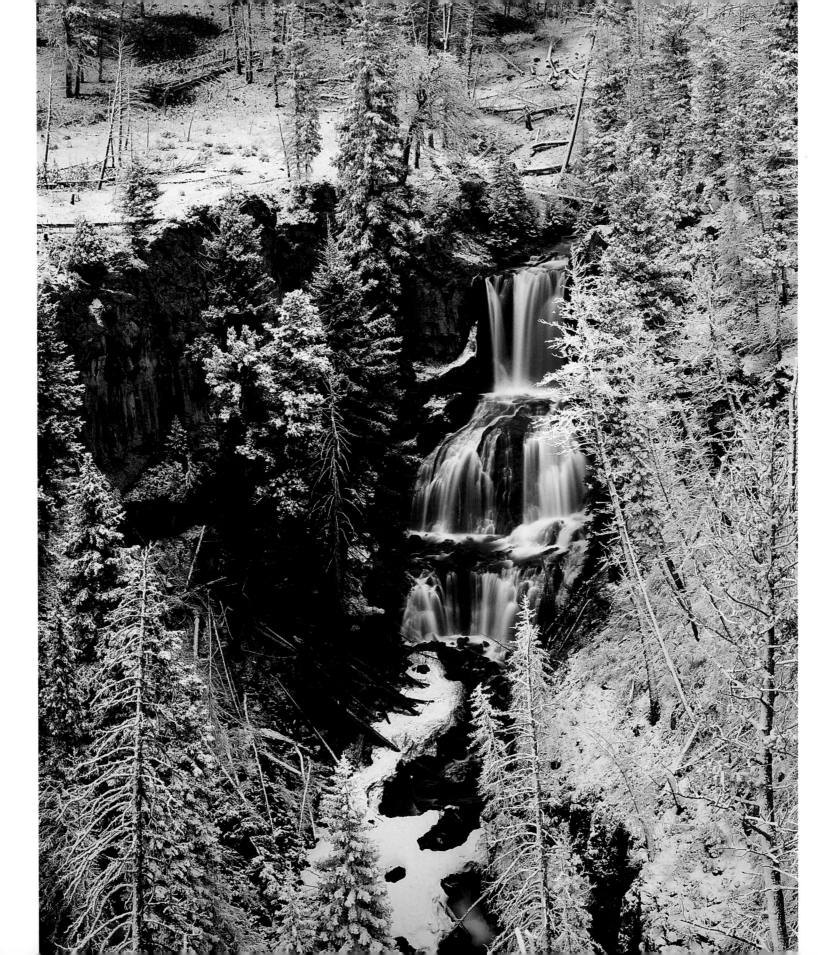

Undine
Falls

17

Snow drift, south of Mammoth

Tree shadows near
Swan Lake Flat

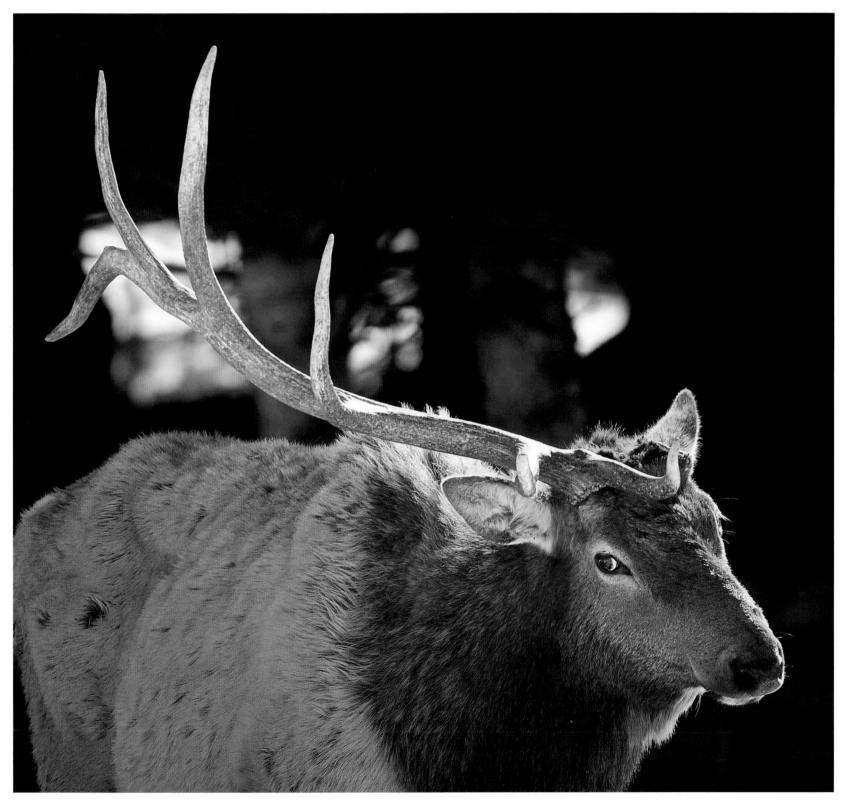

Bull elk shedding antlers in spring, east of Mammoth

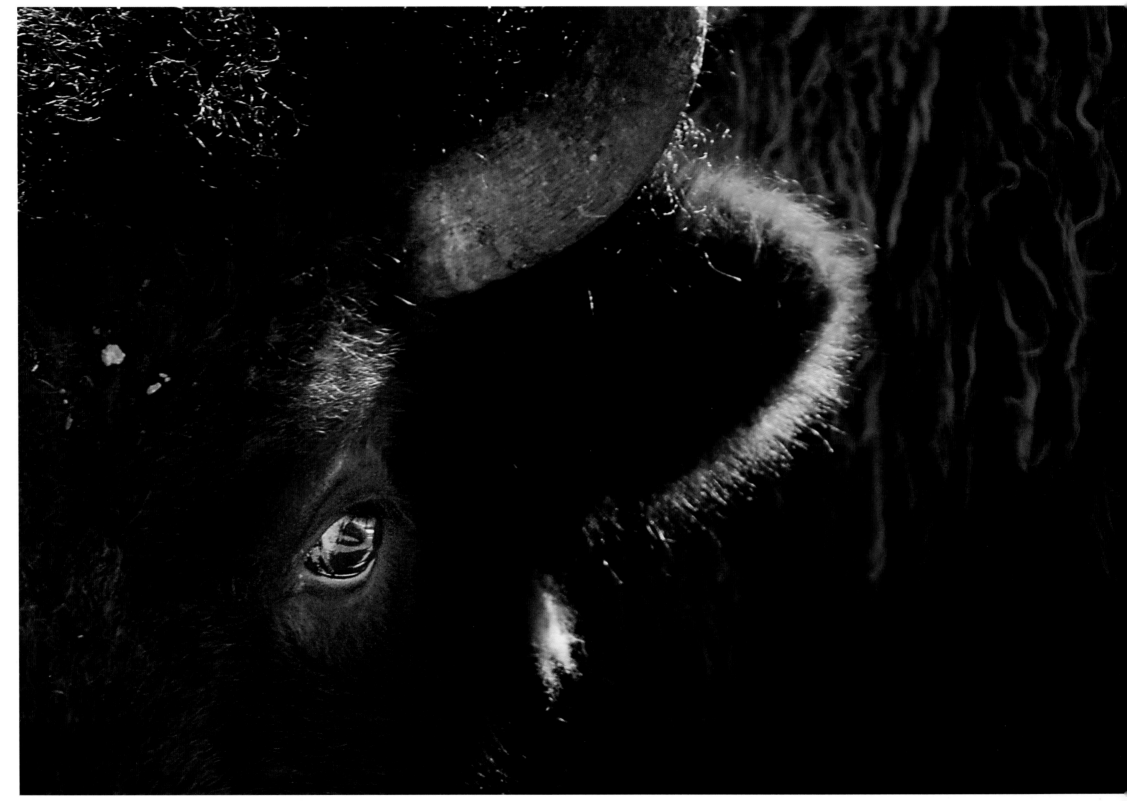

Bison, Lamar Valley

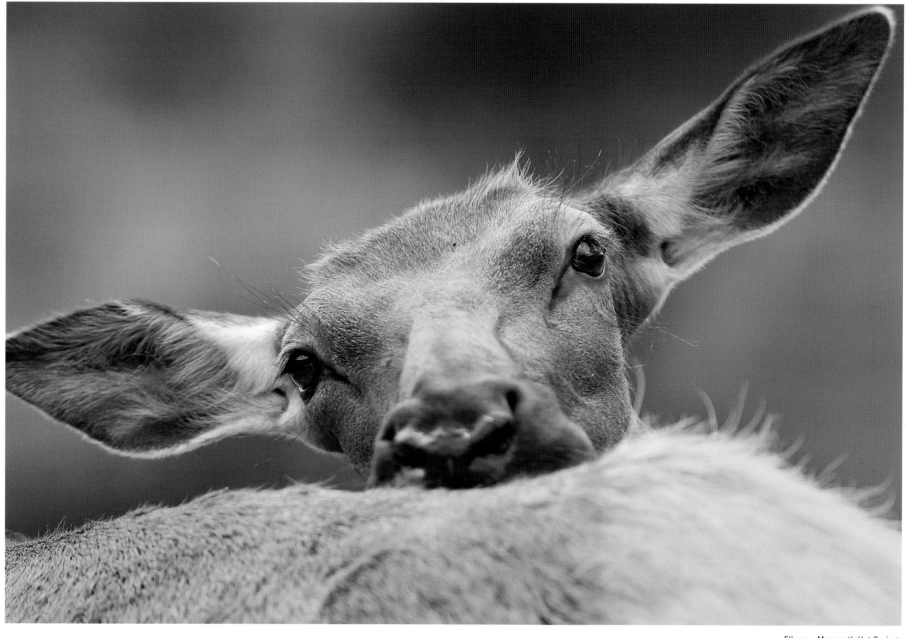

Elk cow, Mammoth Hot Springs

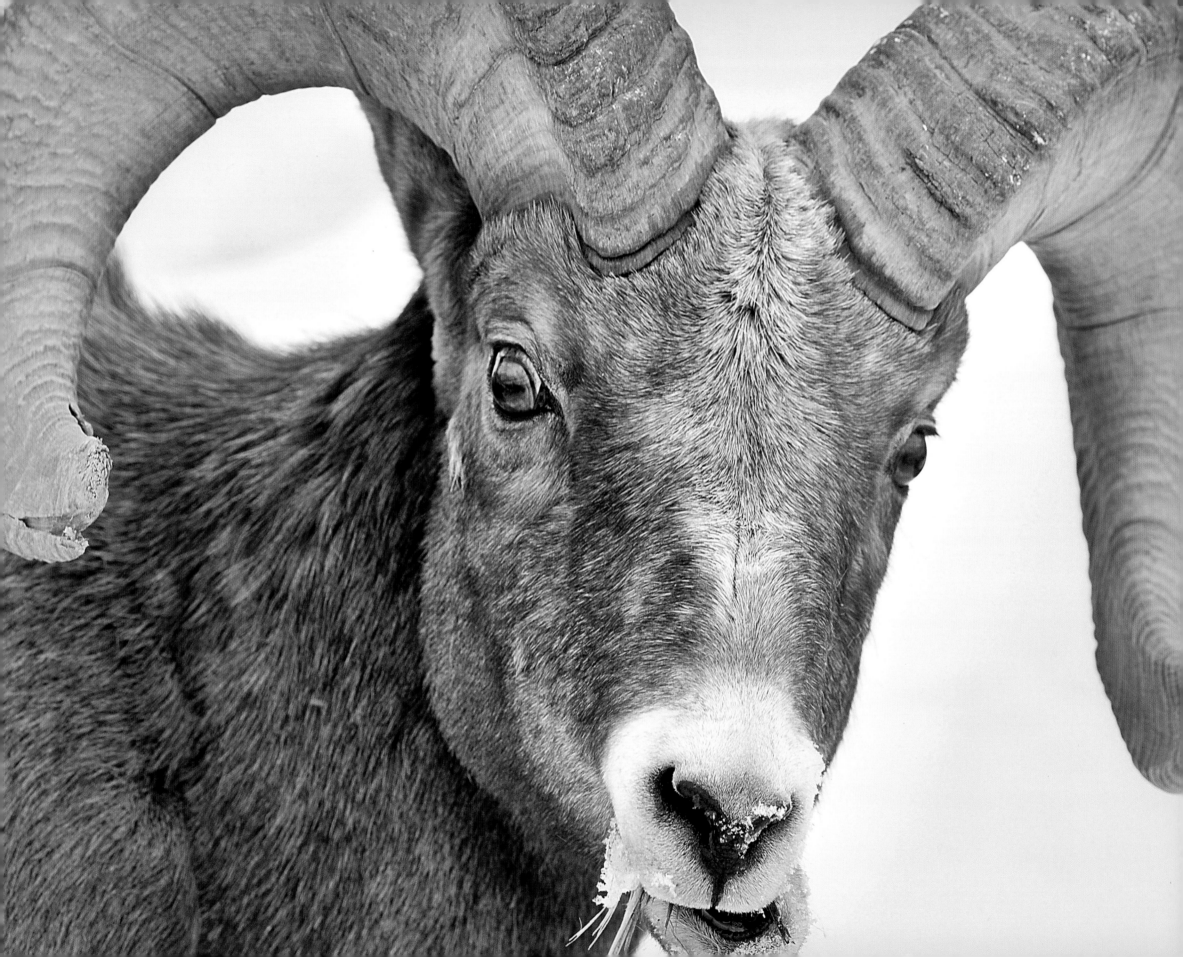

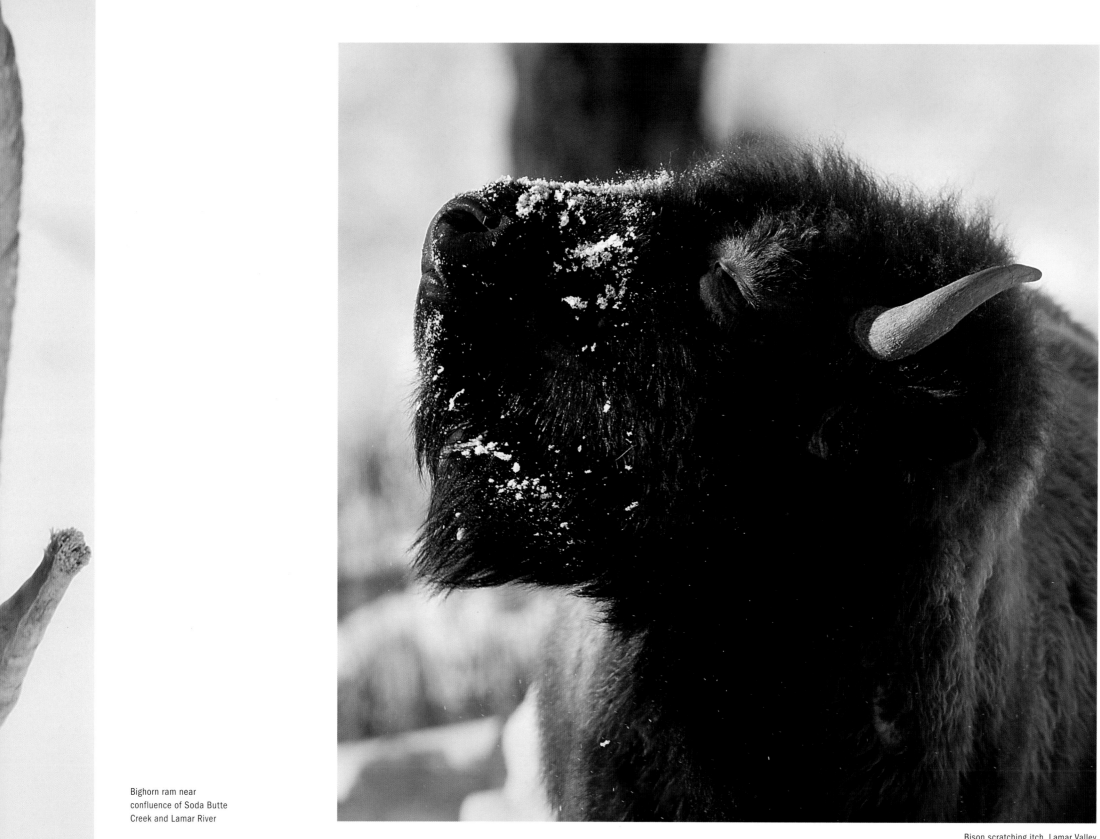

Bighorn ram near
confluence of Soda Butte
Creek and Lamar River

Bison scratching itch, Lamar Valley

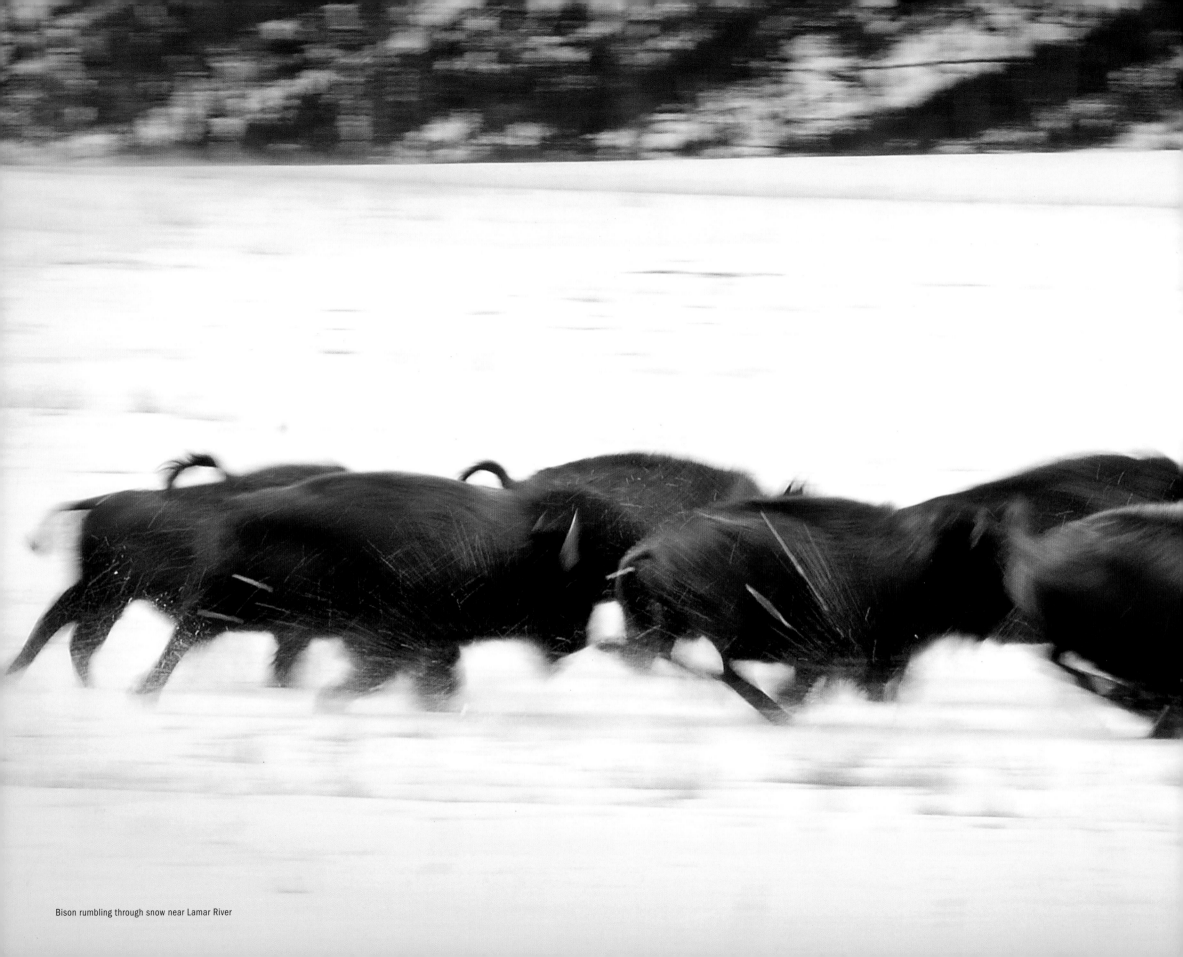

Bison rumbling through snow near Lamar River

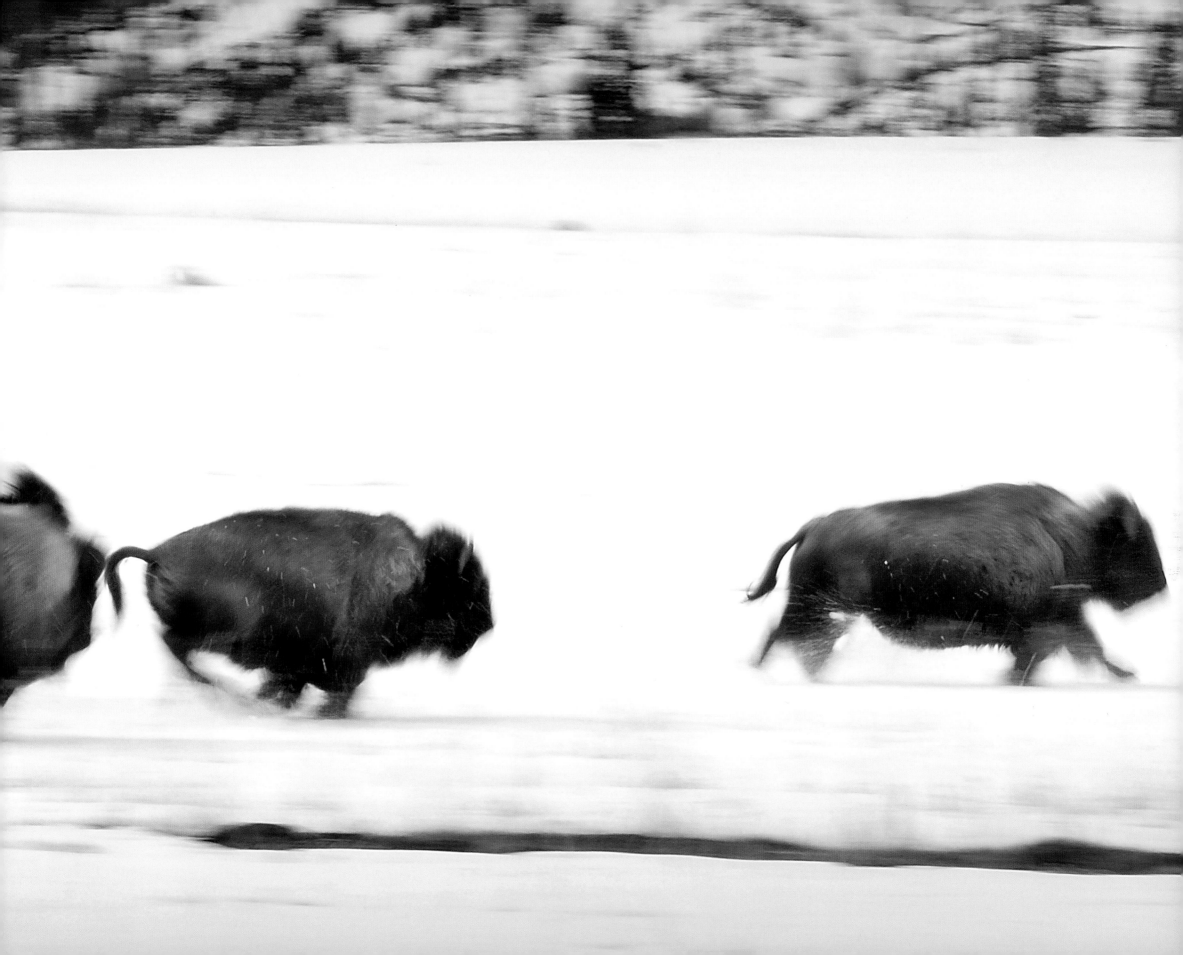

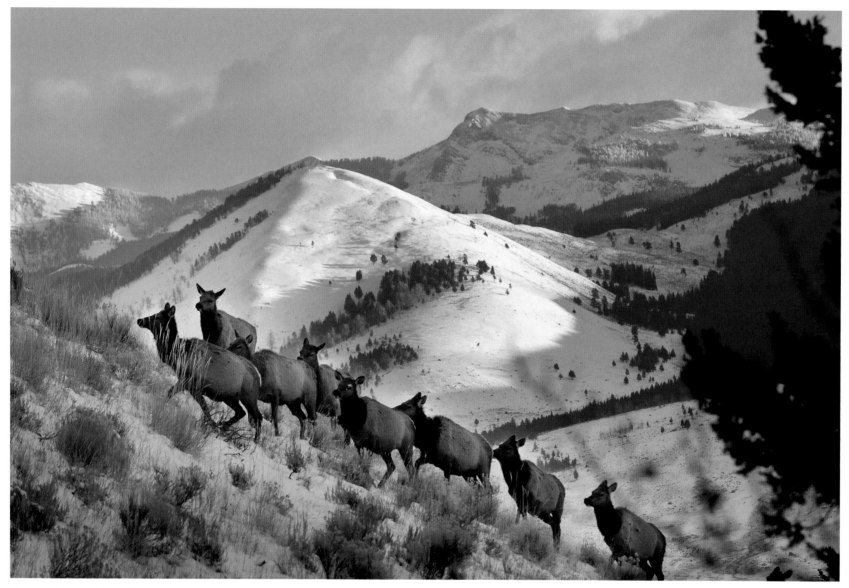
Elk cows moving up ridge near Mammoth

Elk cows move across
meadow east of Mammoth

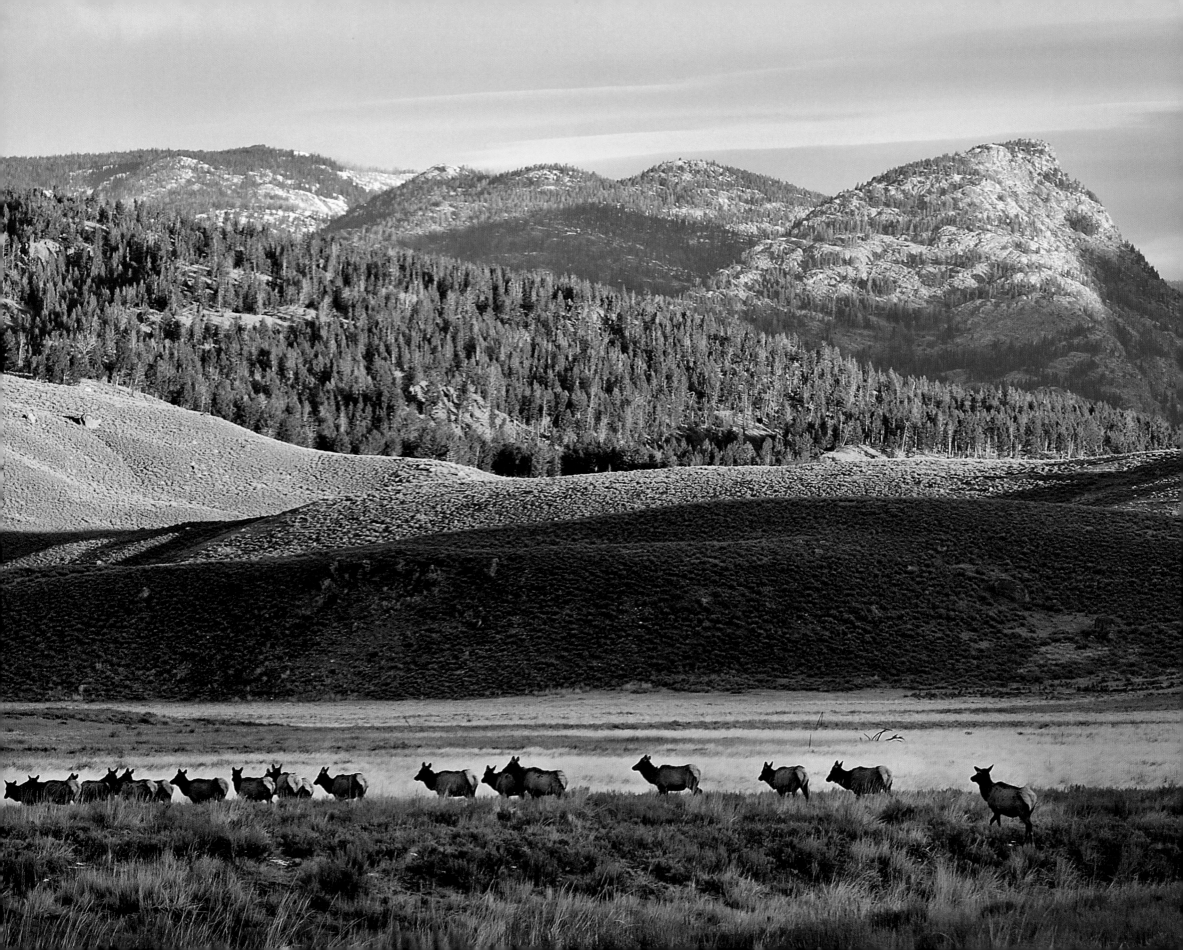

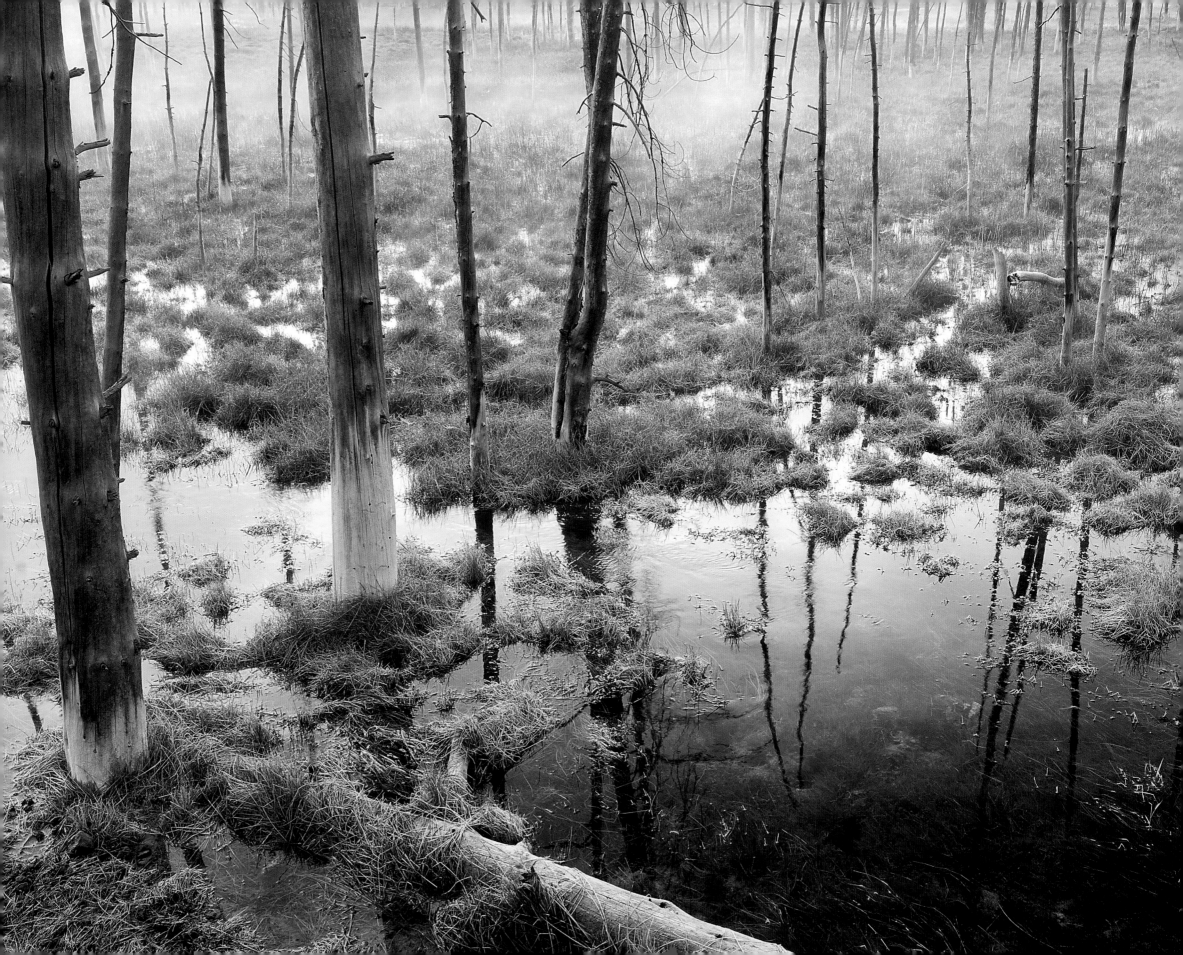

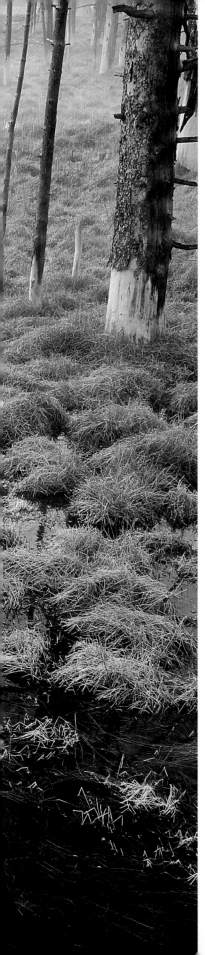

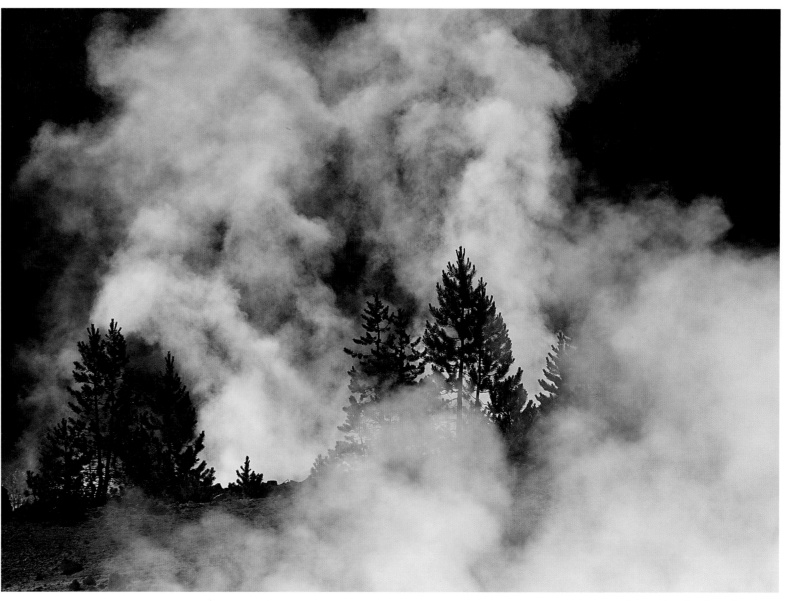

Steam and conifers, Norris Geyser Basin

Dead trees in meadow south of Madison Junction

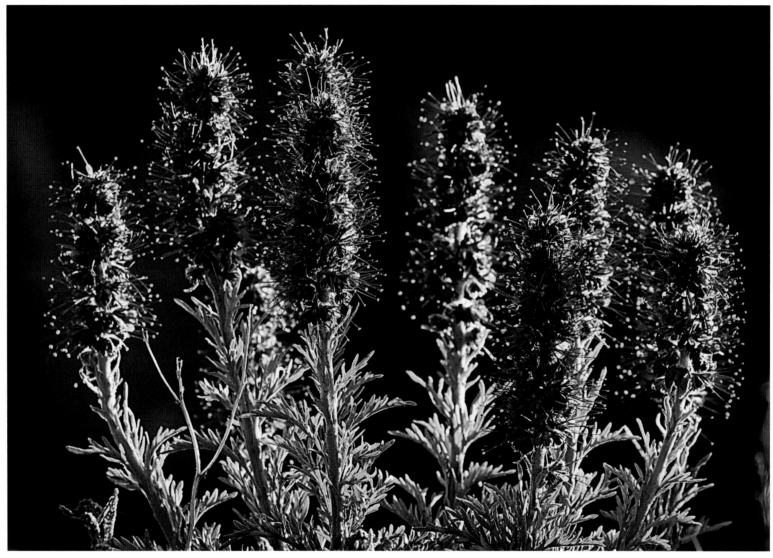

Scorpion weed, Bunsen Peak

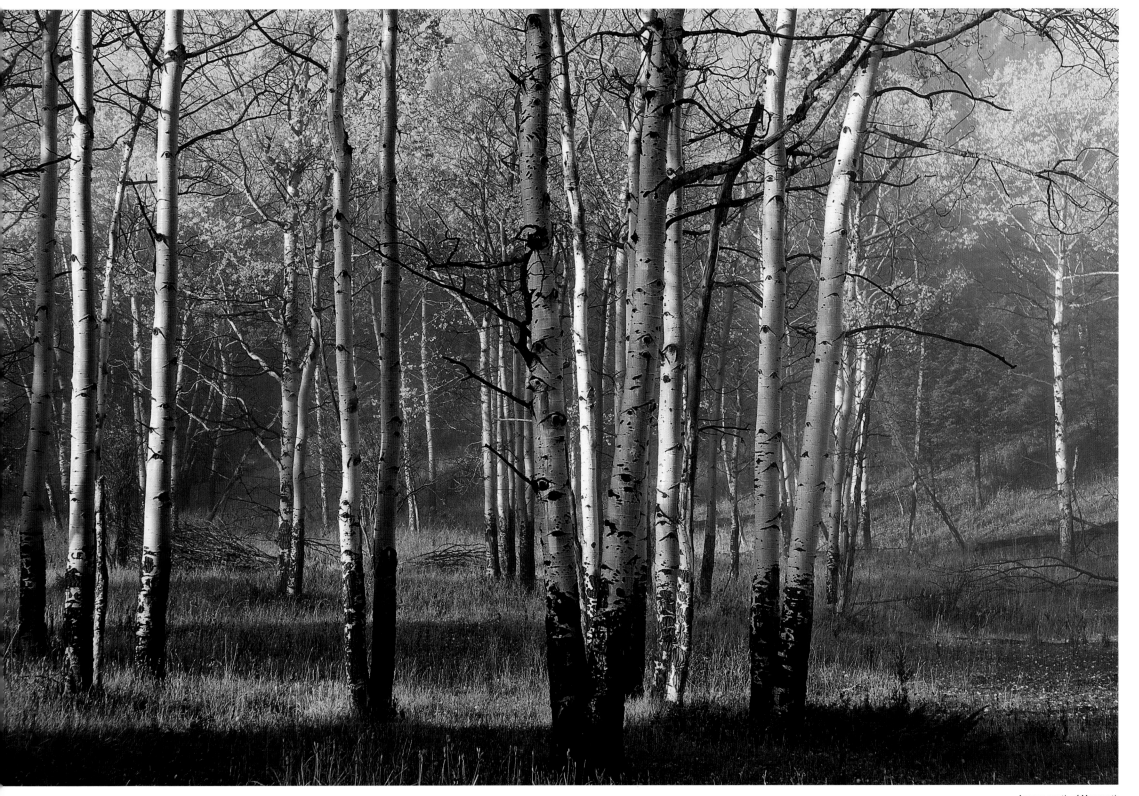

Aspens south of Mammoth

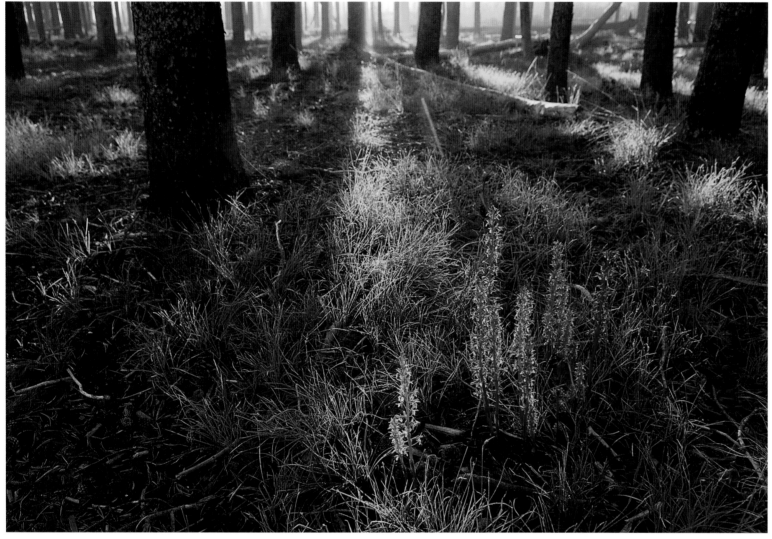

Coralroot near Lower Geyser Basin

Creek running through marsh
near Lower Geyser Basin

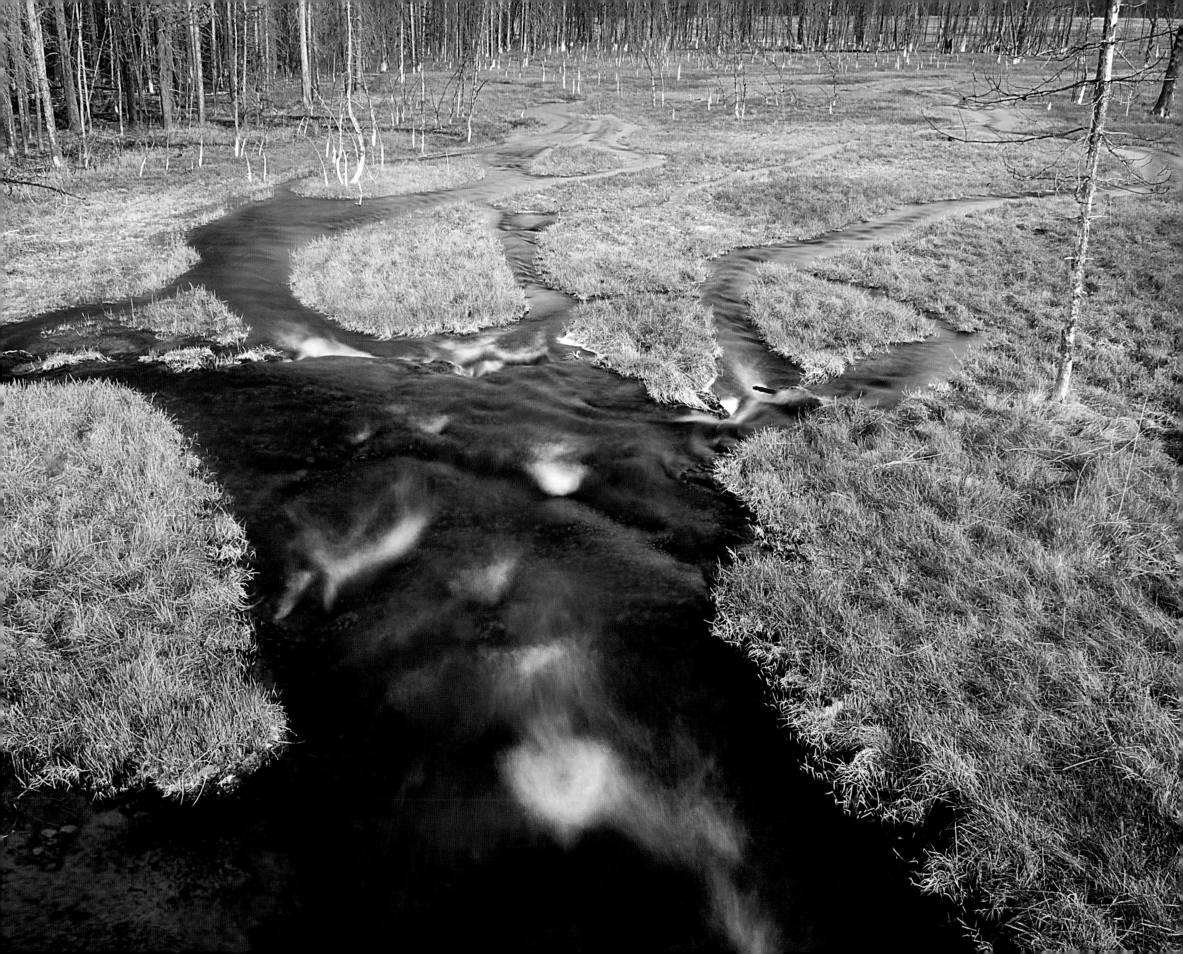

Tree trunks,
Avalanche Peak

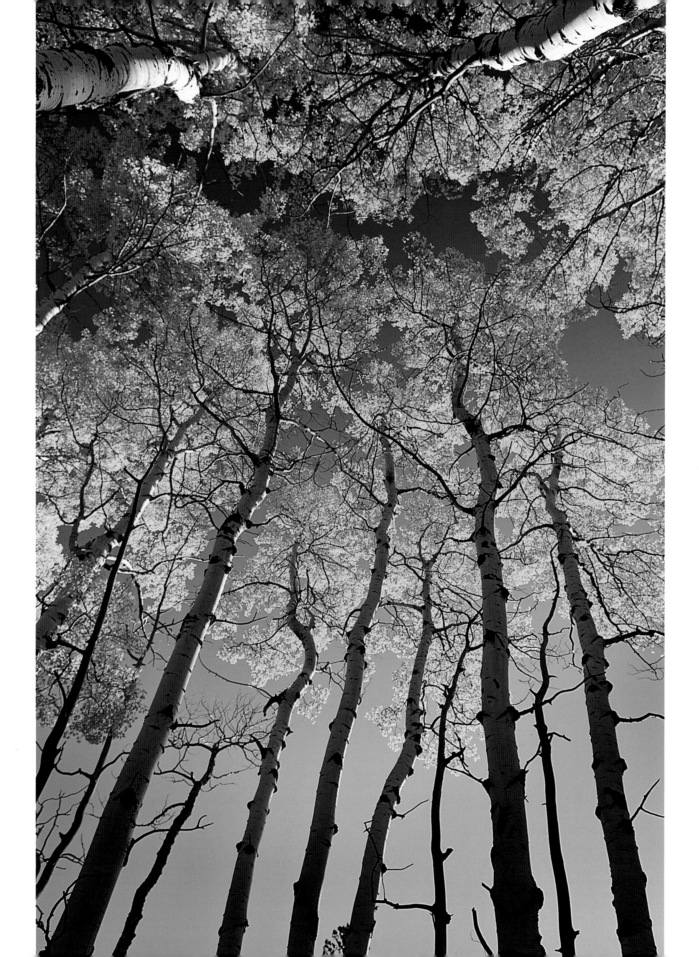

Aspens south
of Mammoth

Rodent tracks near
Swan Lake Flat

Wispy clouds,
early fog,
Specimen Ridge

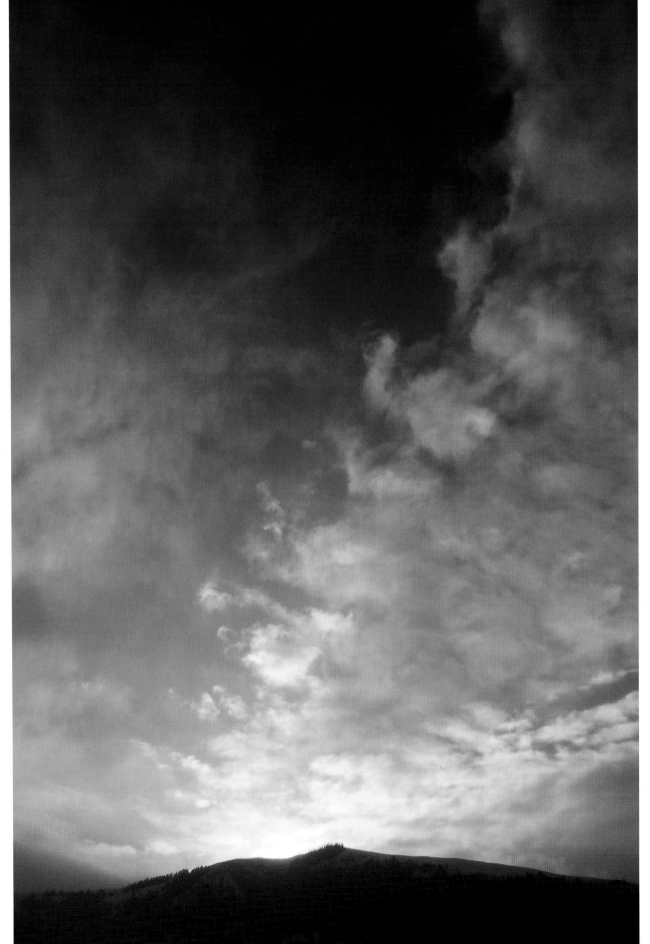

37

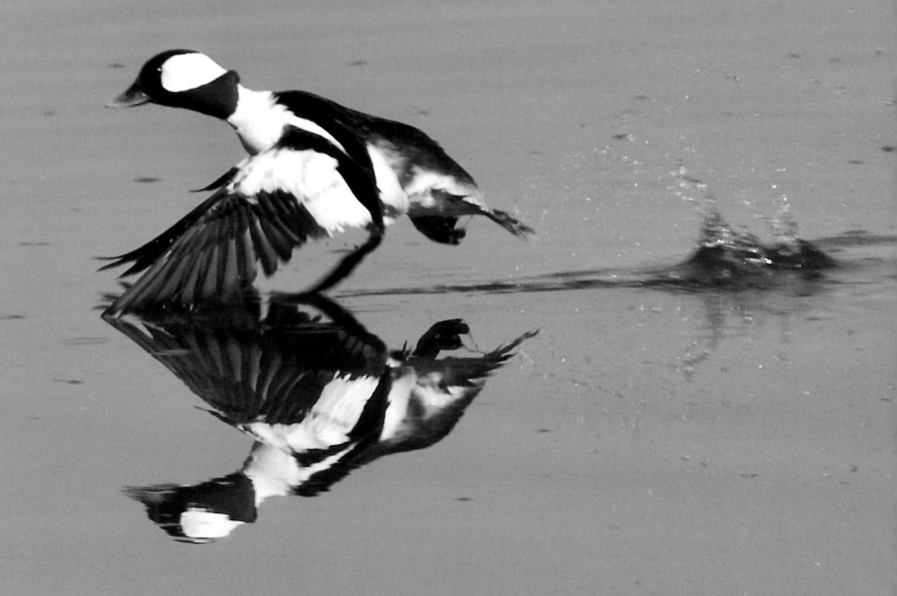
Bufflehead, Yellowstone Lake

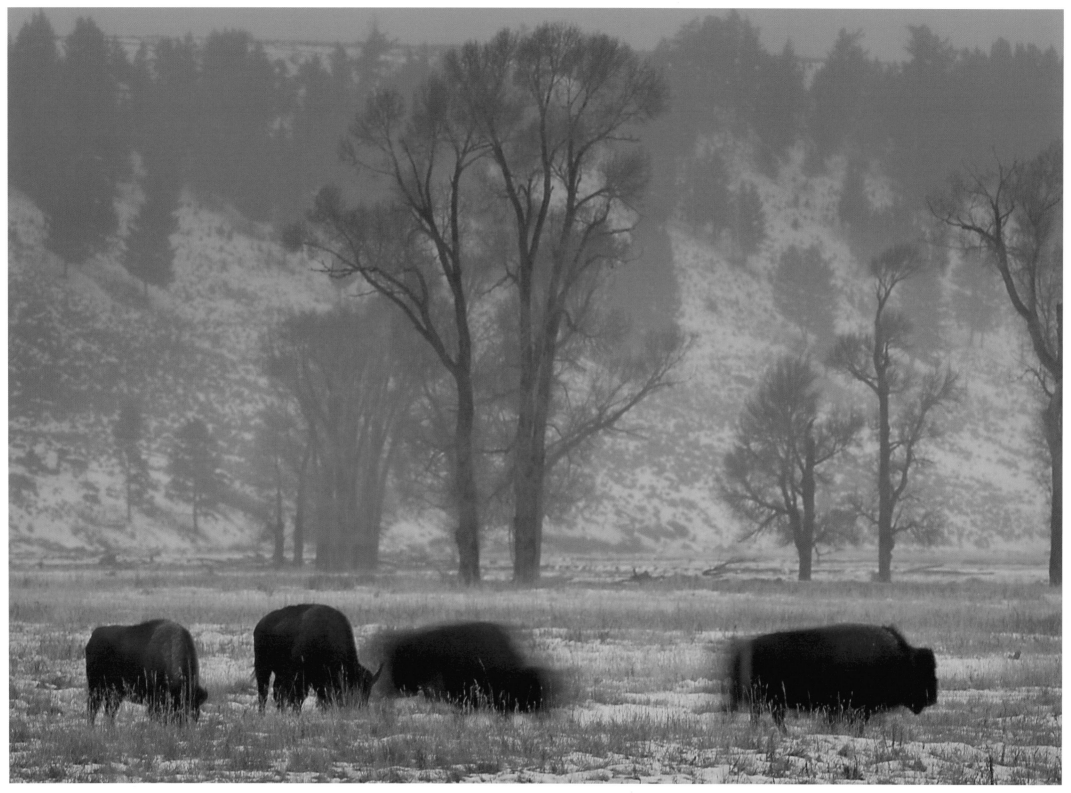

Bison, foggy morning, Lamar Valley

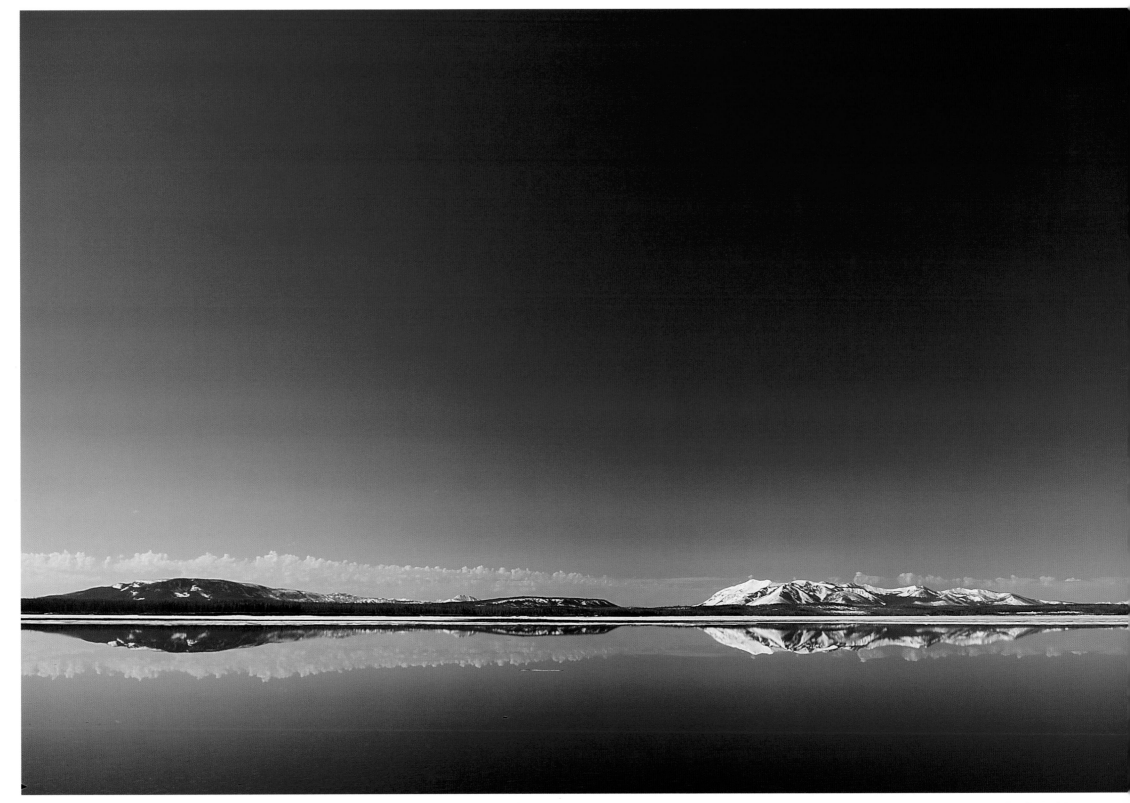

Red Mountains, Yellowstone Lake, from Pumice Point

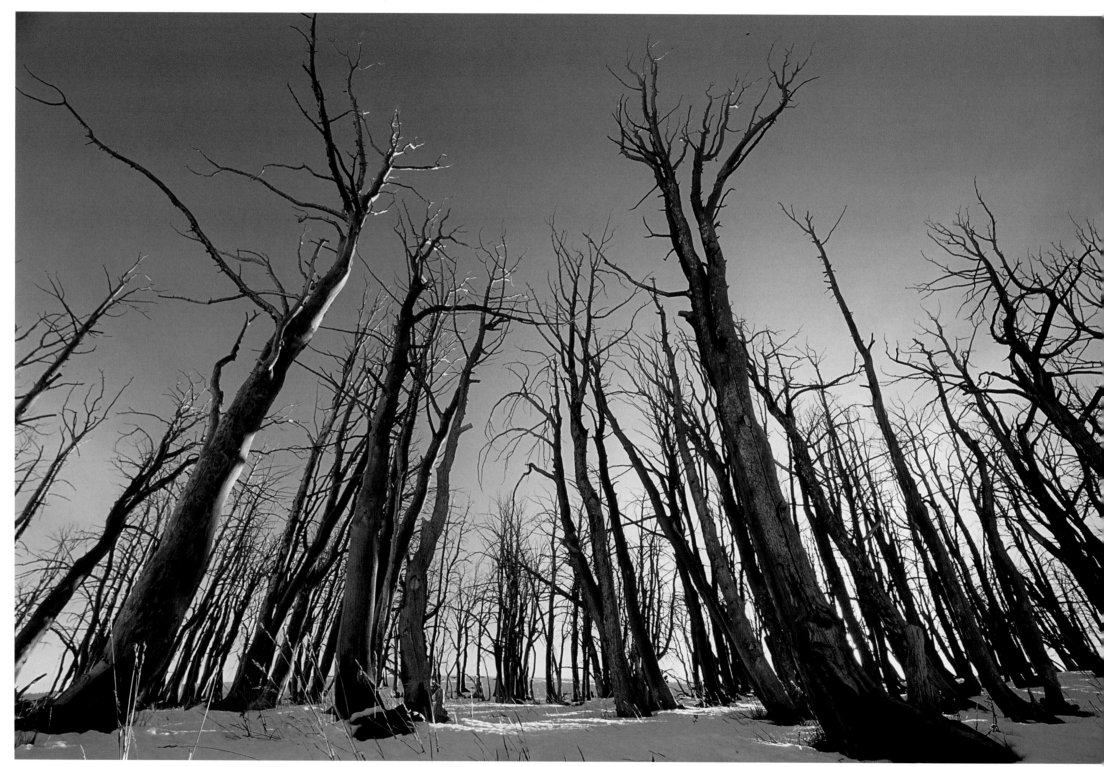

Tree trunks scorched in the 1988 fires, Mount Washburn

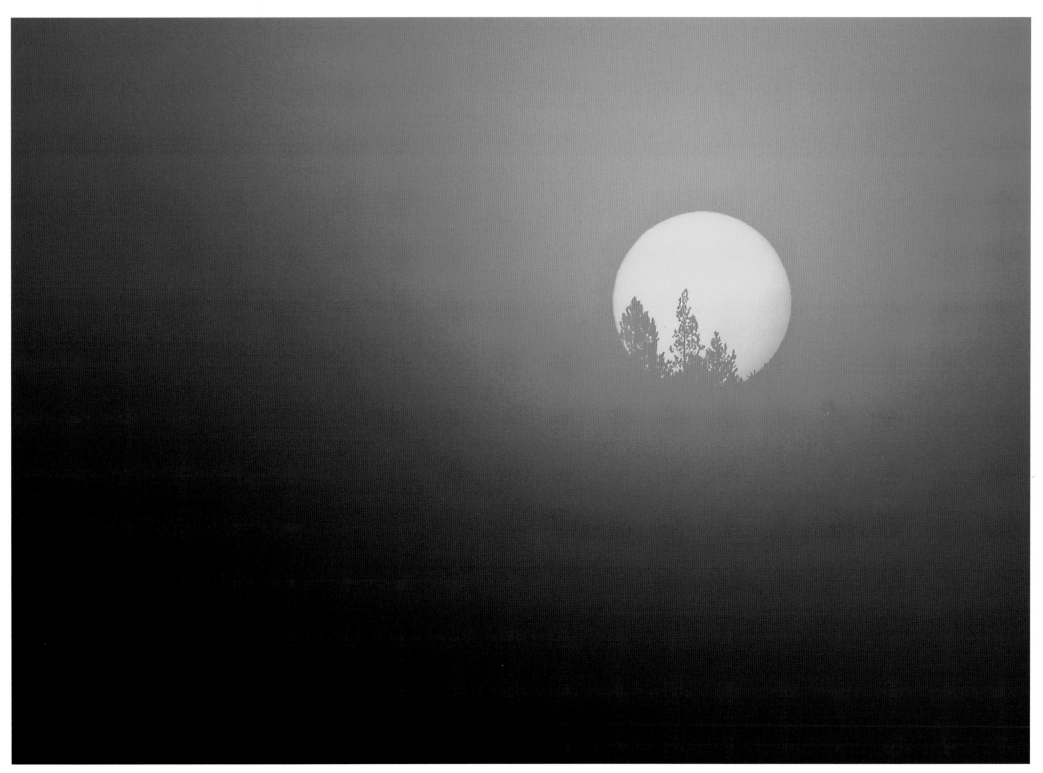

Rising sun through fog, Hayden Valley

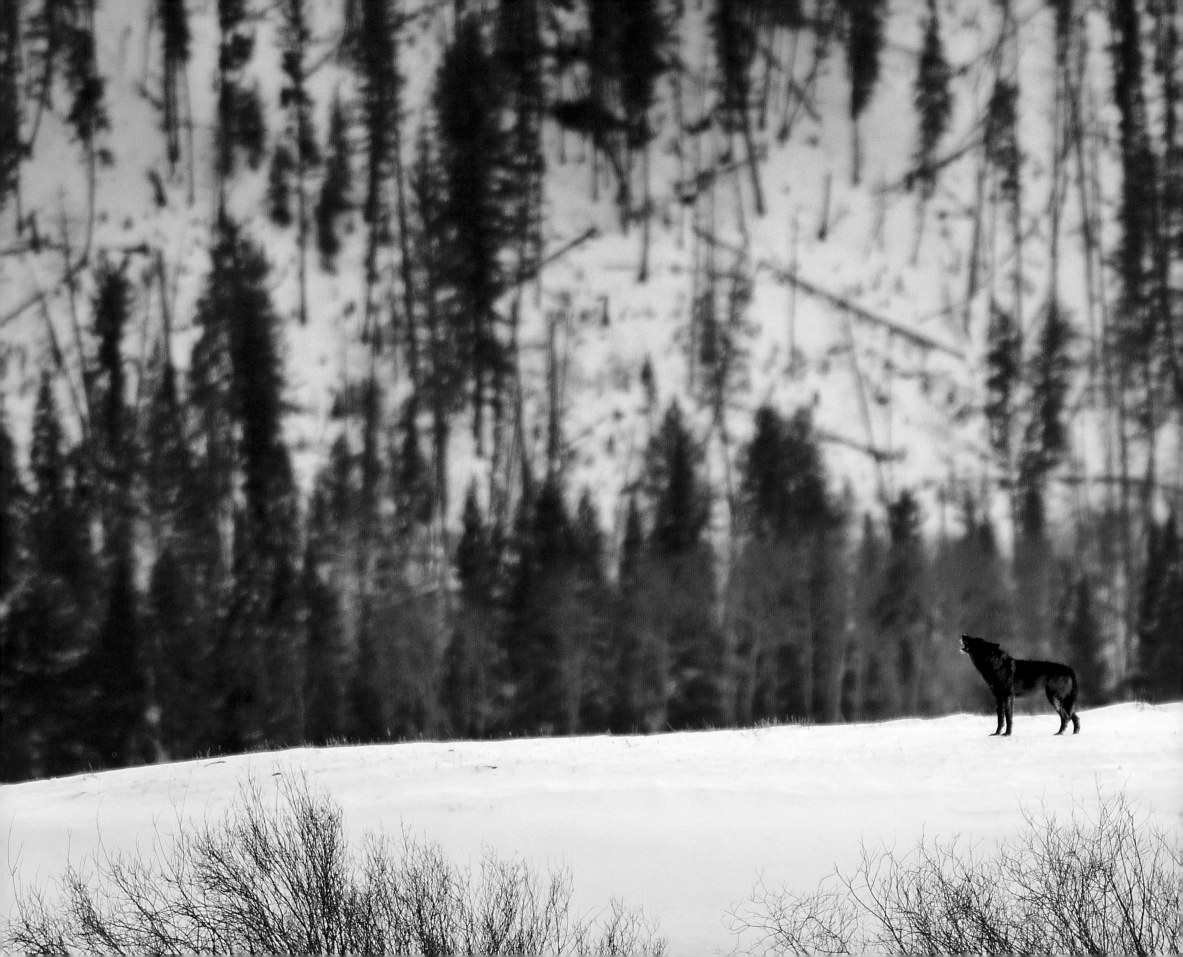

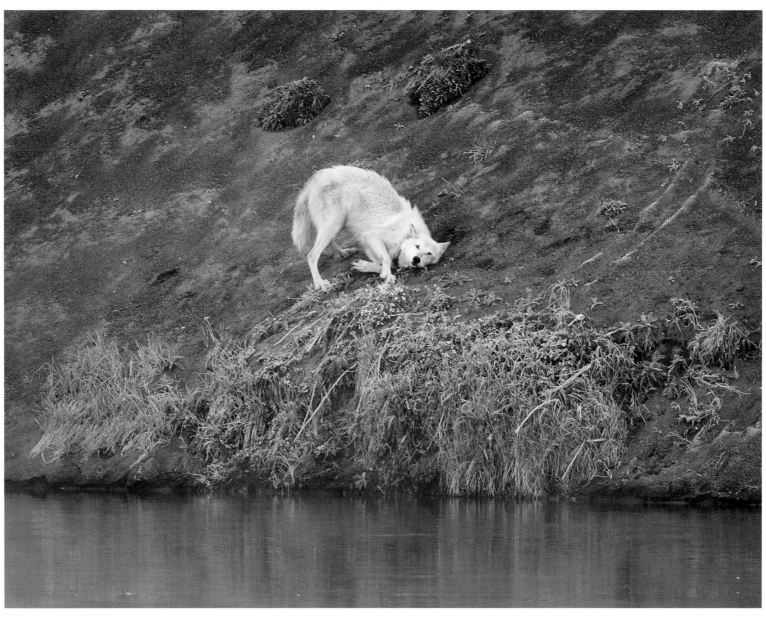

White wolf near confluence of Otter Creek and Yellowstone River, Hayden Valley

Wolf howling, Lamar River

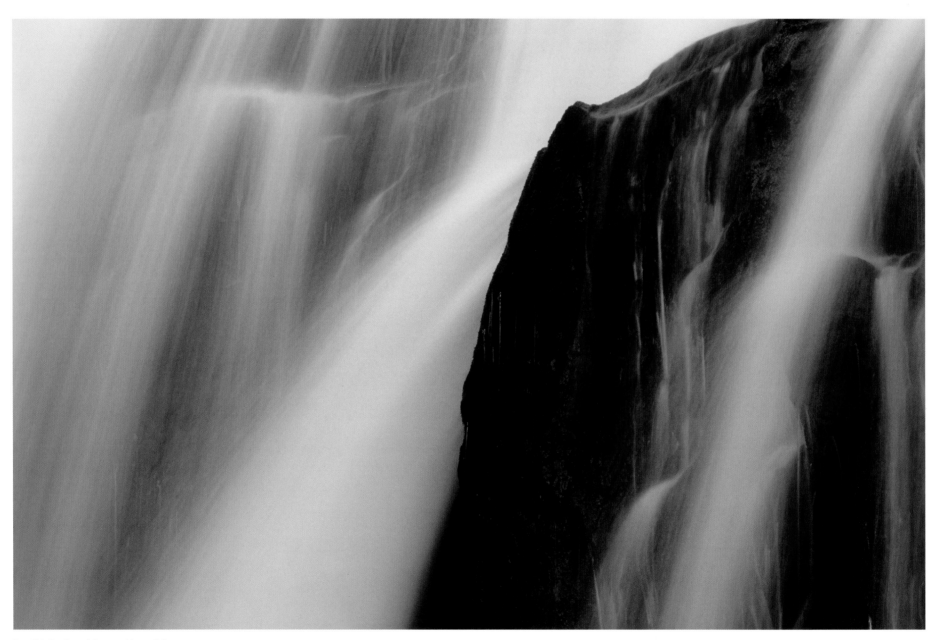

Crawfish Creek tumbling over Moose Falls

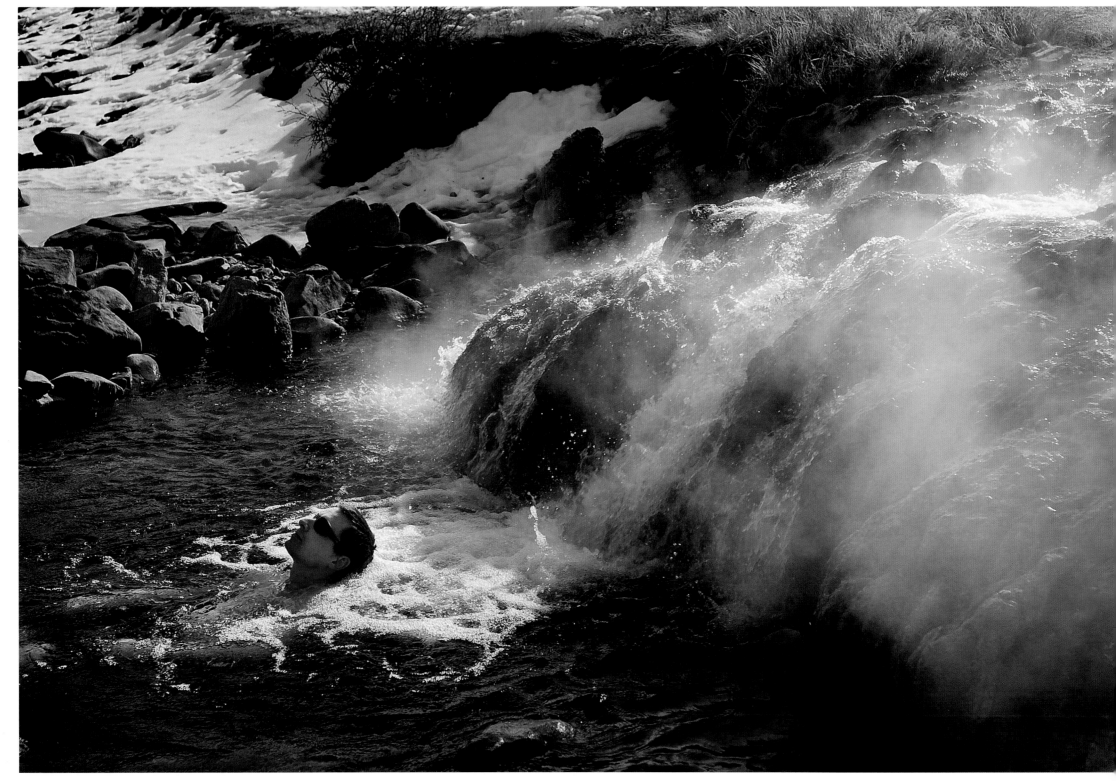

Boiling River

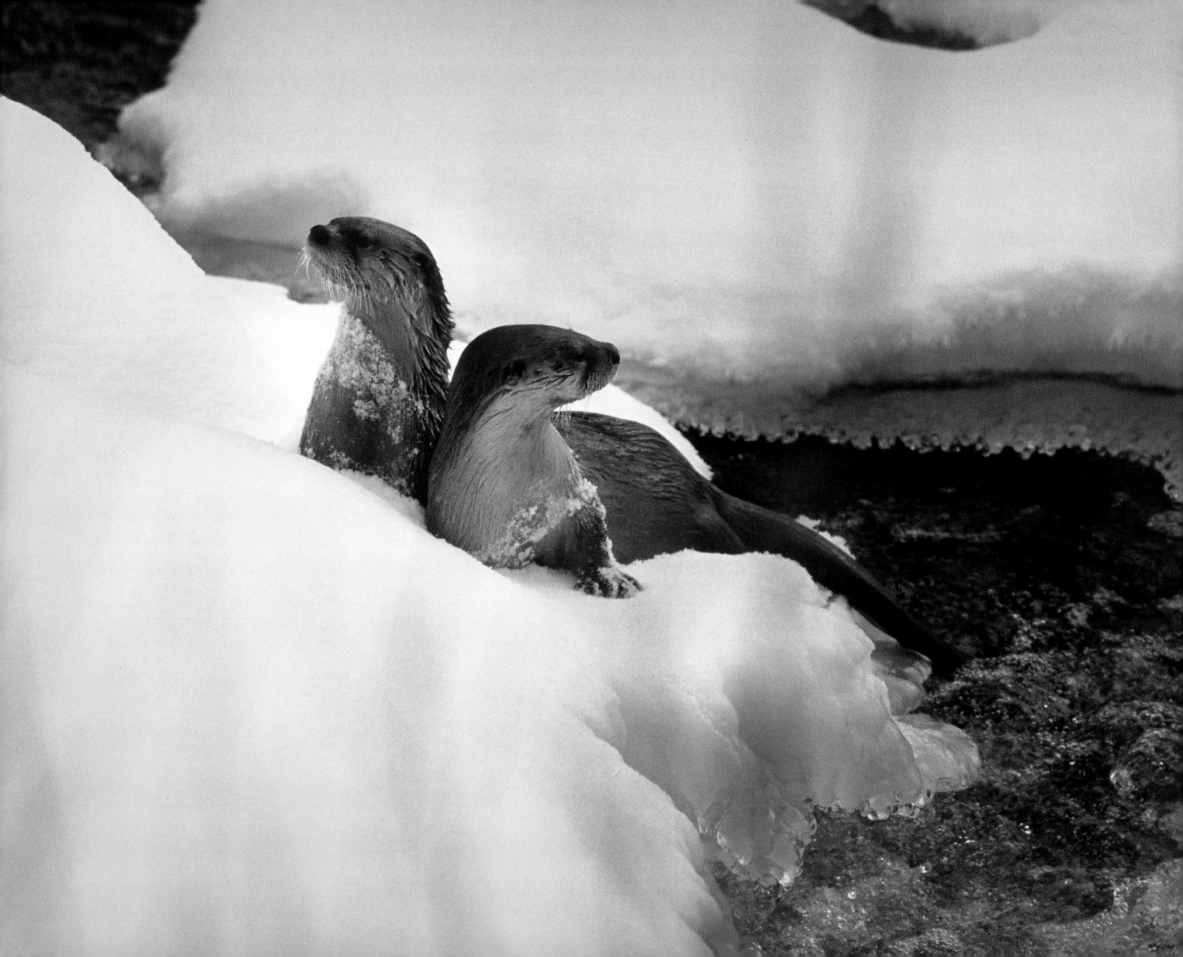

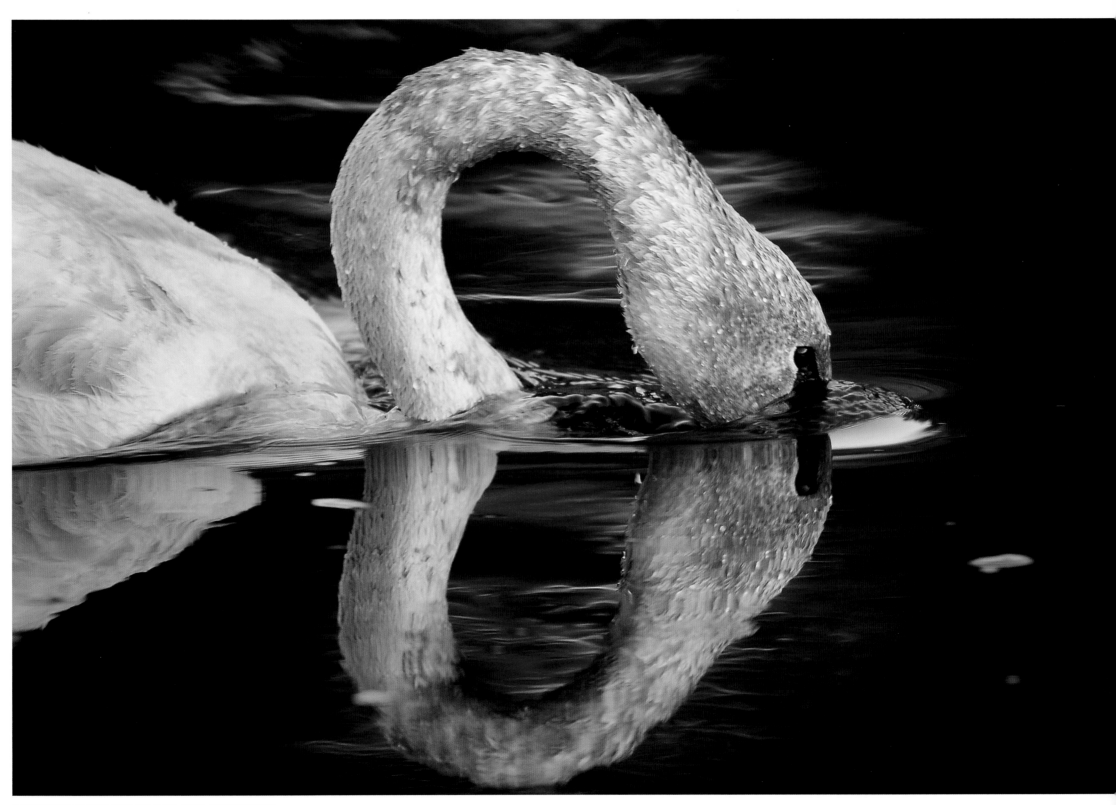

Trumpeter swan, Madison River, and at left, otters, Soda Butte Creek

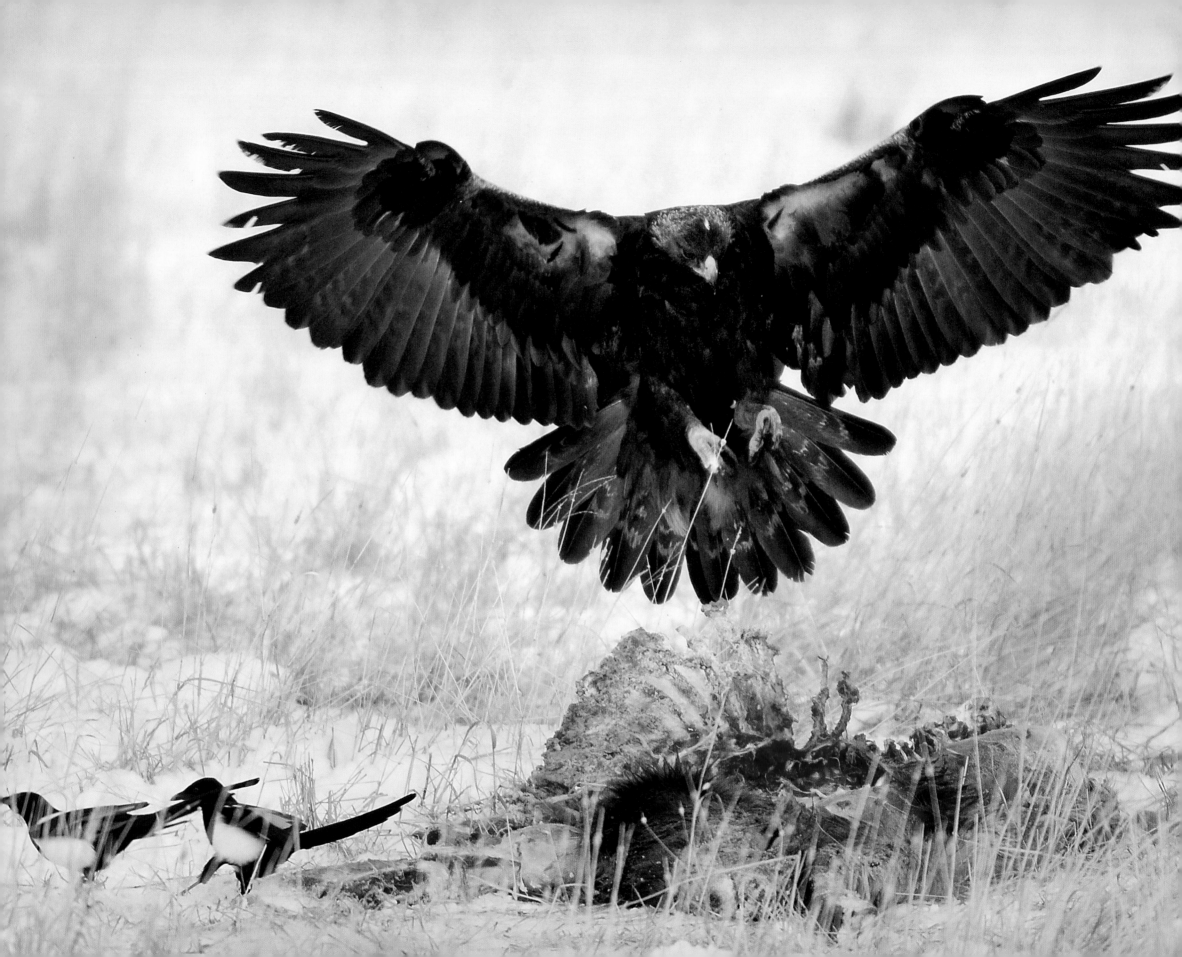

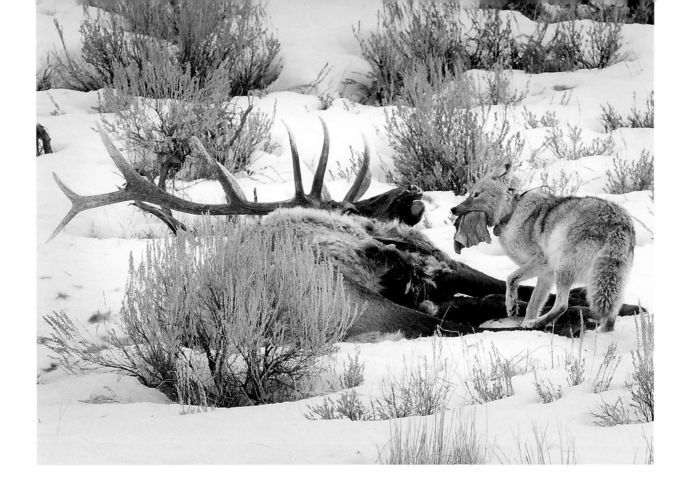

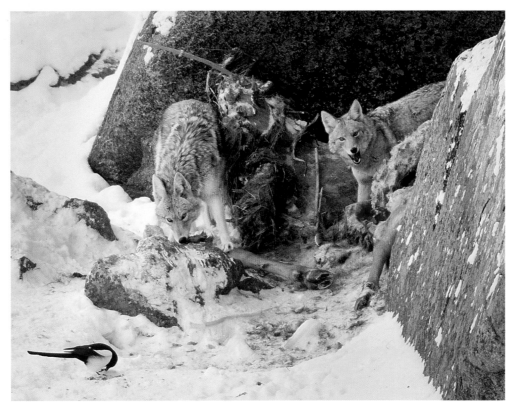

Far left, golden eagle,
elk carcass,
Lamar Valley

Above, coyote
and elk steak,
Lamar Valley

Left, coyotes
and elk leftovers,
Lamar River

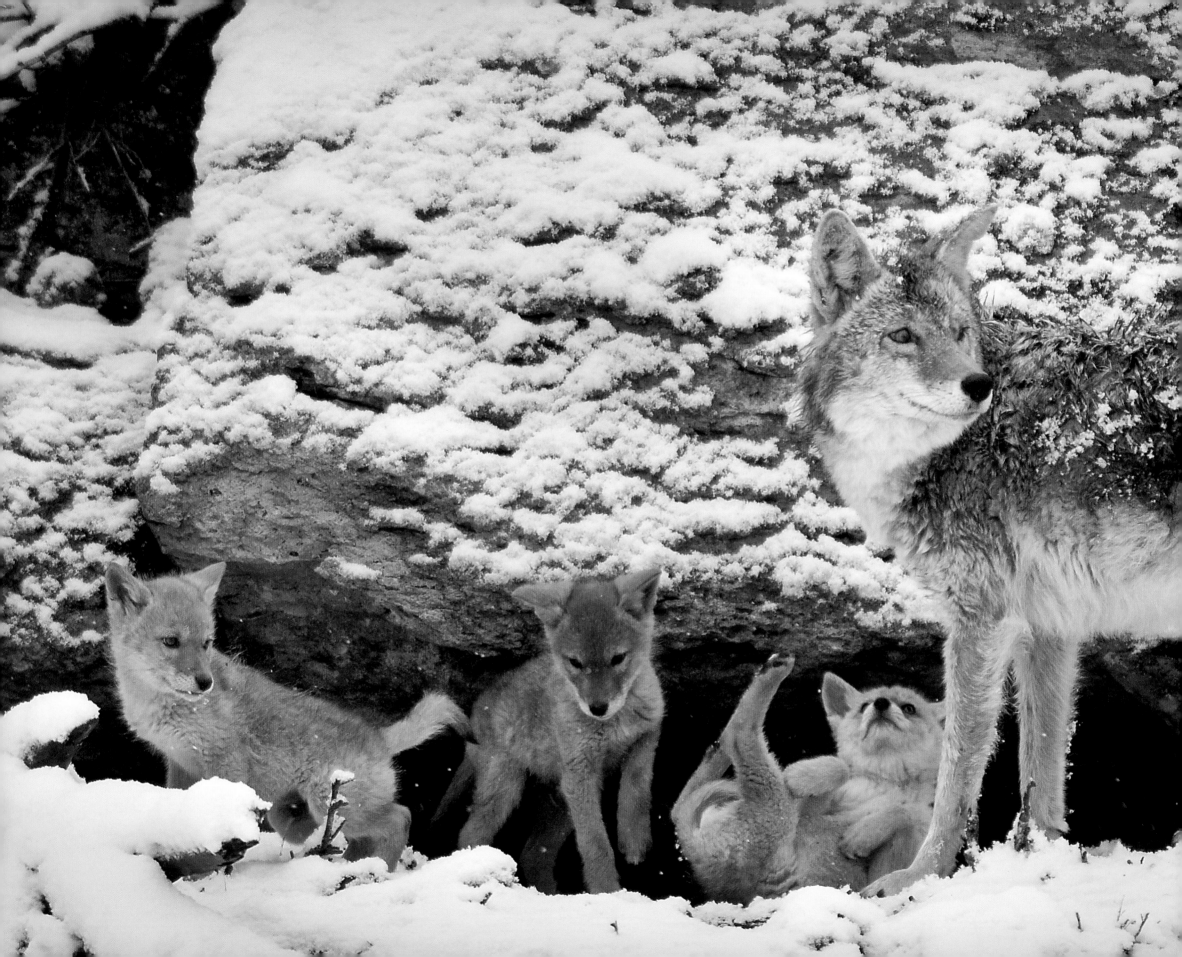

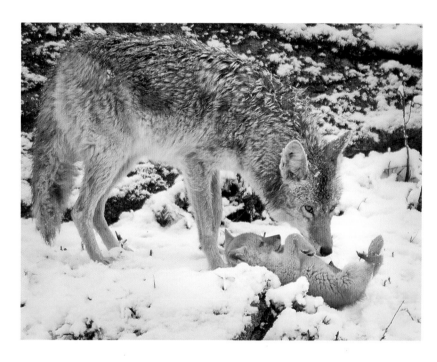

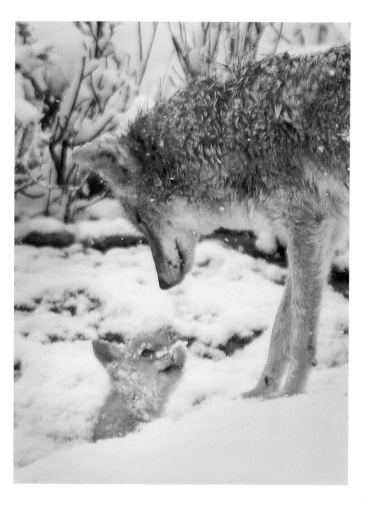

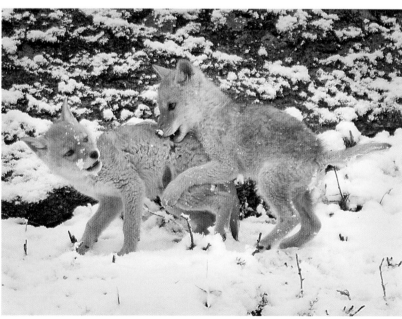

Coyote and pups, Blacktail Deer Plateau

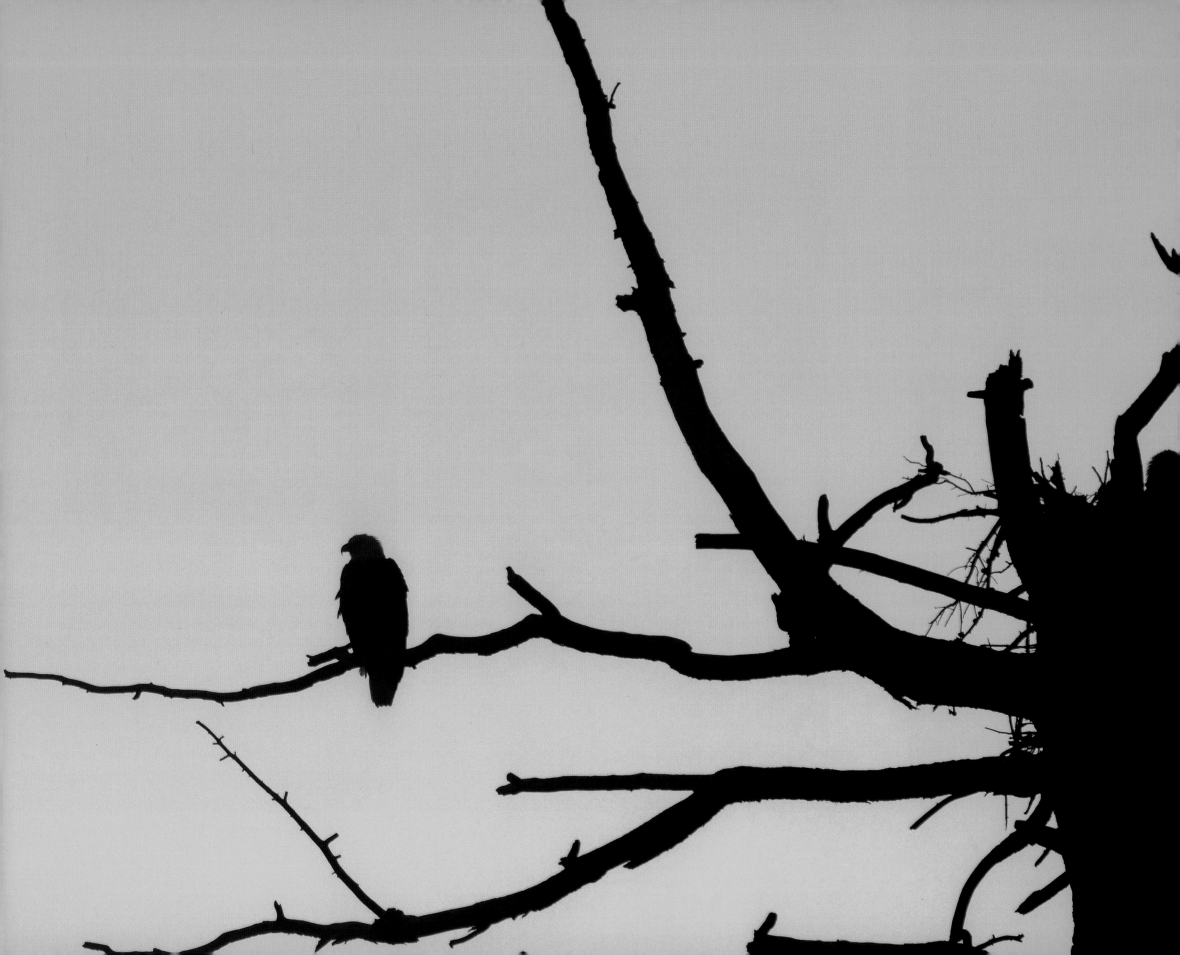

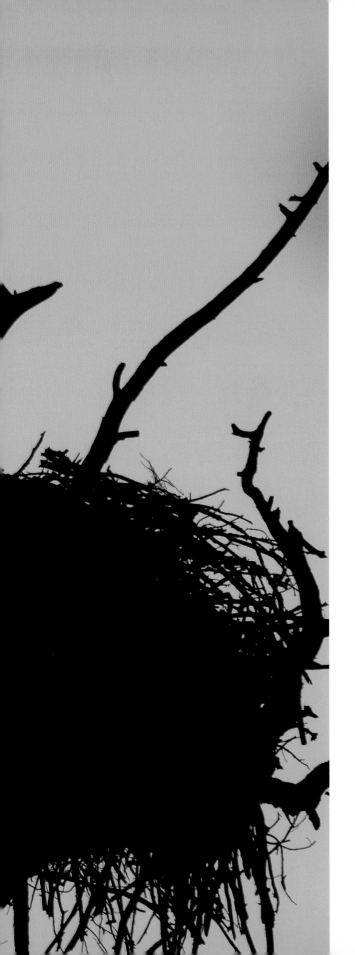

Bald eagle and nest along Madison River

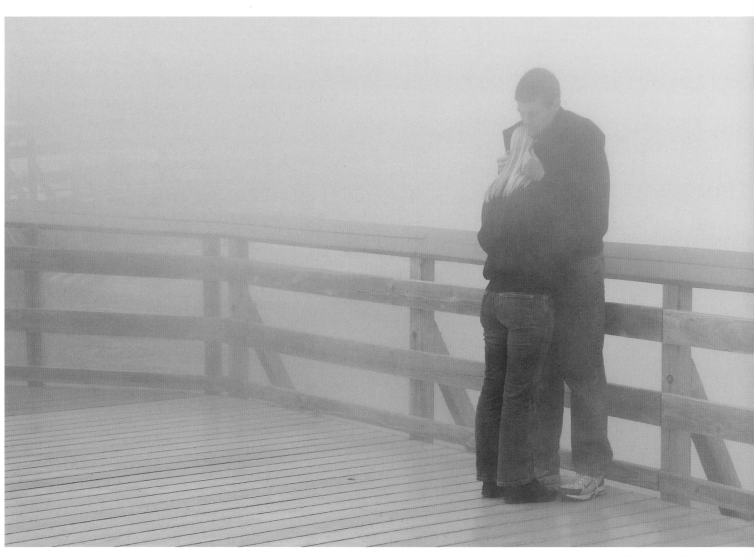

Young couple embracing, Midway Geyser Basin

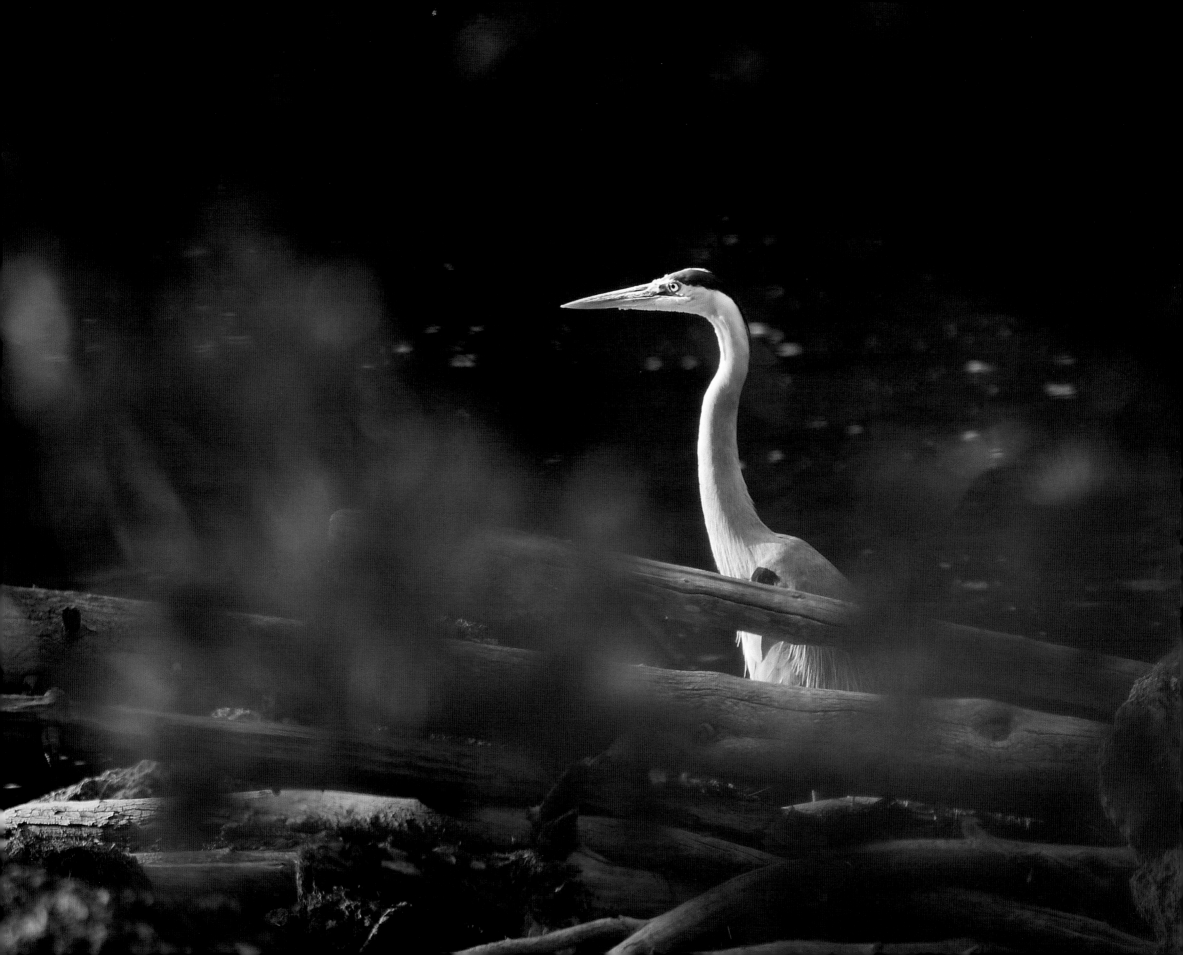

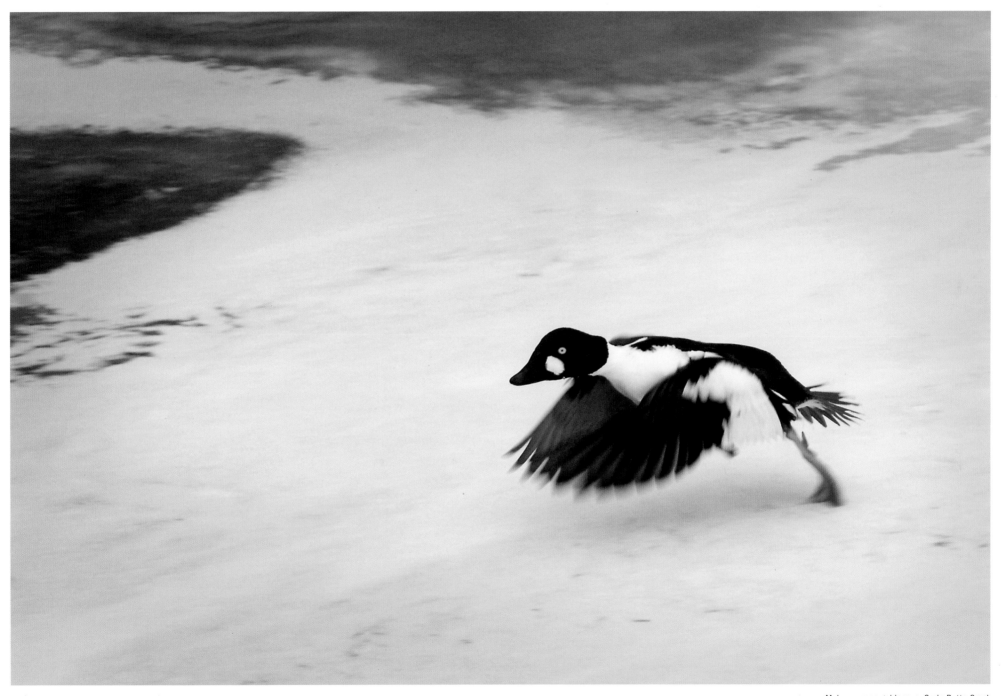

Male common goldeneye, Soda Butte Creek

Great blue heron, Firehole River

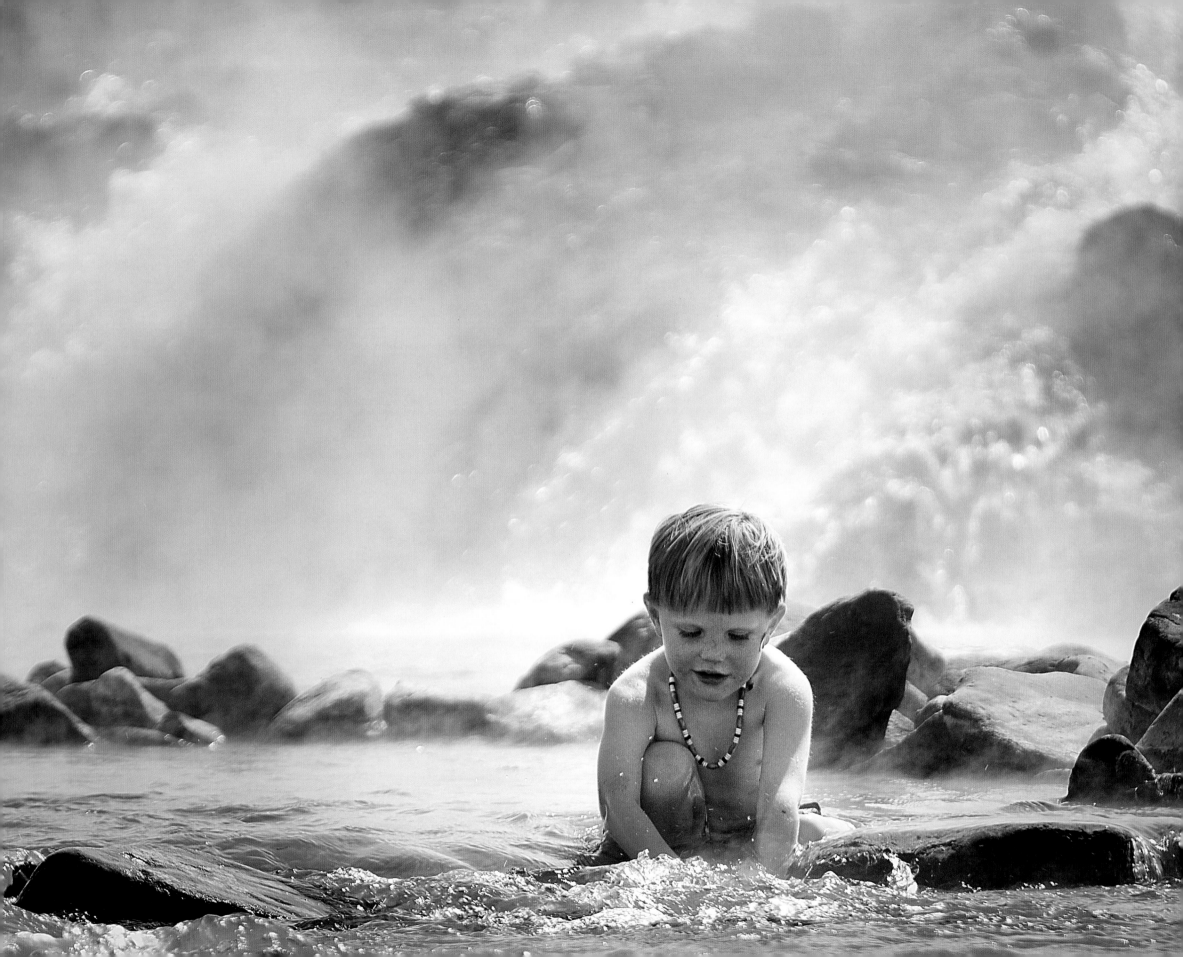

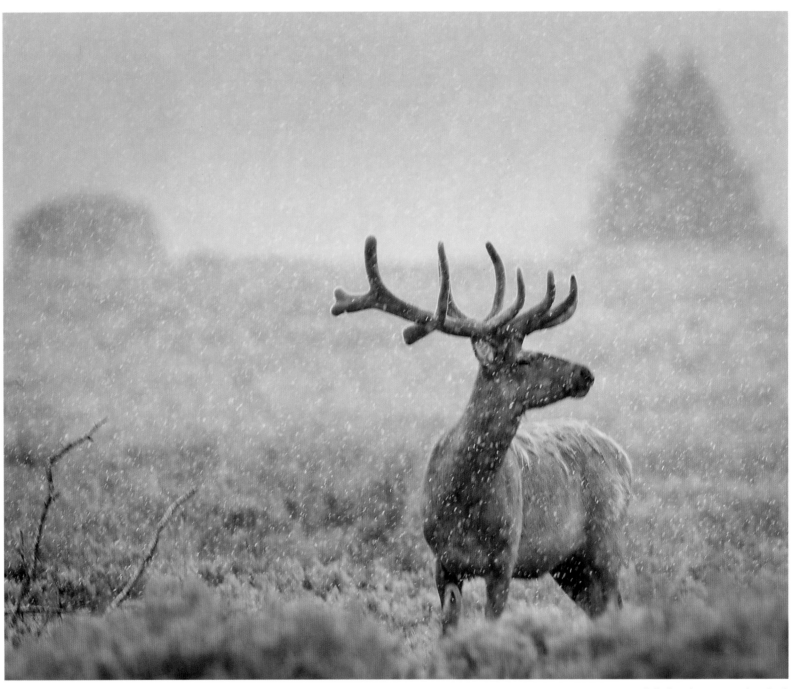

Bull elk, spring snow, near Lava Creek

Boiling River

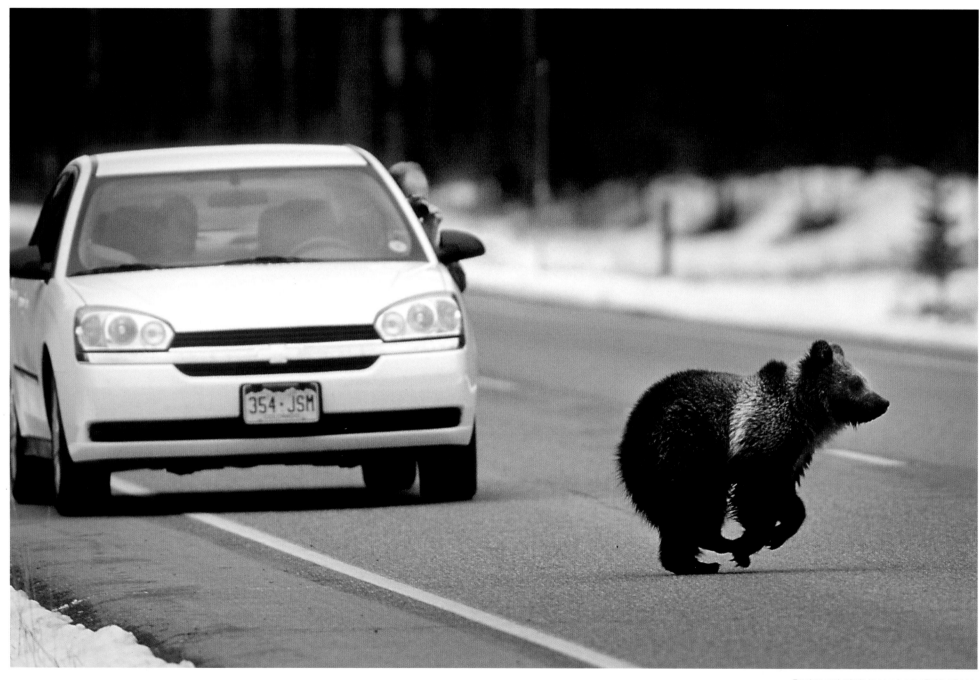

Tourists and grizzly bear cub near Fishing Bridge

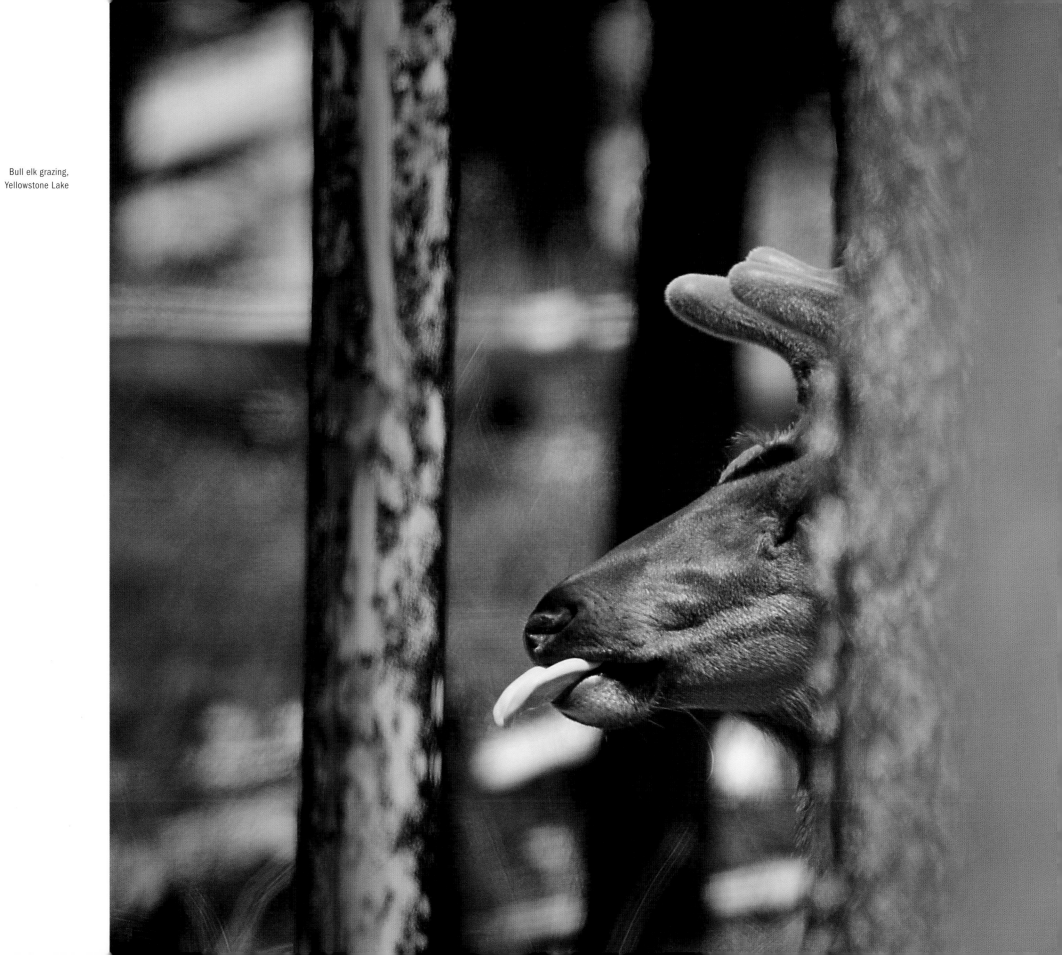

Bull elk grazing,
Yellowstone Lake

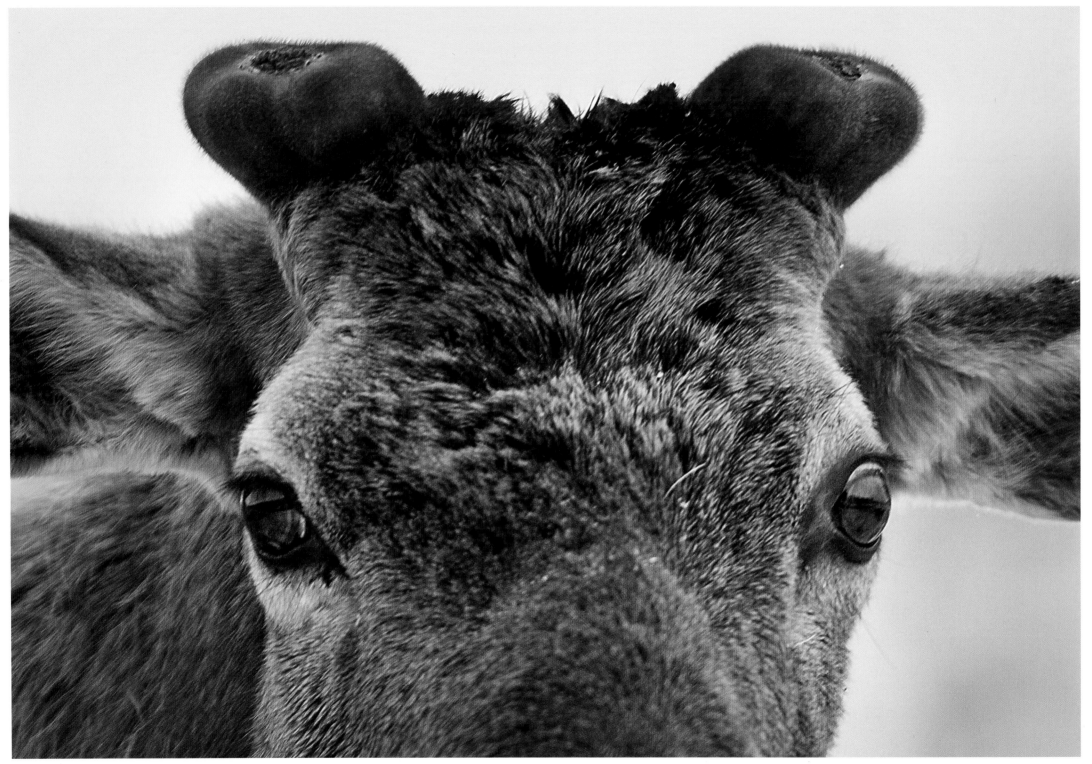

Bull elk begins to grow antlers, Lava Creek

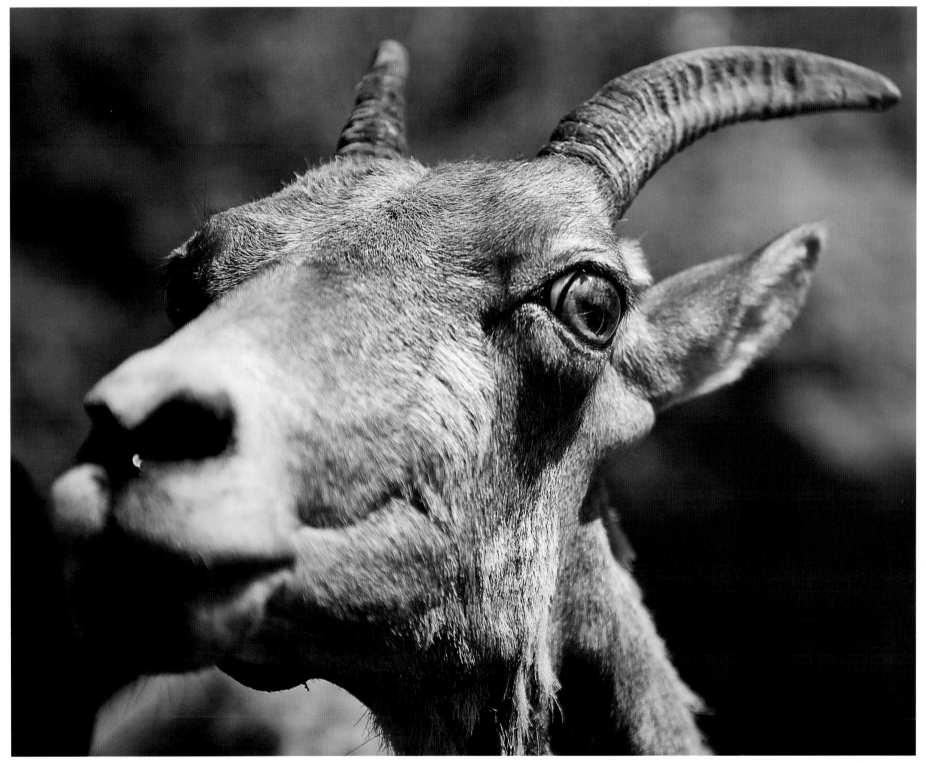

Bighorn ewe, Dunraven Pass

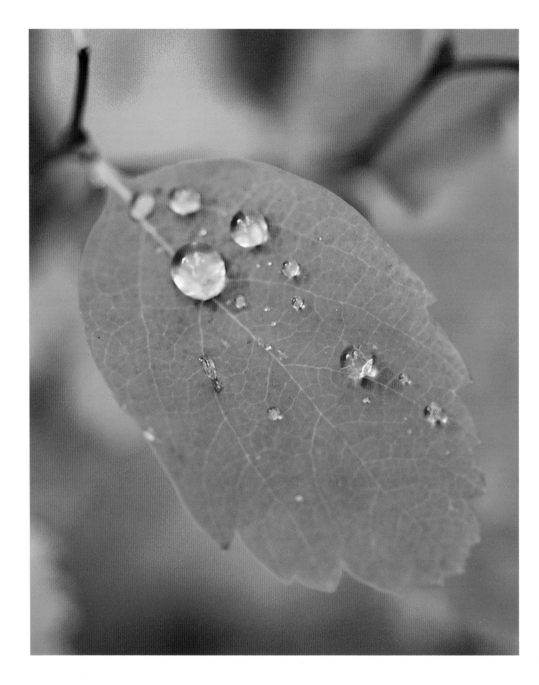

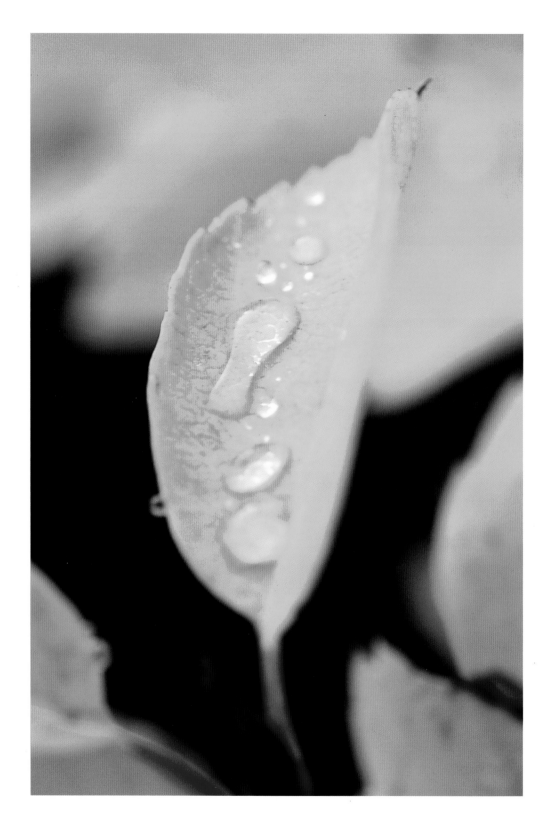

Water droplets and changing
leaves, Moose Falls

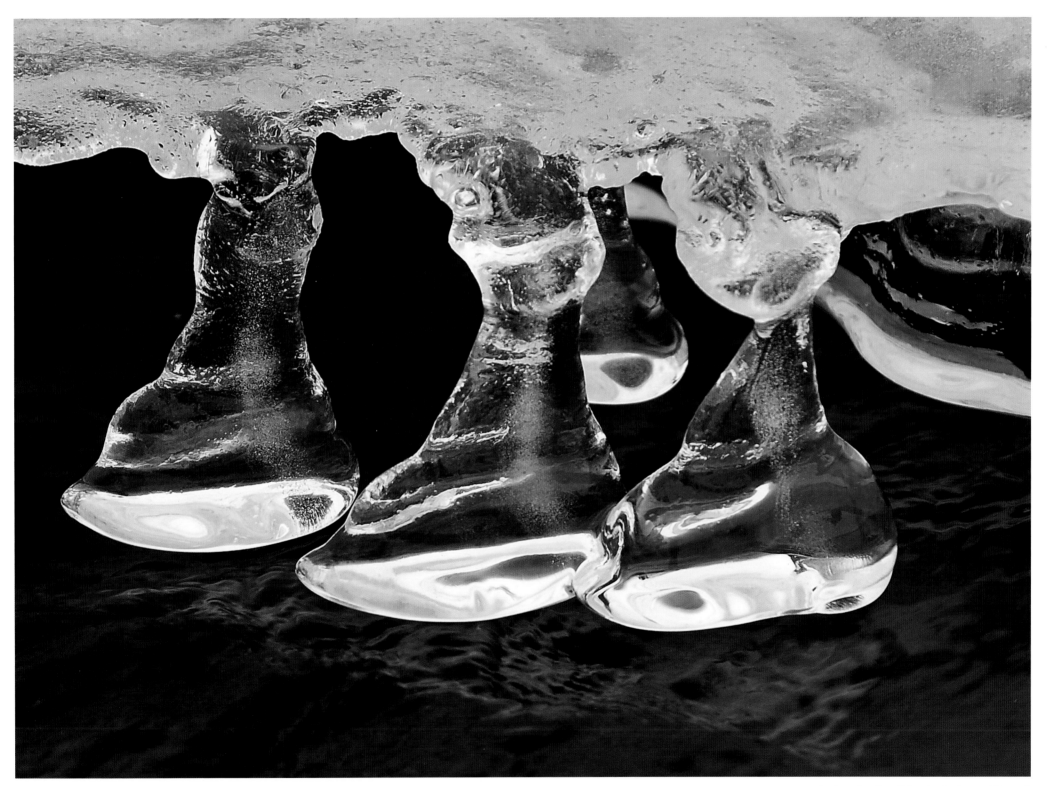

Ice formation above Hellroaring Creek east of Mammoth

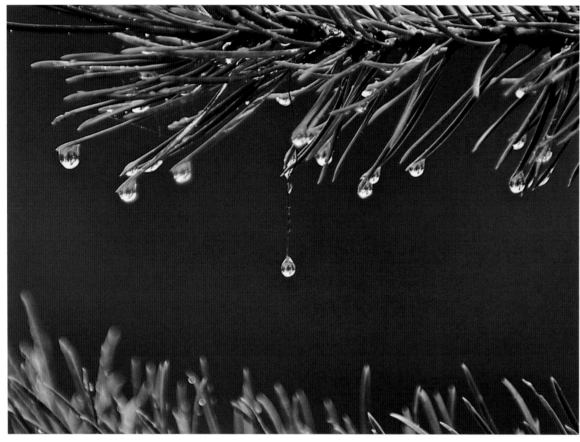

Pine branch in rain, near Canyon Village

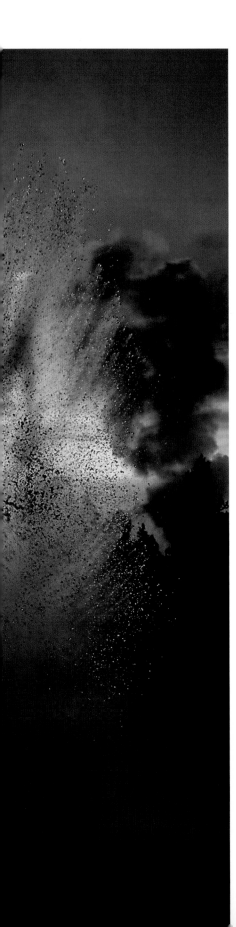

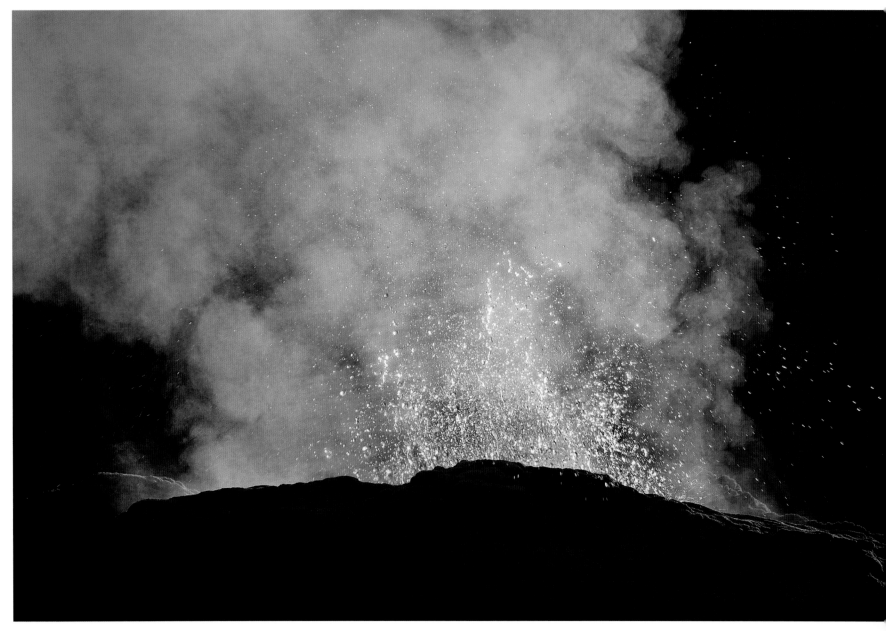

Lion Geyser Group near Old Faithful

Sawmill Geyser near Old Faithful

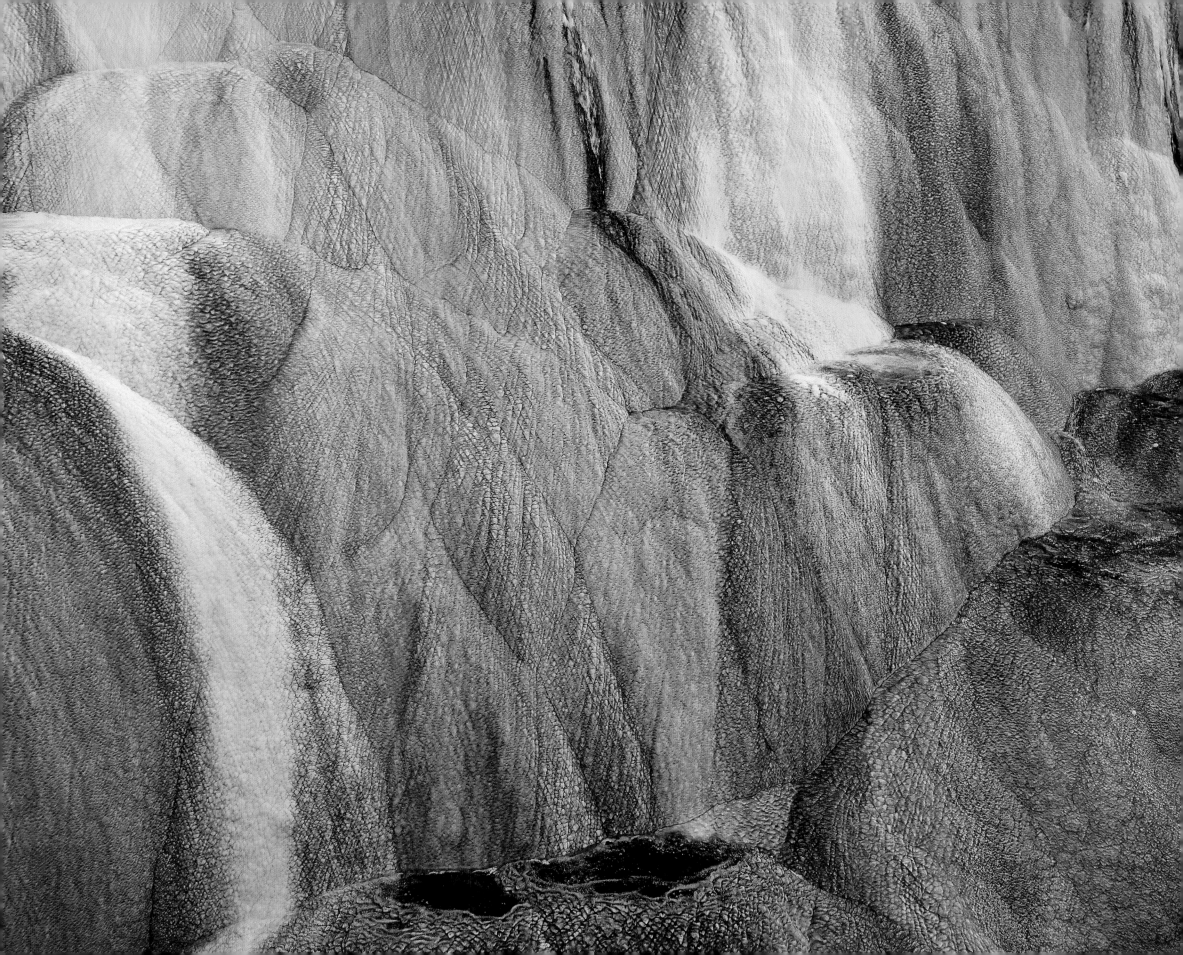

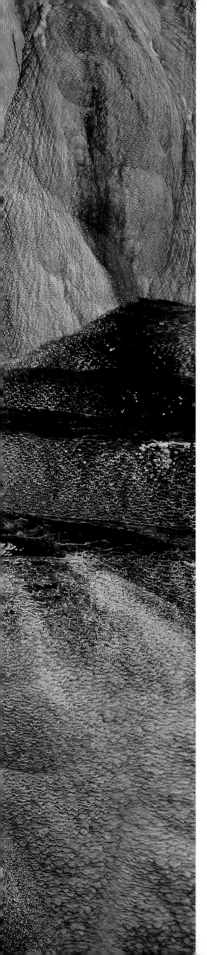

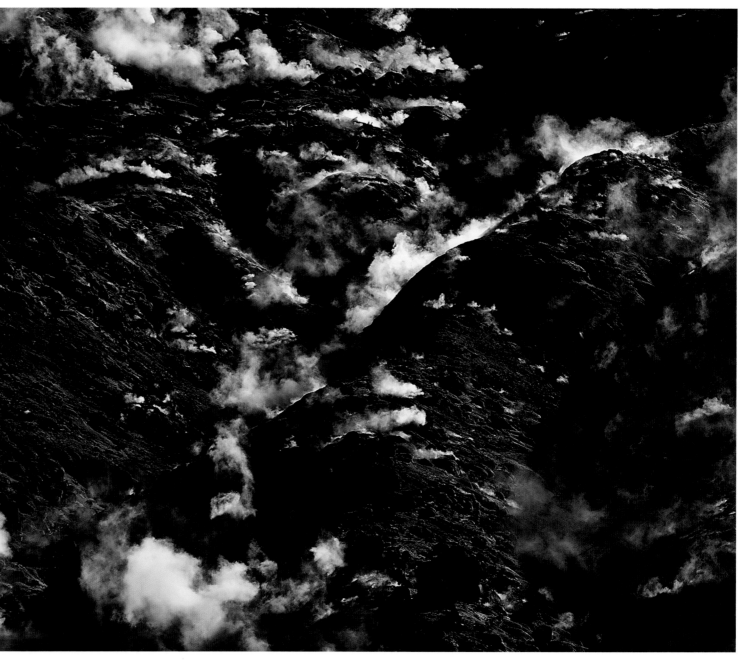

Roaring Mountain near Norris Geyser Basin

Hymen Terrace, Mammoth Hot Springs

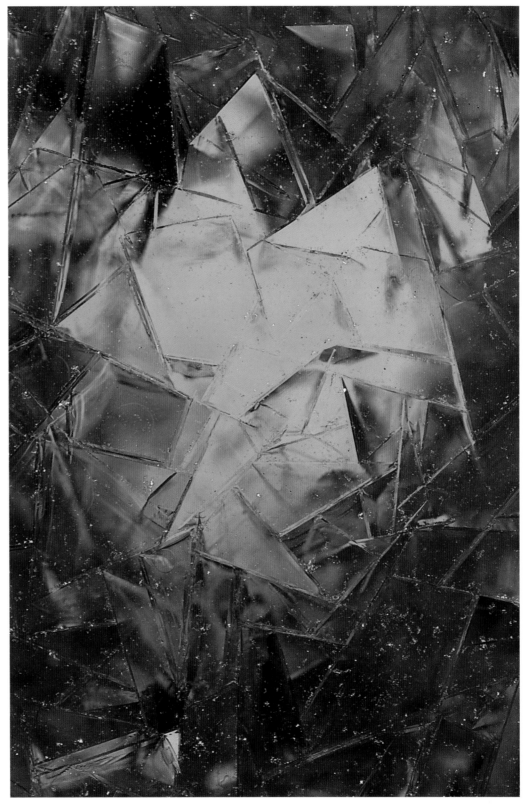

Ice forming over
creek bed,
Soda Butte Creek

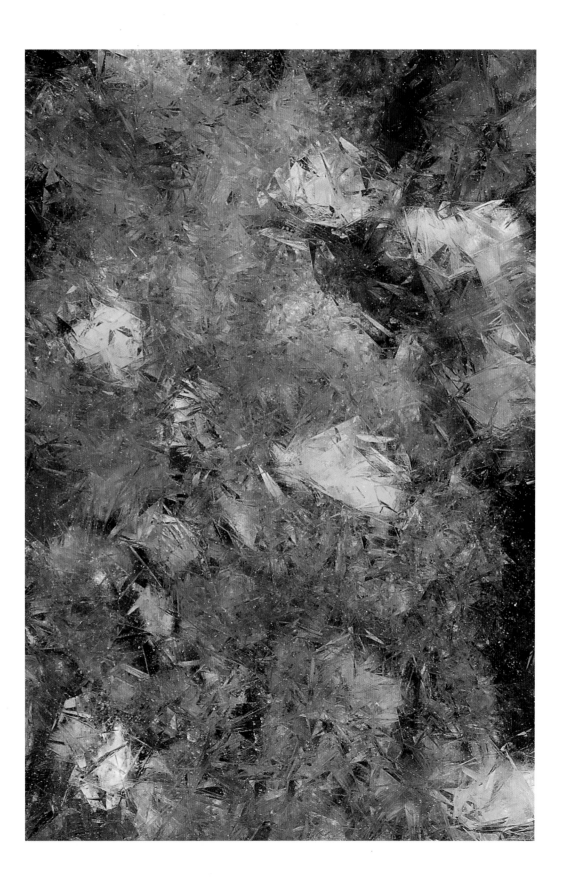

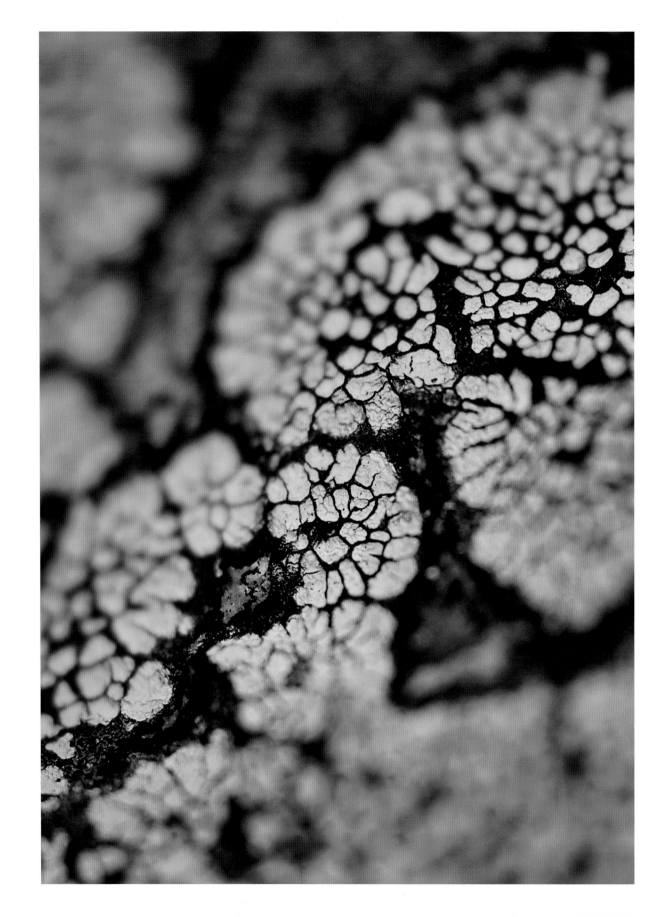

Lichen on boulder,
Lamar Valley

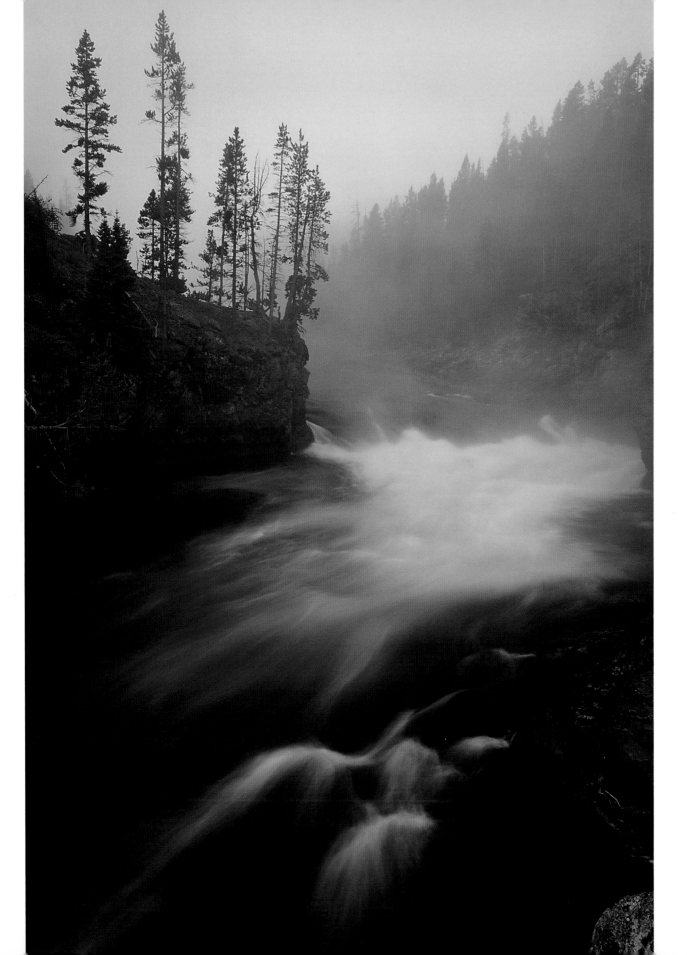

Yellowstone River at brink of Upper Falls,
Grand Canyon of the Yellowstone

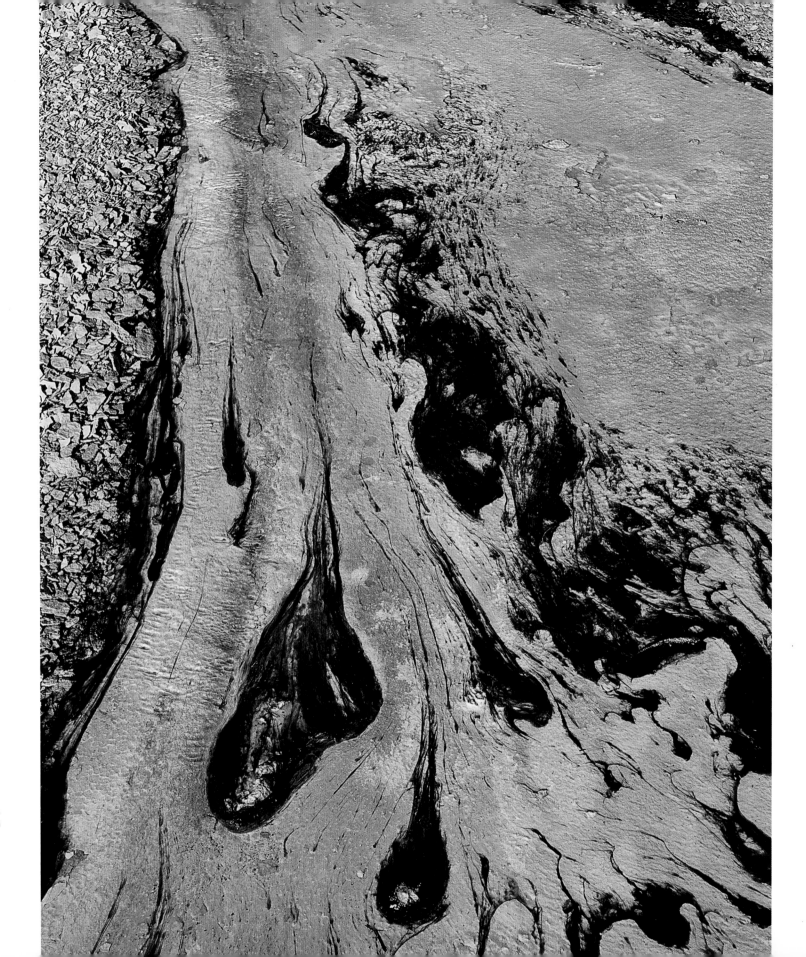

Ground detail,
Norris Geyser Basin

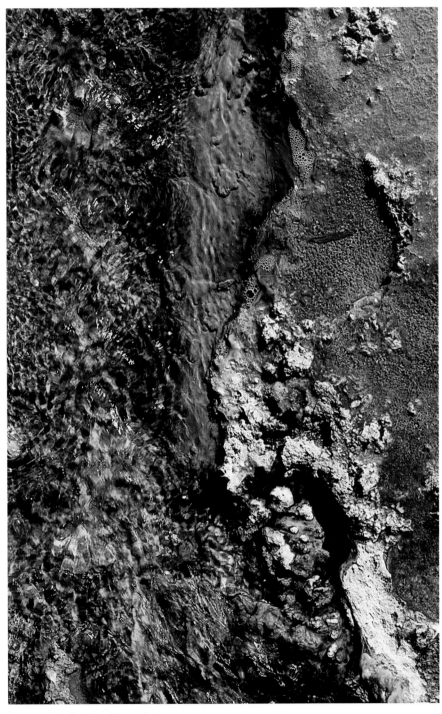

Ground details, Black Sand Geyser Basin

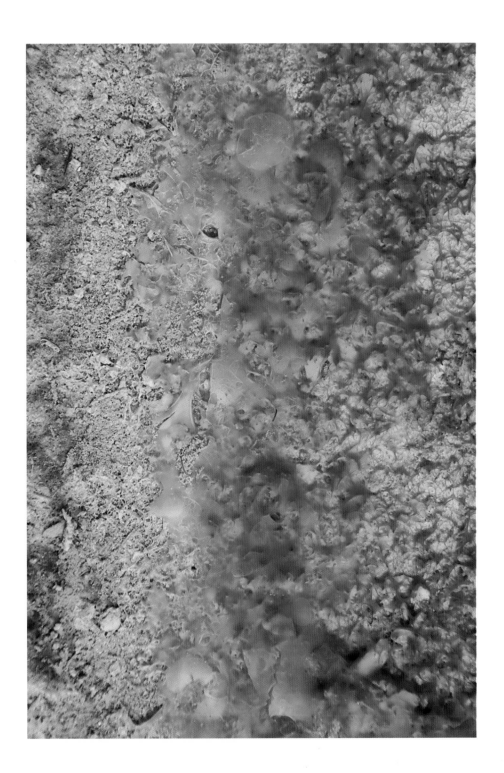

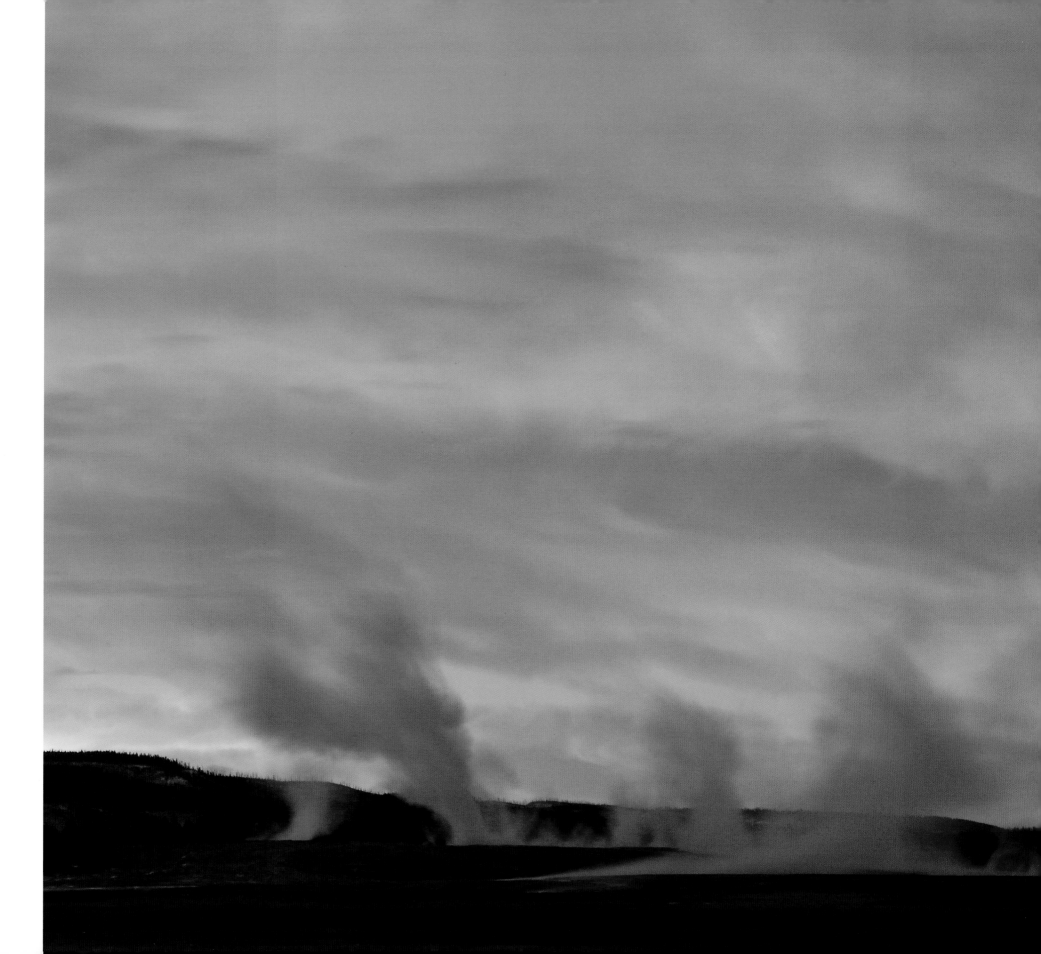

Sunrise, Lower Geyser Basin

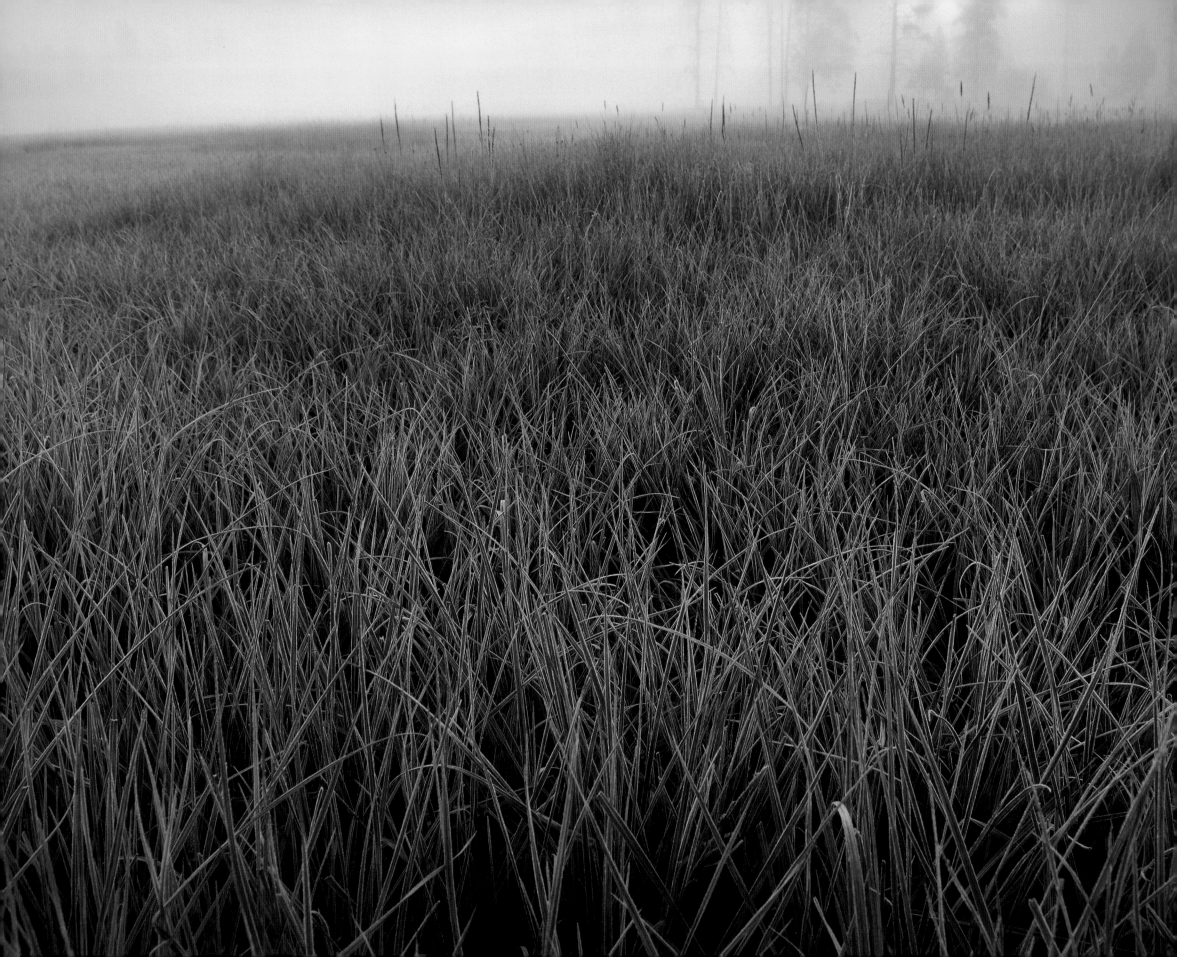

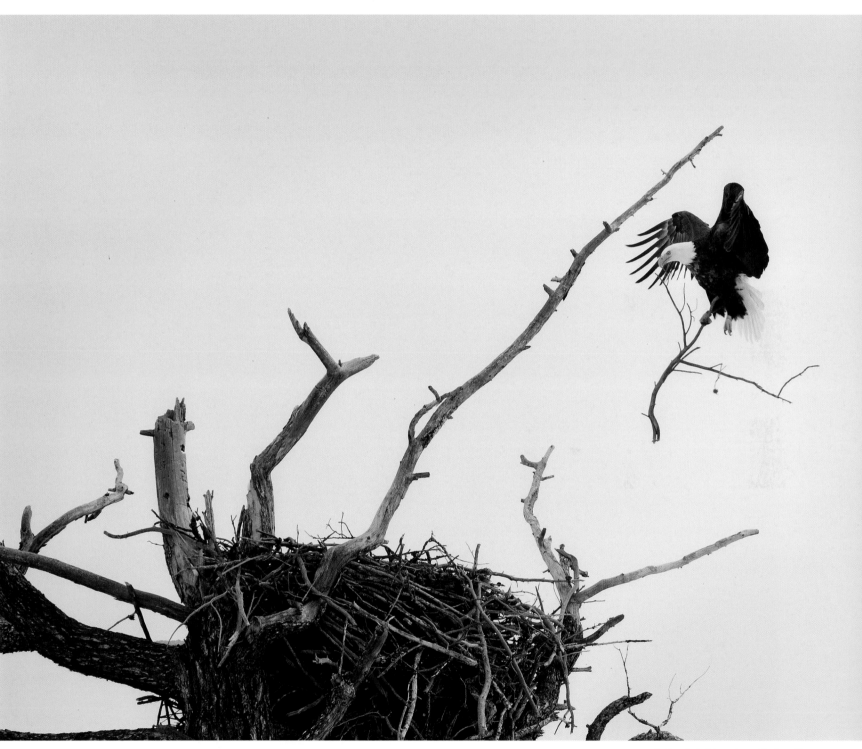

Bald eagle builds nest near Madison River

Dewy grass, foggy morning, near Madison Junction

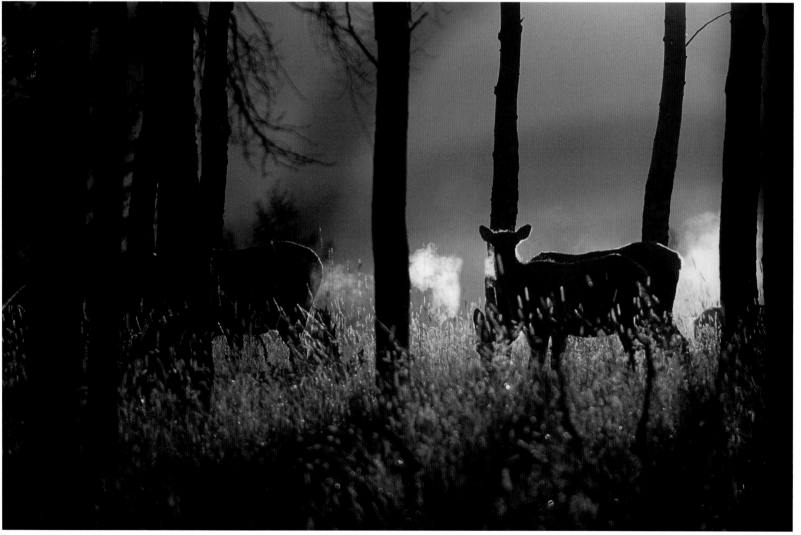

Sunrise, elk cows, south of Mammoth

Tree stand in fog, near Madison Junction

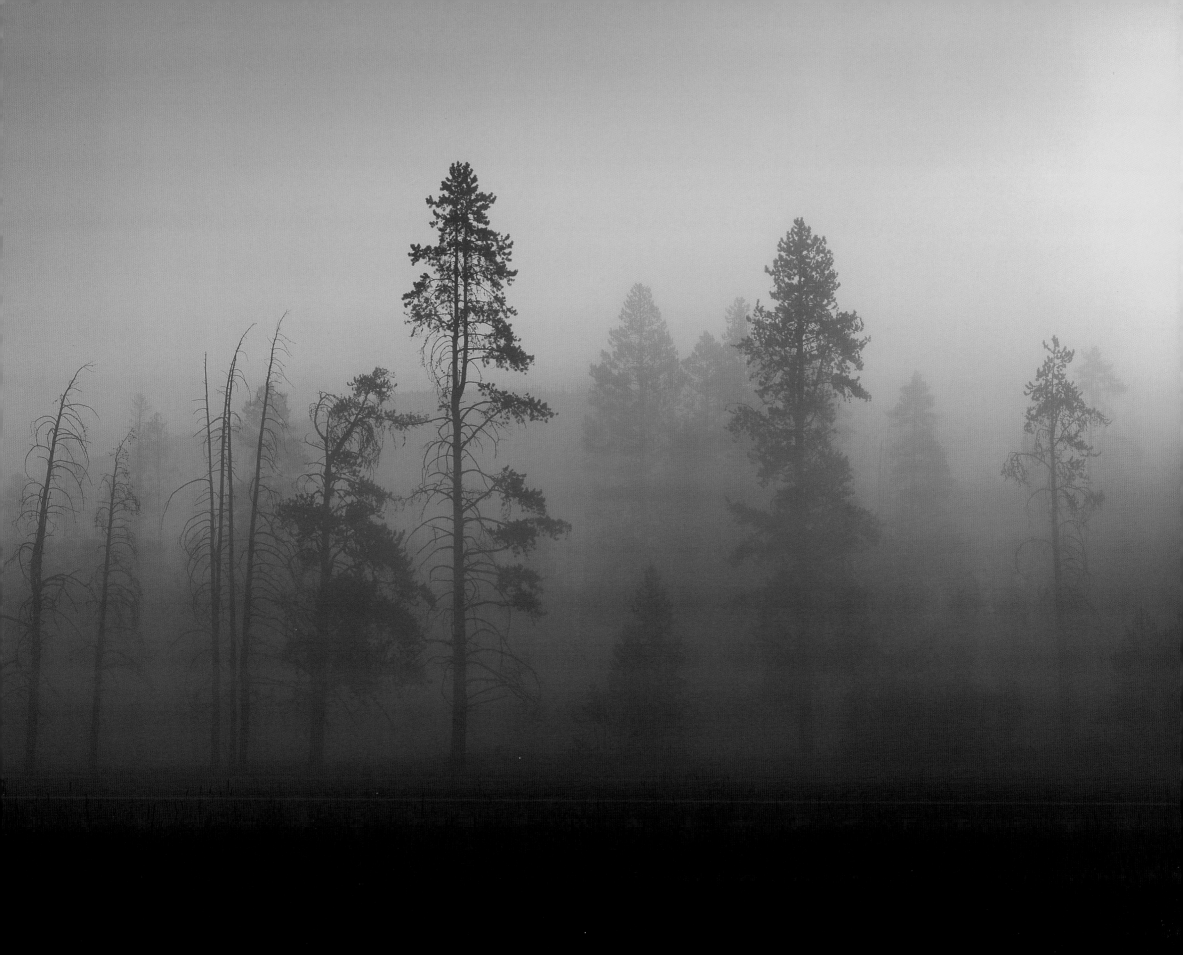

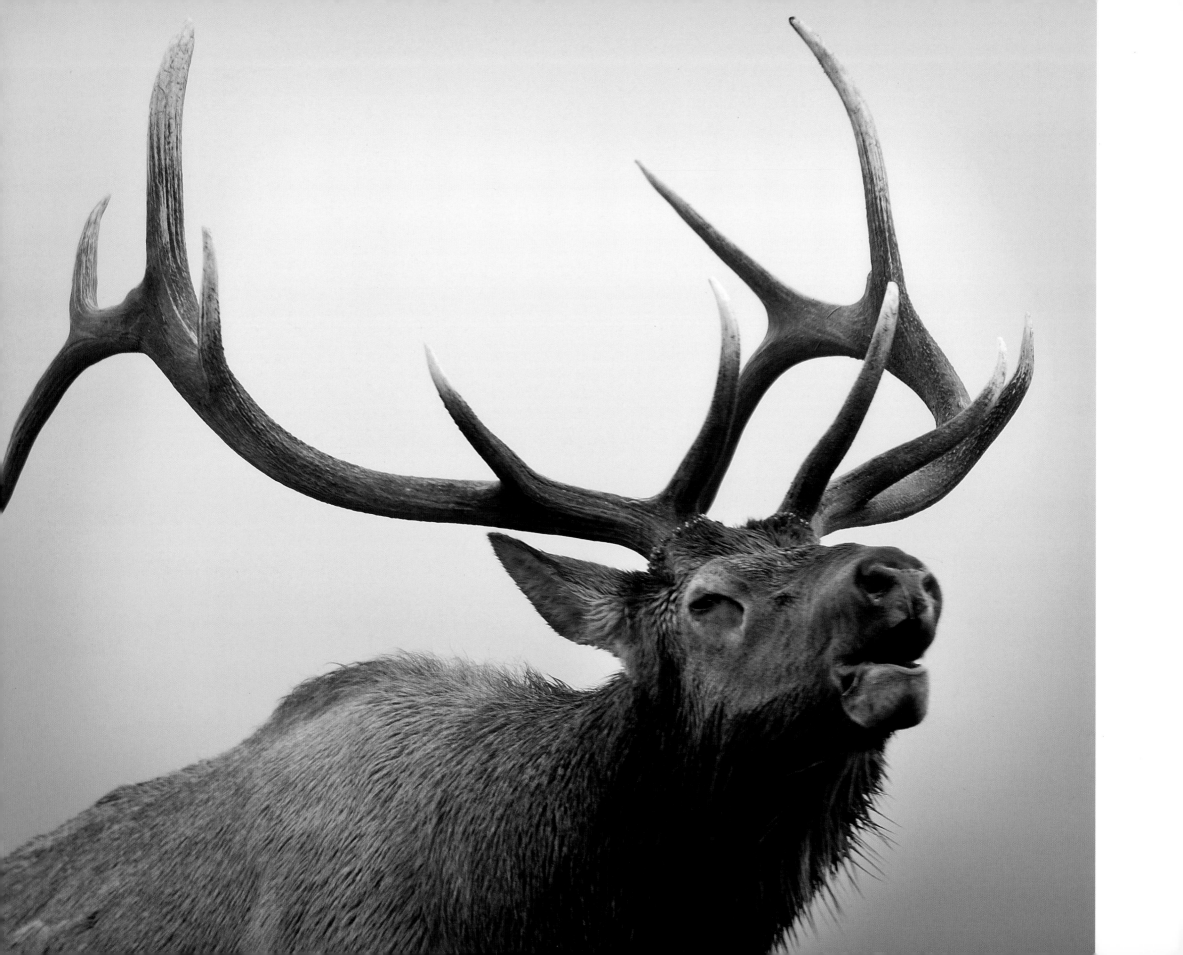

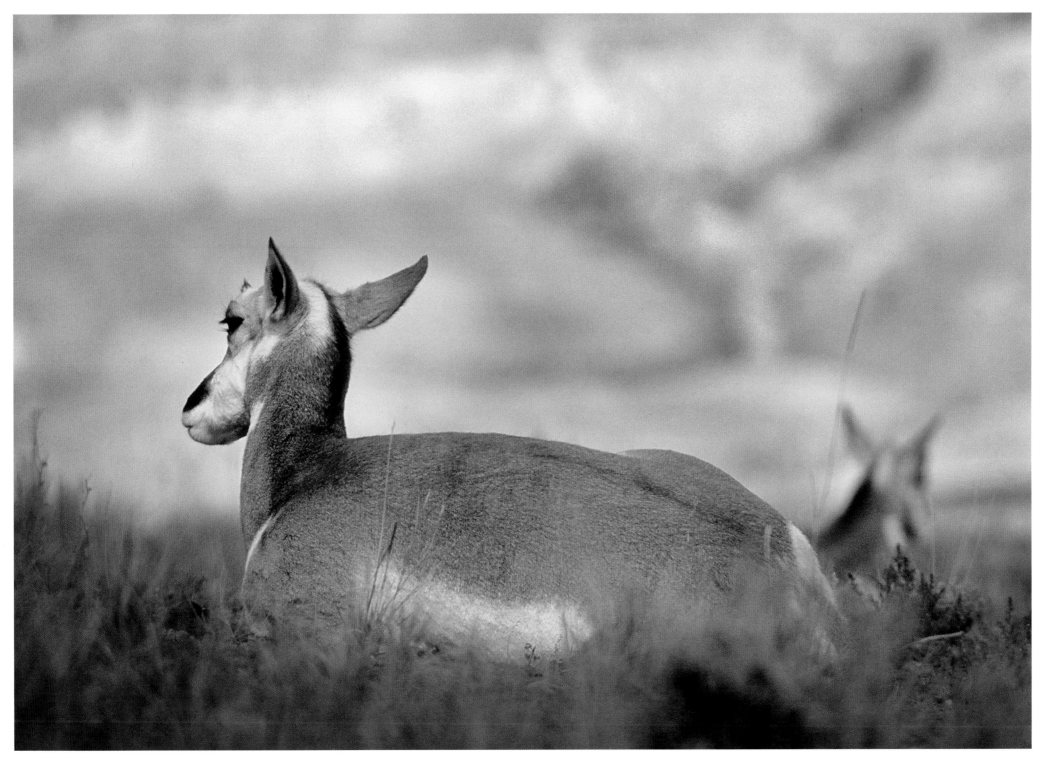

Pronghorn resting near north entrance

Bull elk bugling
east of Mammoth

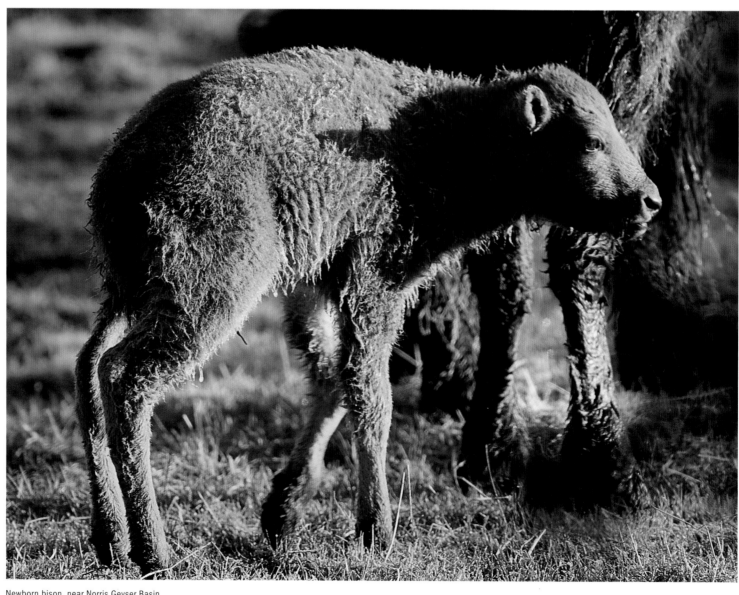

Newborn bison, near Norris Geyser Basin

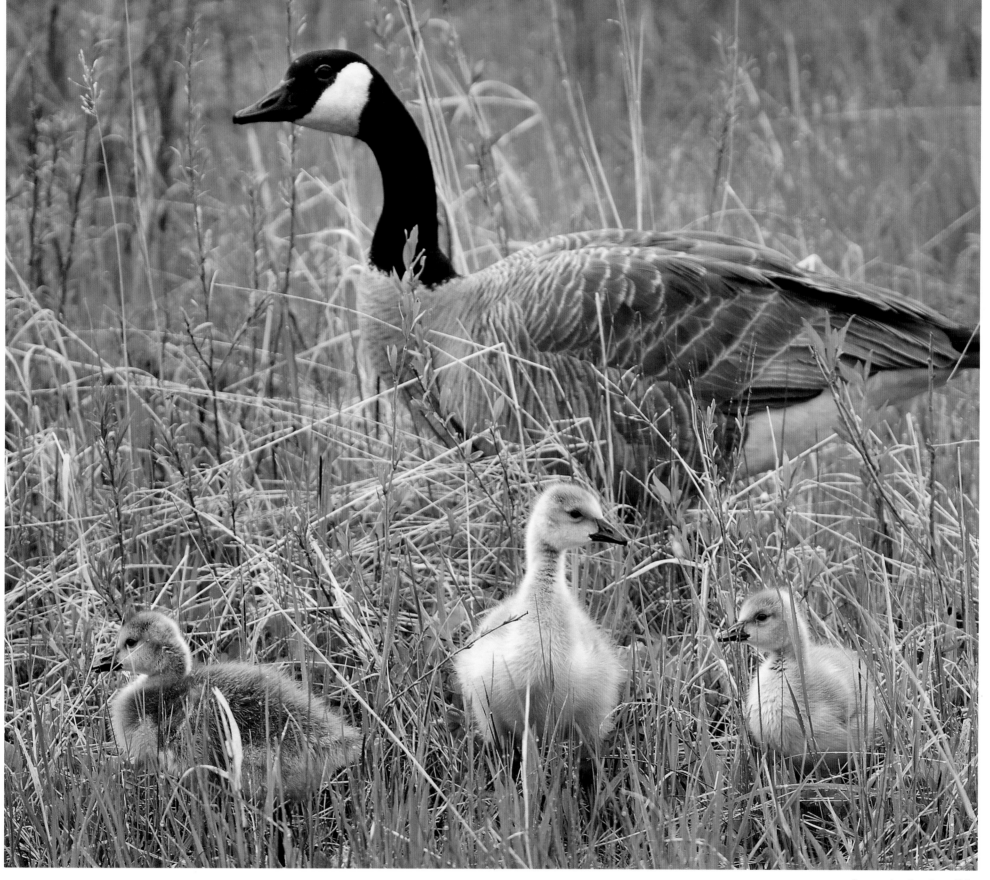

Goose and goslings, Lamar Valley

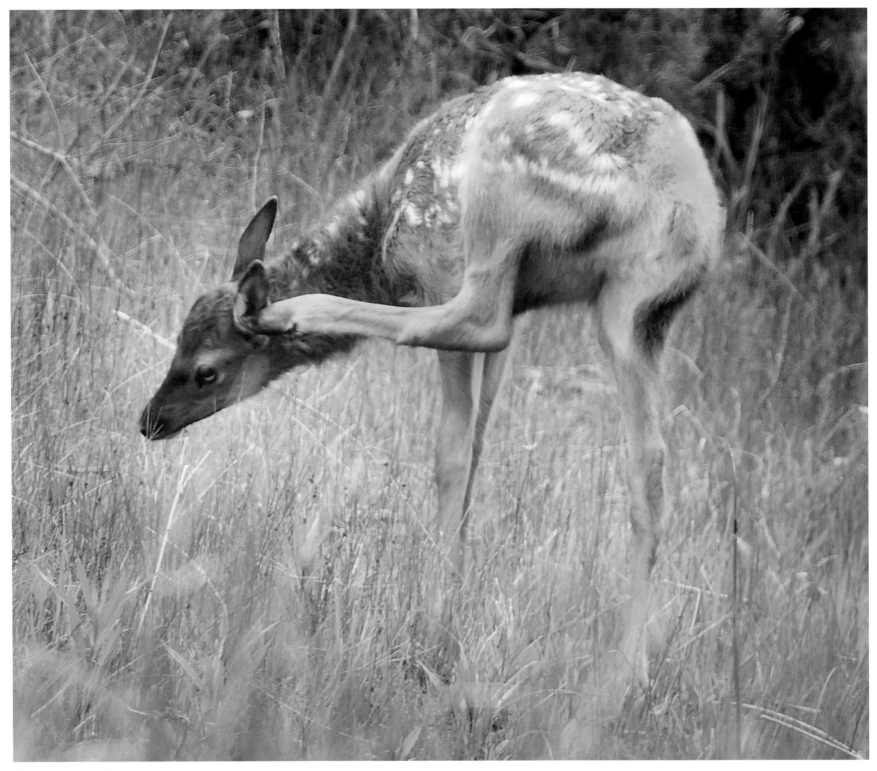

Elk calf scratching near Mammoth

Moose cow and calf grazing near Cascade Lake

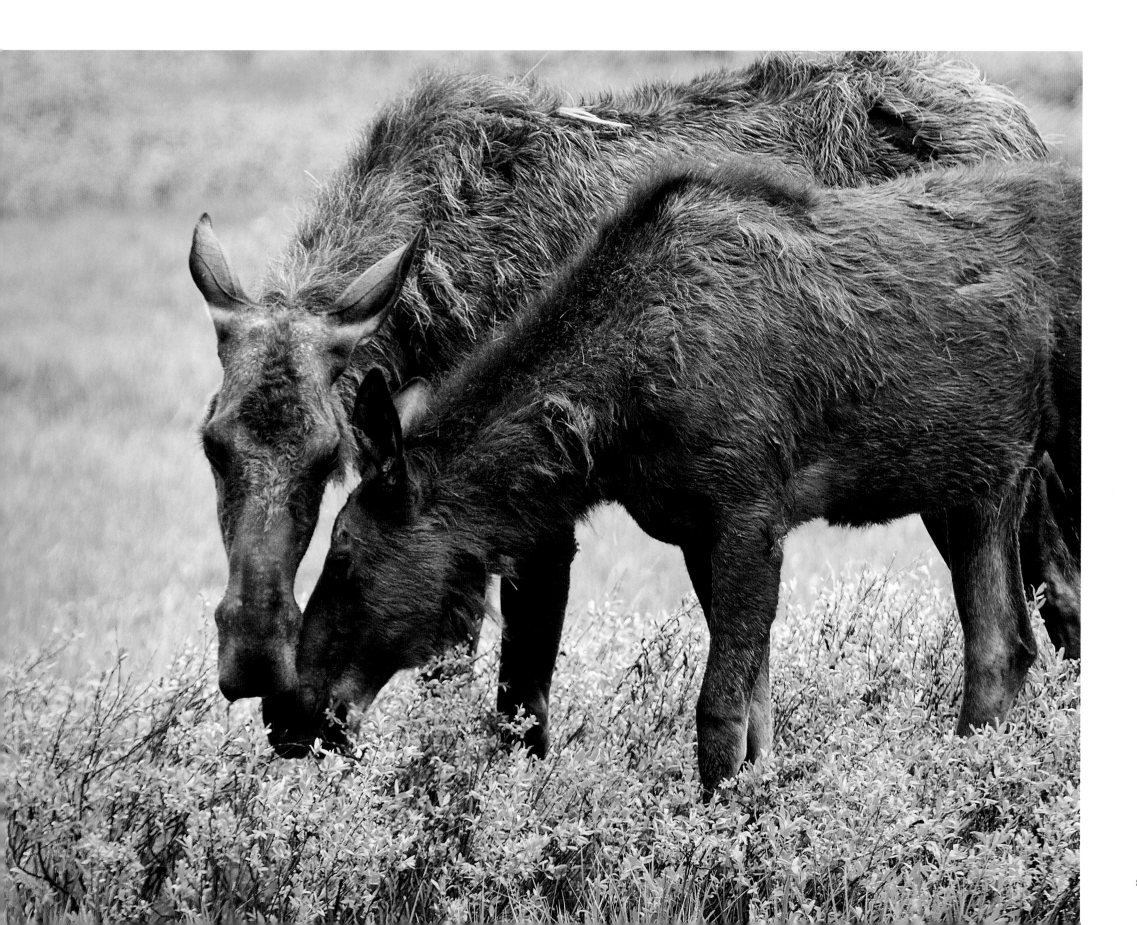

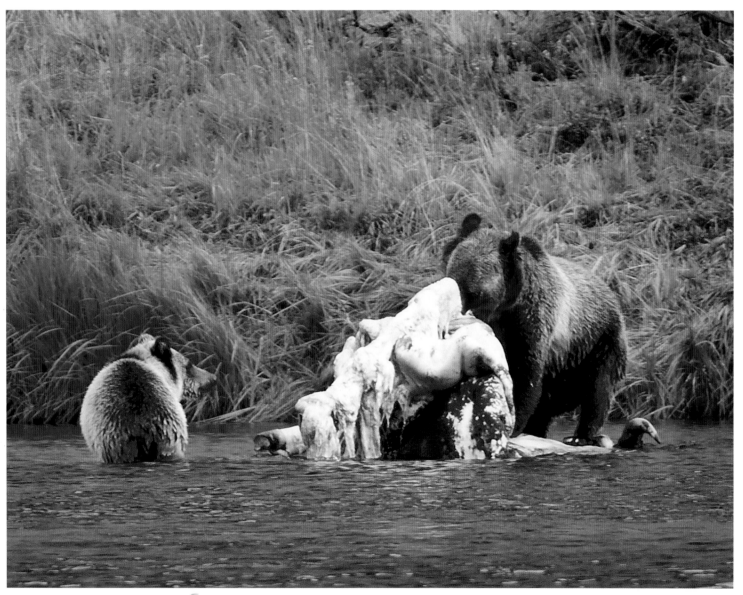

Grizzly and cub feeding on bison carcass, Yellowstone River, Nez Perce Ford

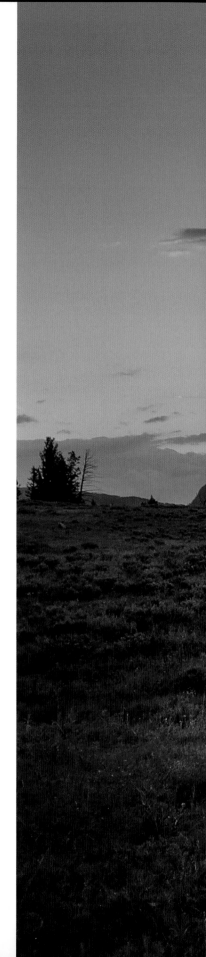

Mule deer grazing, early morning, near Floating Island Lake

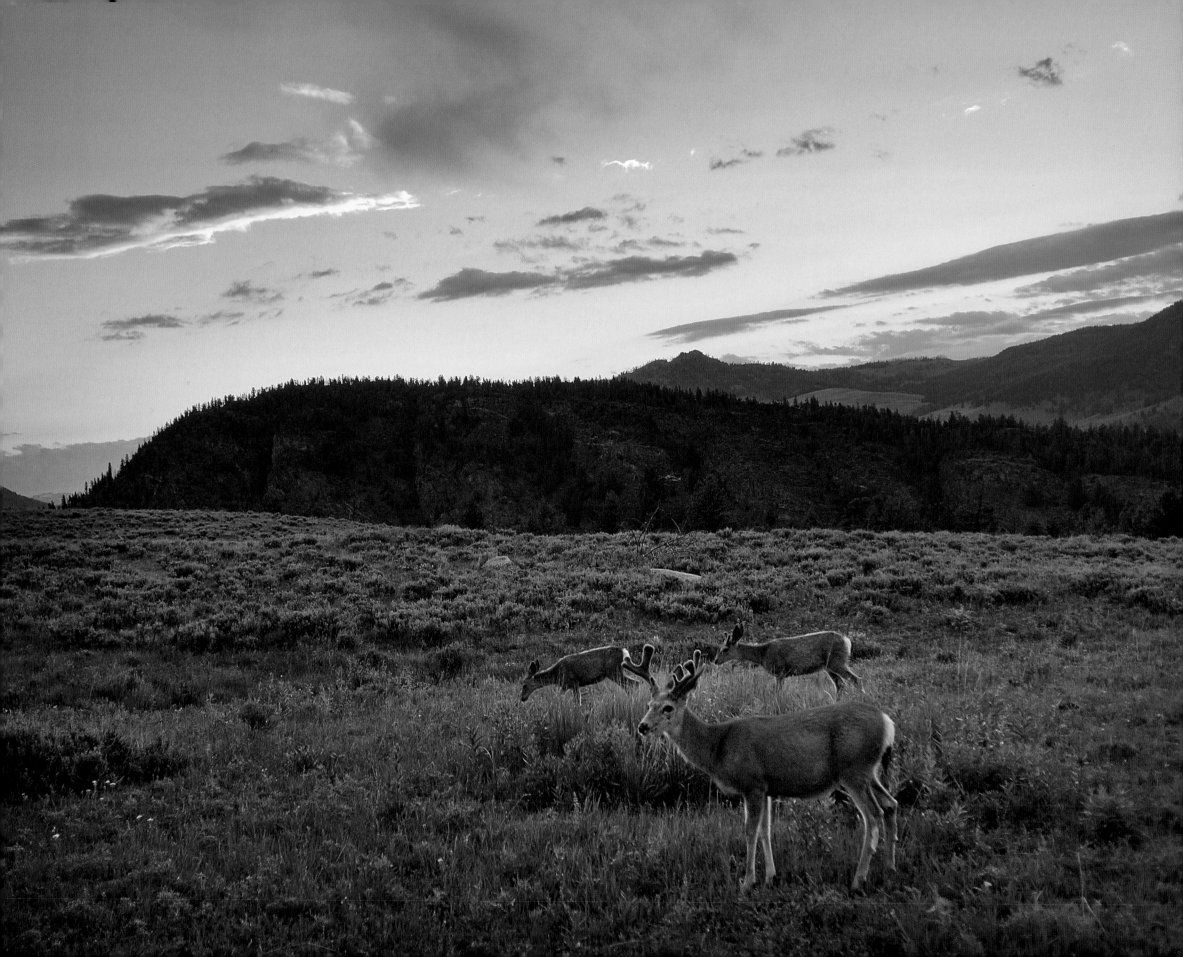

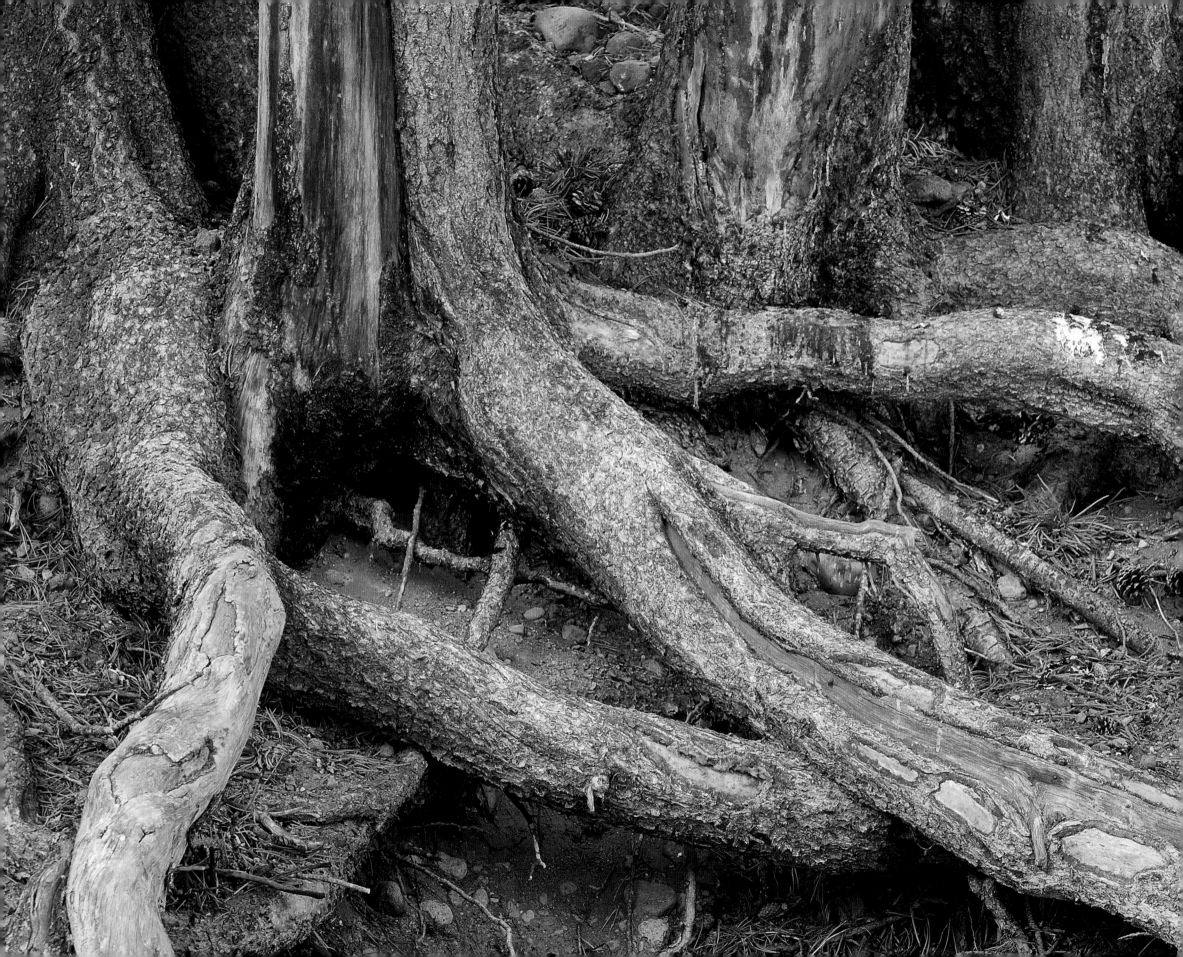

White-tailed deer, Tower Junction

Tree roots, near Lamar River

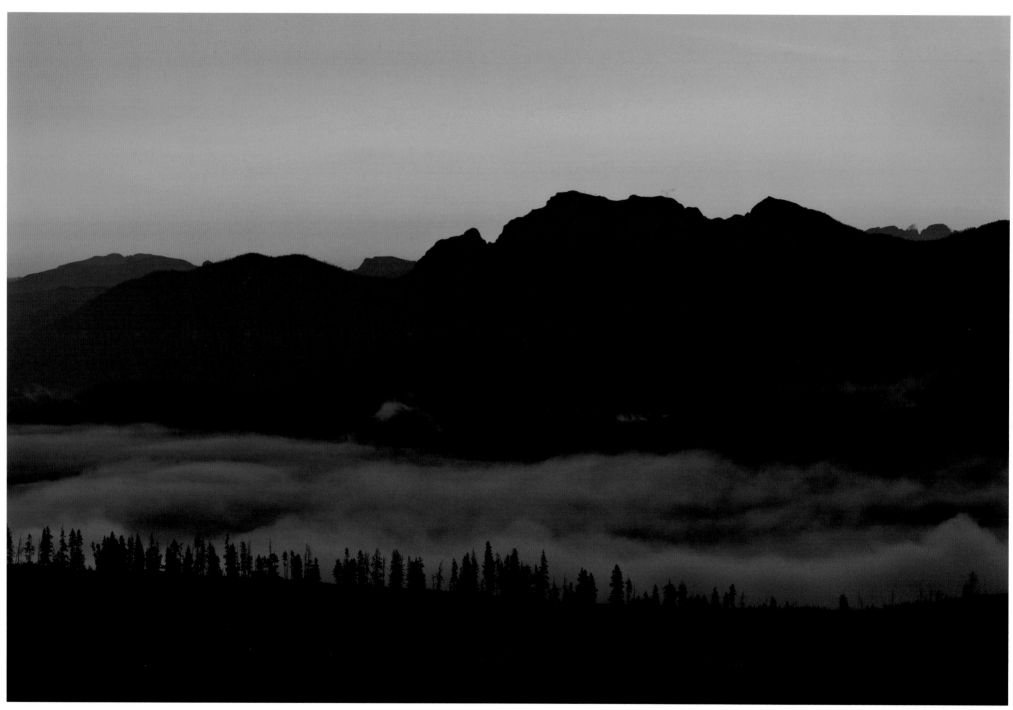

Sunrise, Beartooth Mountains from Mount Washburn

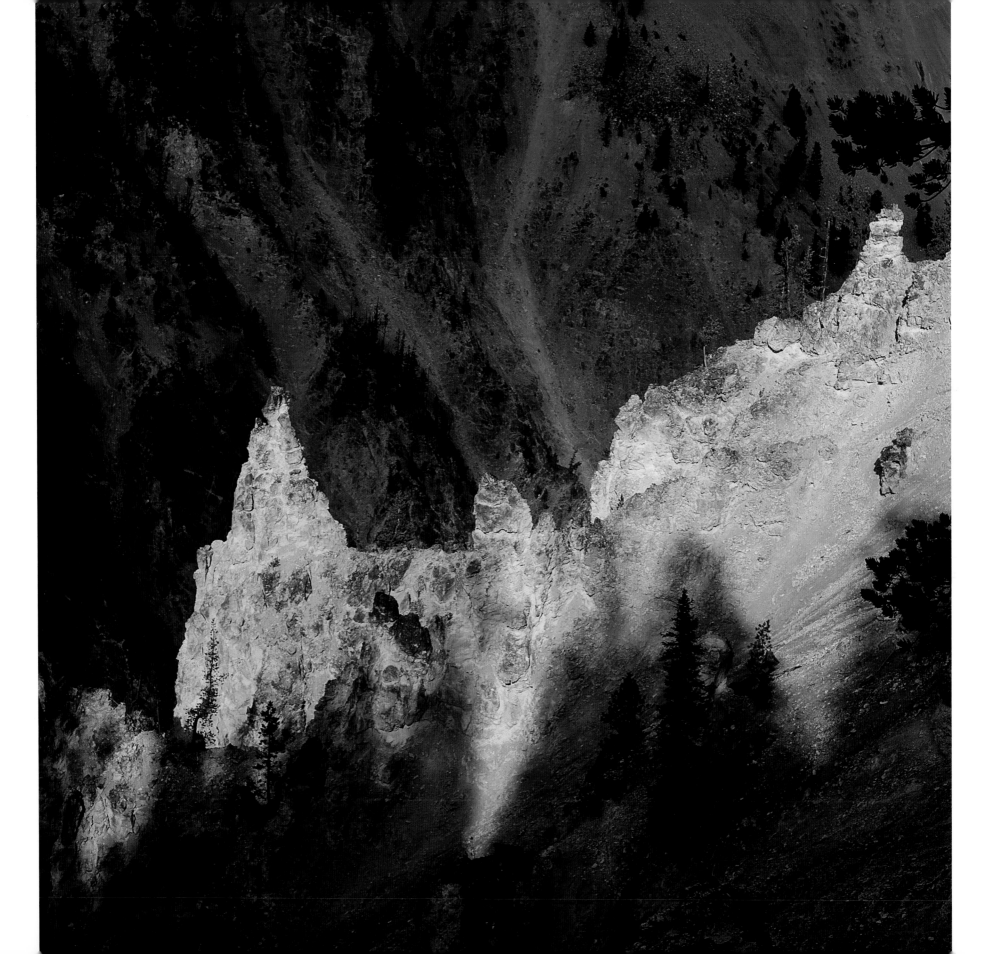

Artist Point

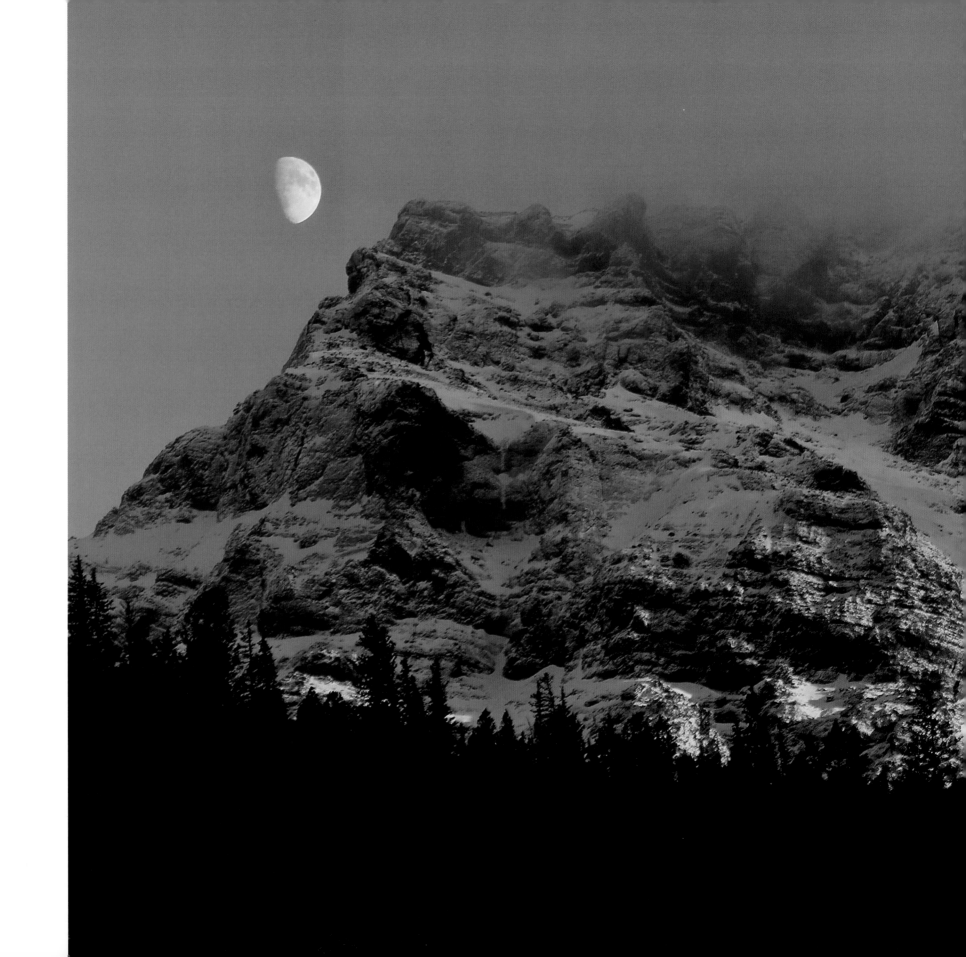

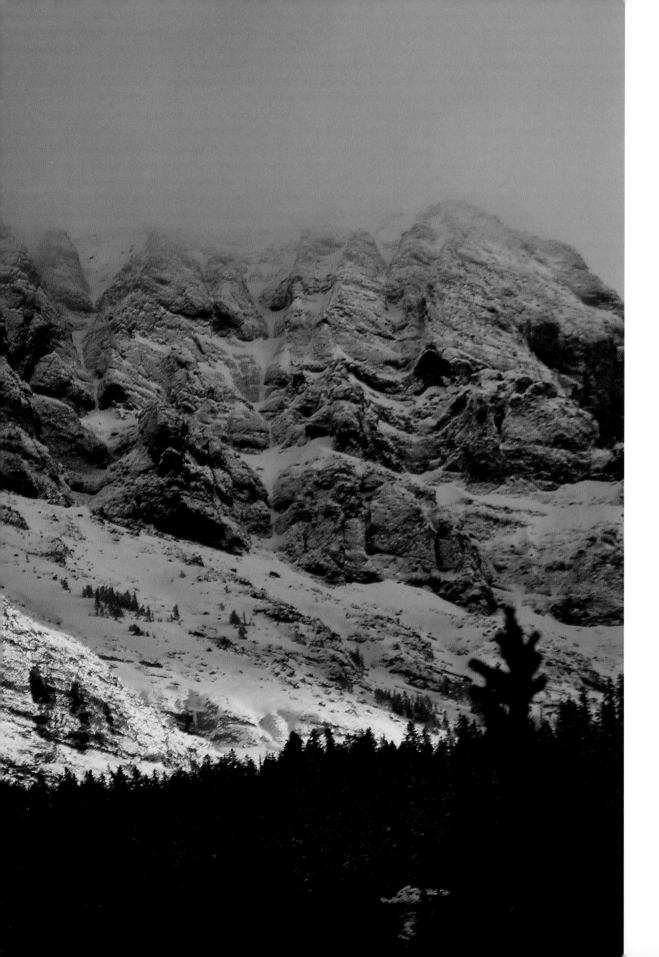

Moon rising over
Abiathar Peak

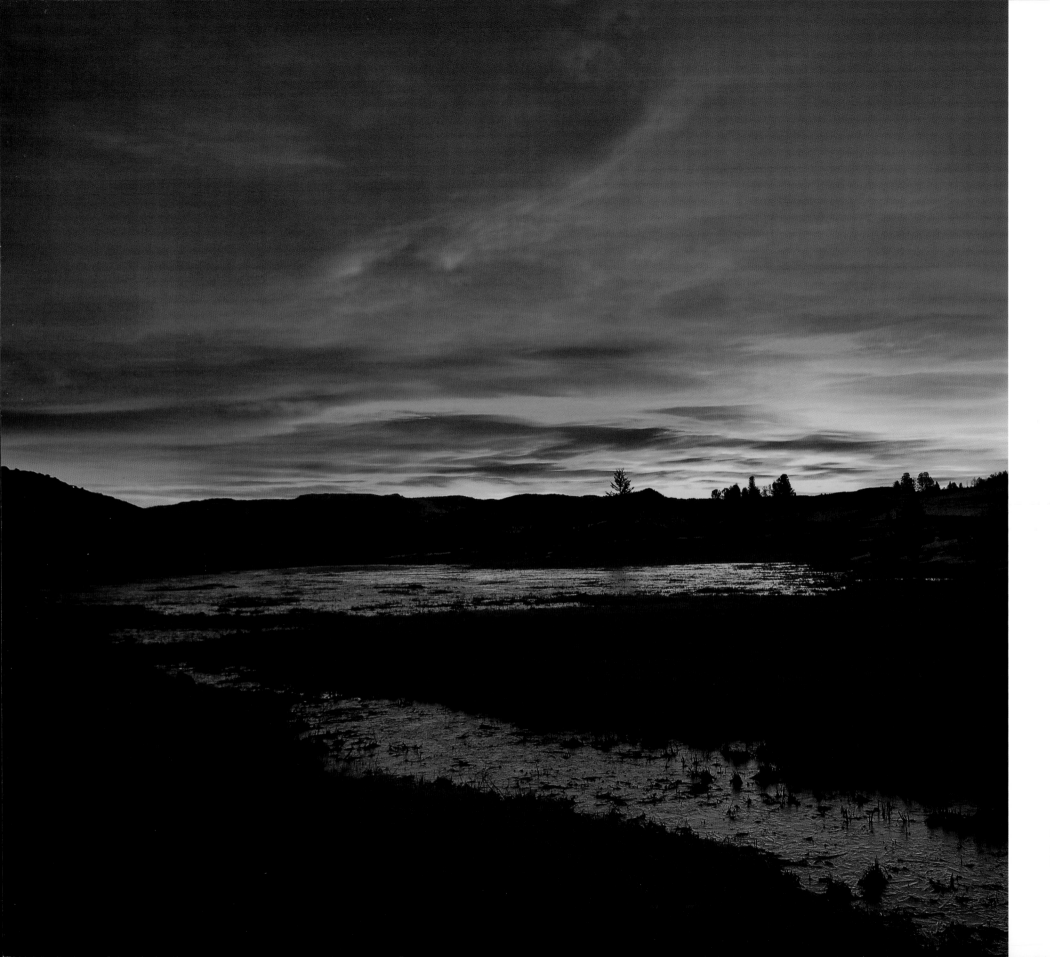

Sunrise reflecting
off marsh near
Lamar Valley

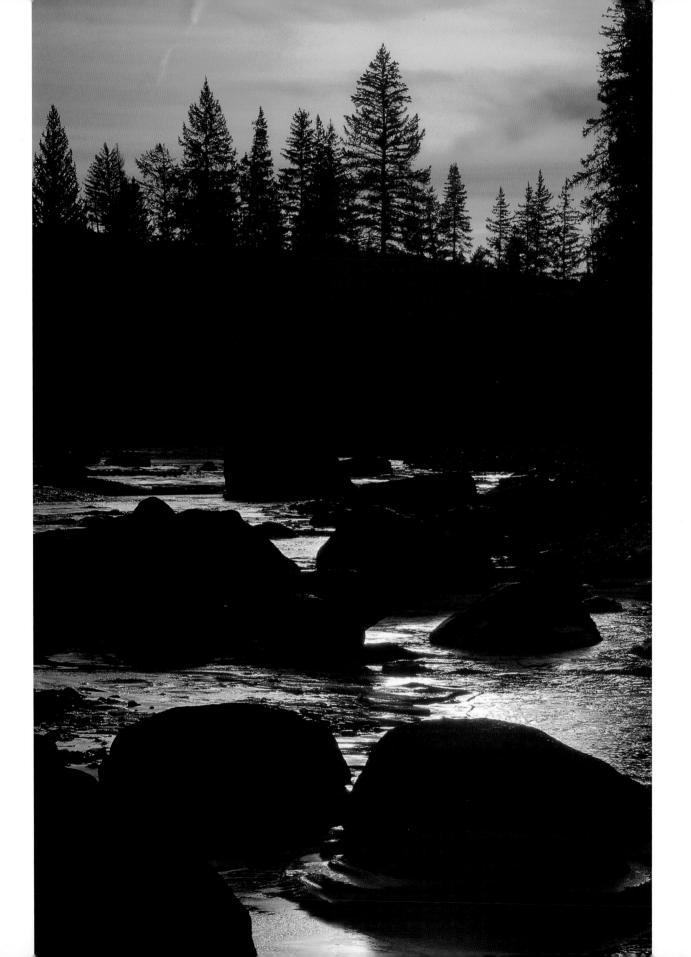

Sunrise over
Lamar River

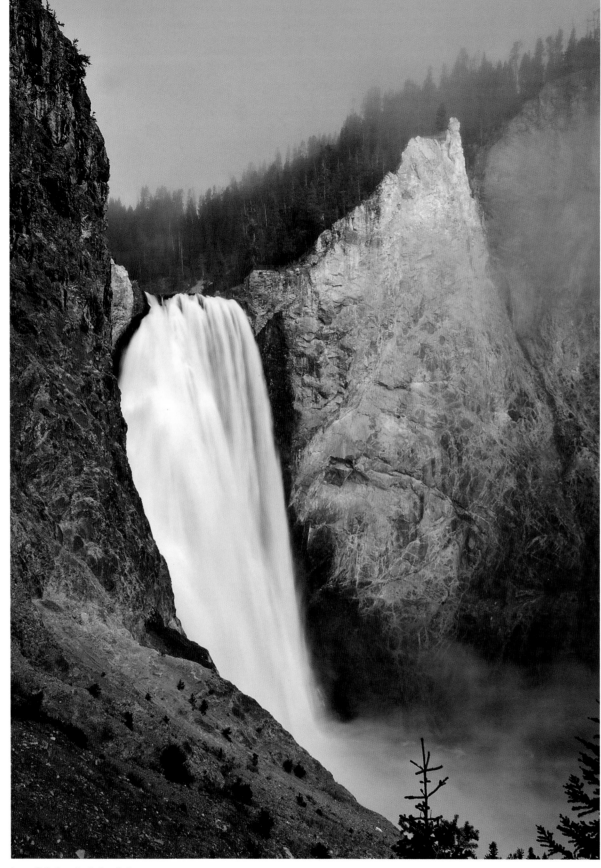

Lower Falls from Uncle Tom Trail

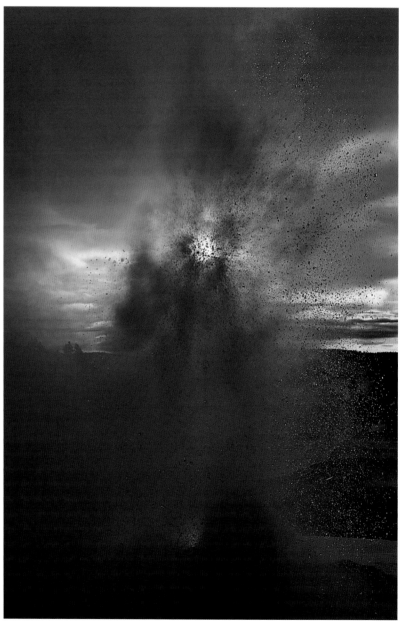

Sawmill Geyser near Old Faithful

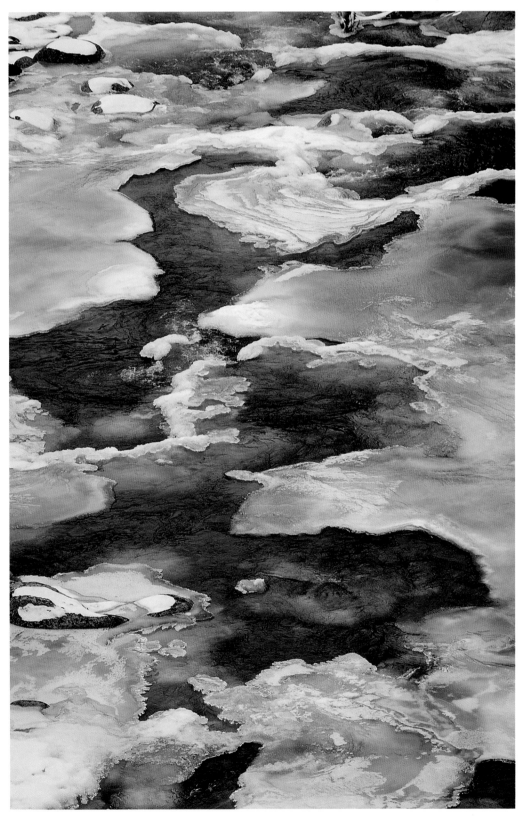

Ice forming on Hellroaring Creek near Yellowstone River confluence

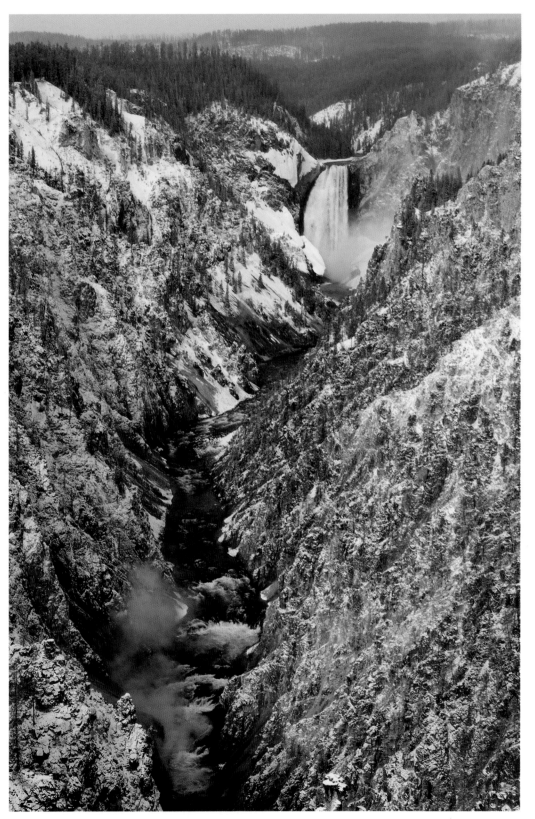

Grand Canyon of the Yellowstone and Lower Falls from Artist Point in spring

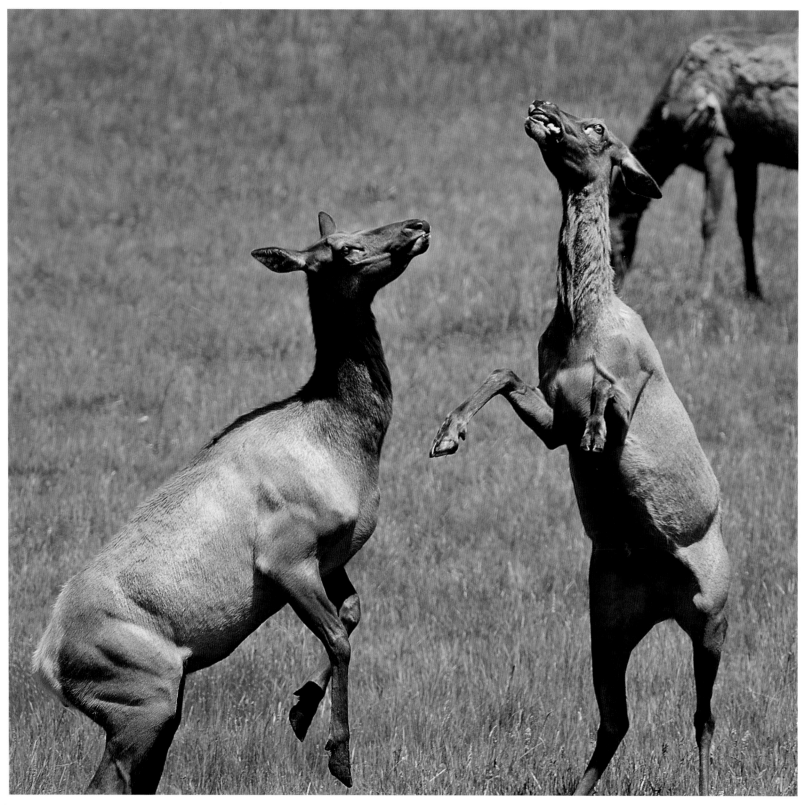

Cow elk sparring near Madison Junction

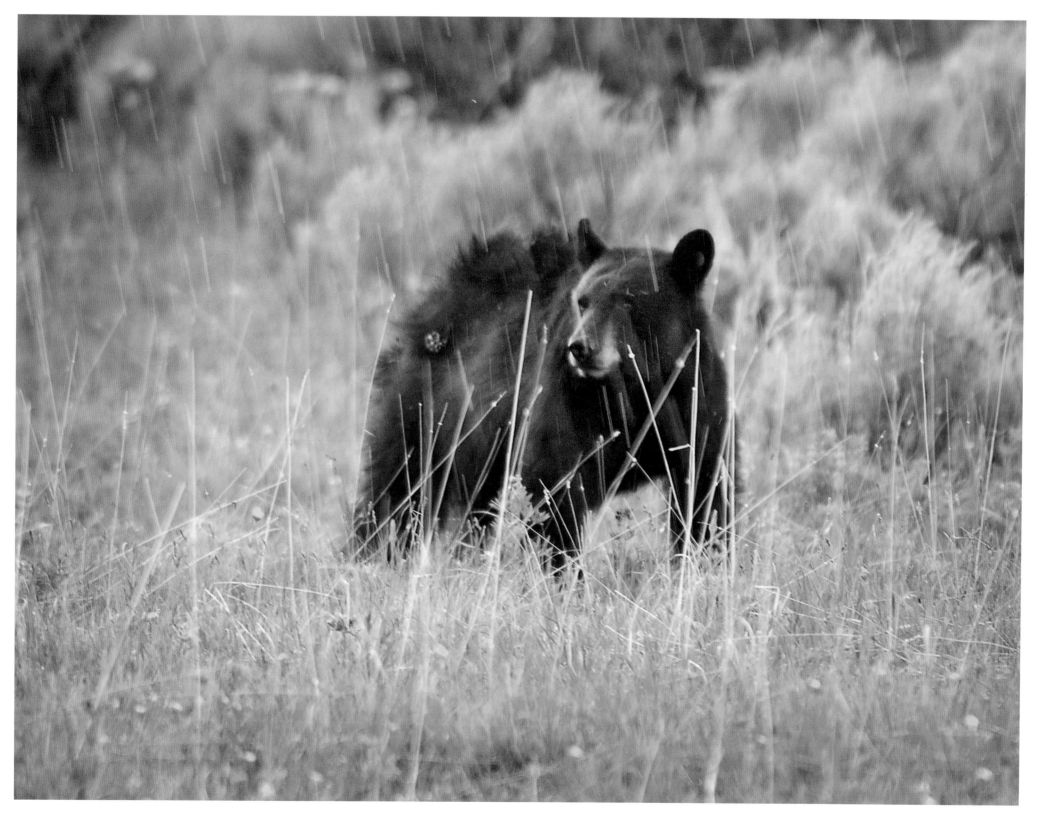

Black bear grazing near Mount Washburn

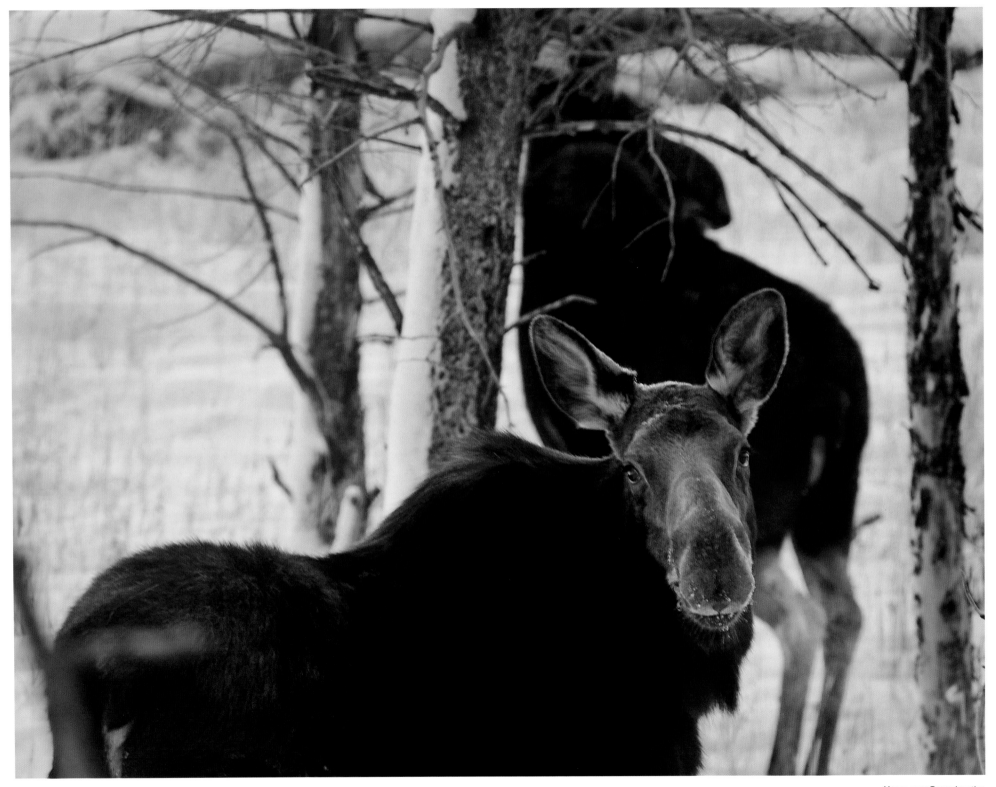

Moose near Tower Junction

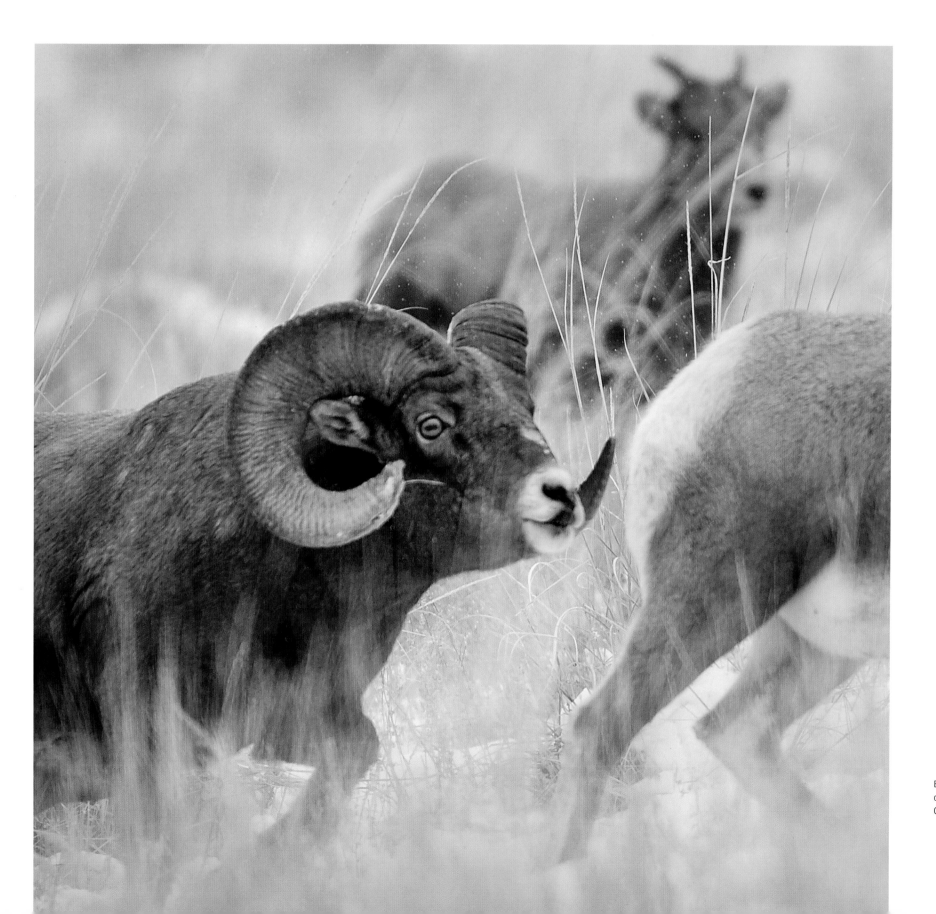

Bighorn ram near
confluence of Soda Butte
Creek with Lamar River

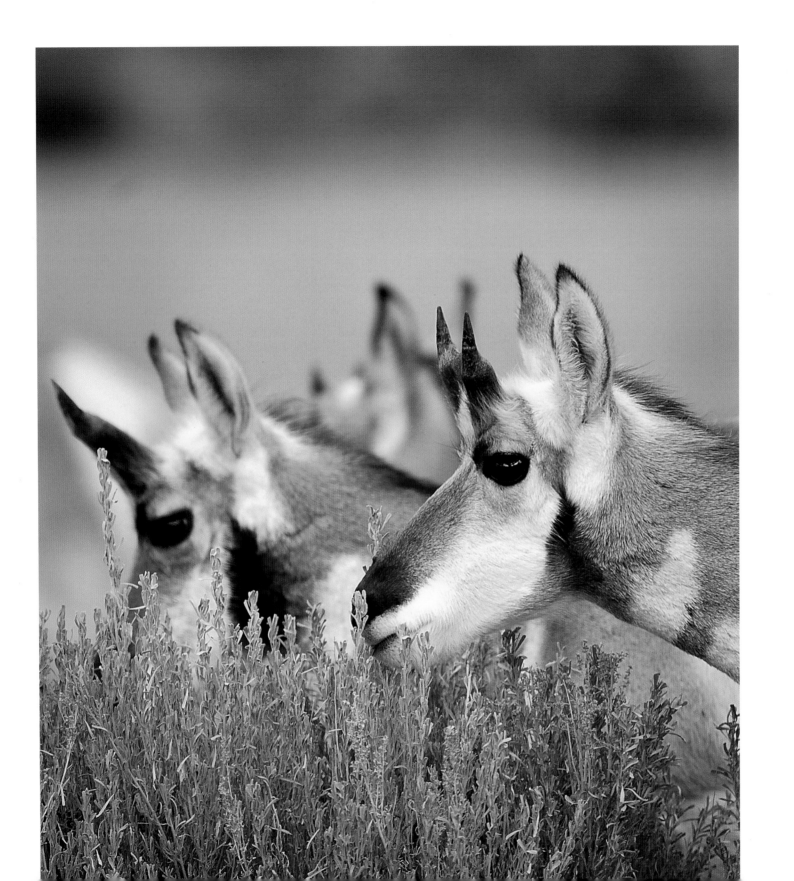

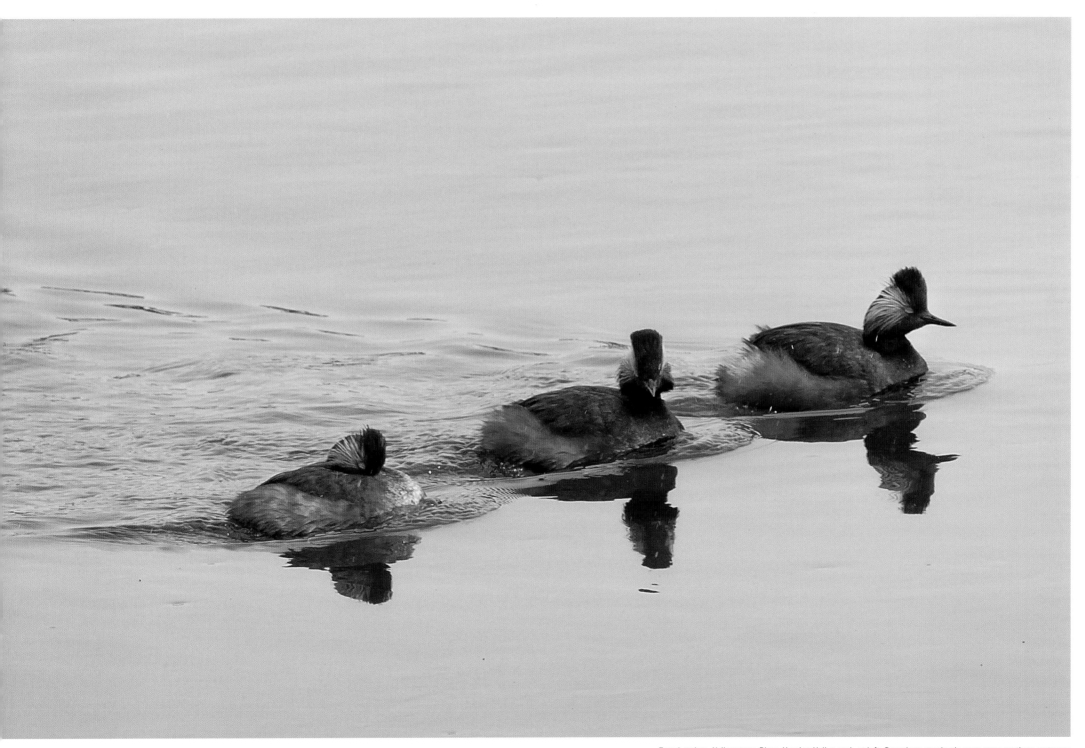

Eared grebes, Yellowstone River, Hayden Valley and, at left, Pronghorn grazing in sage near northern entrance

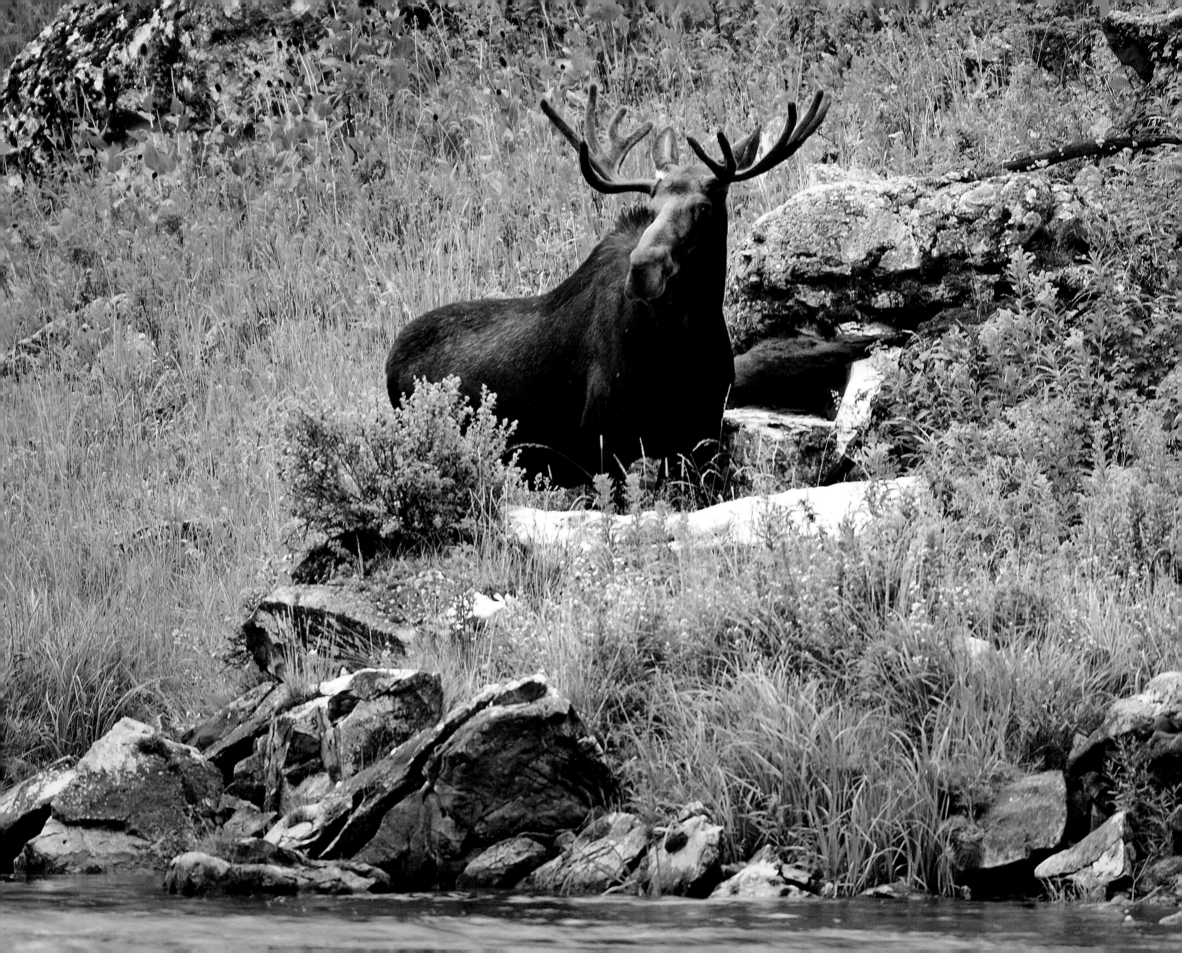

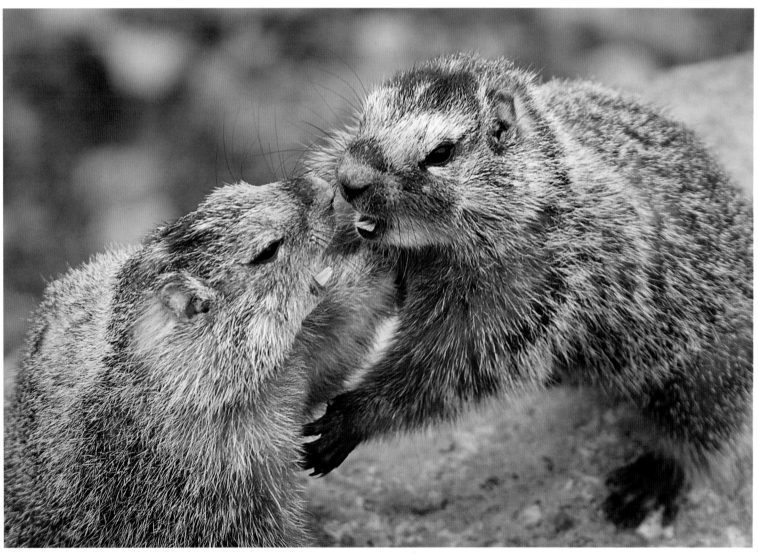

Yellow-bellied marmots near Artemisia Spring

Bull moose, Gallatin River

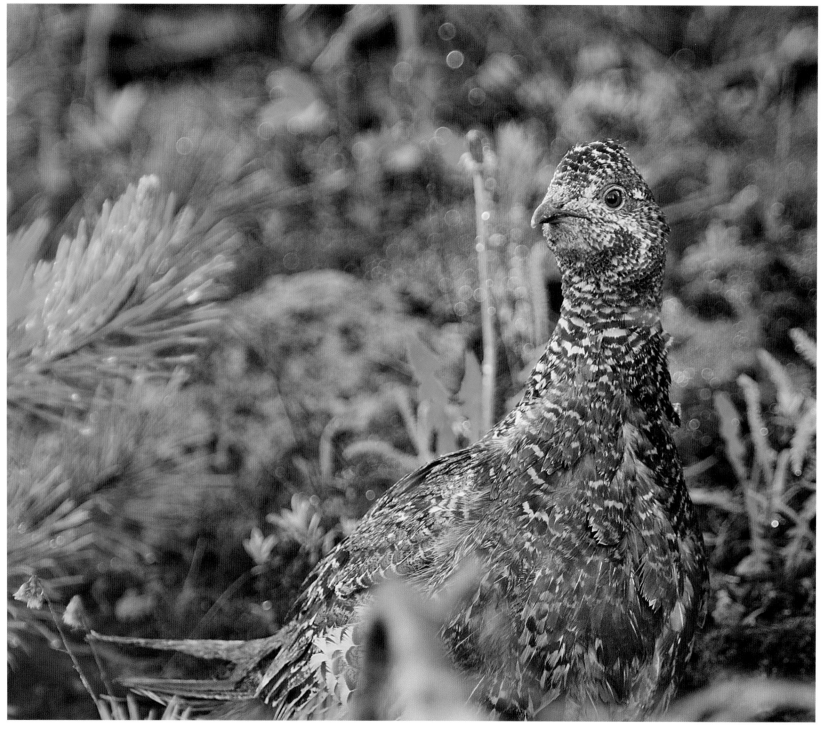

Grouse, Bunsen Peak

Great gray owl south of Canyon Village

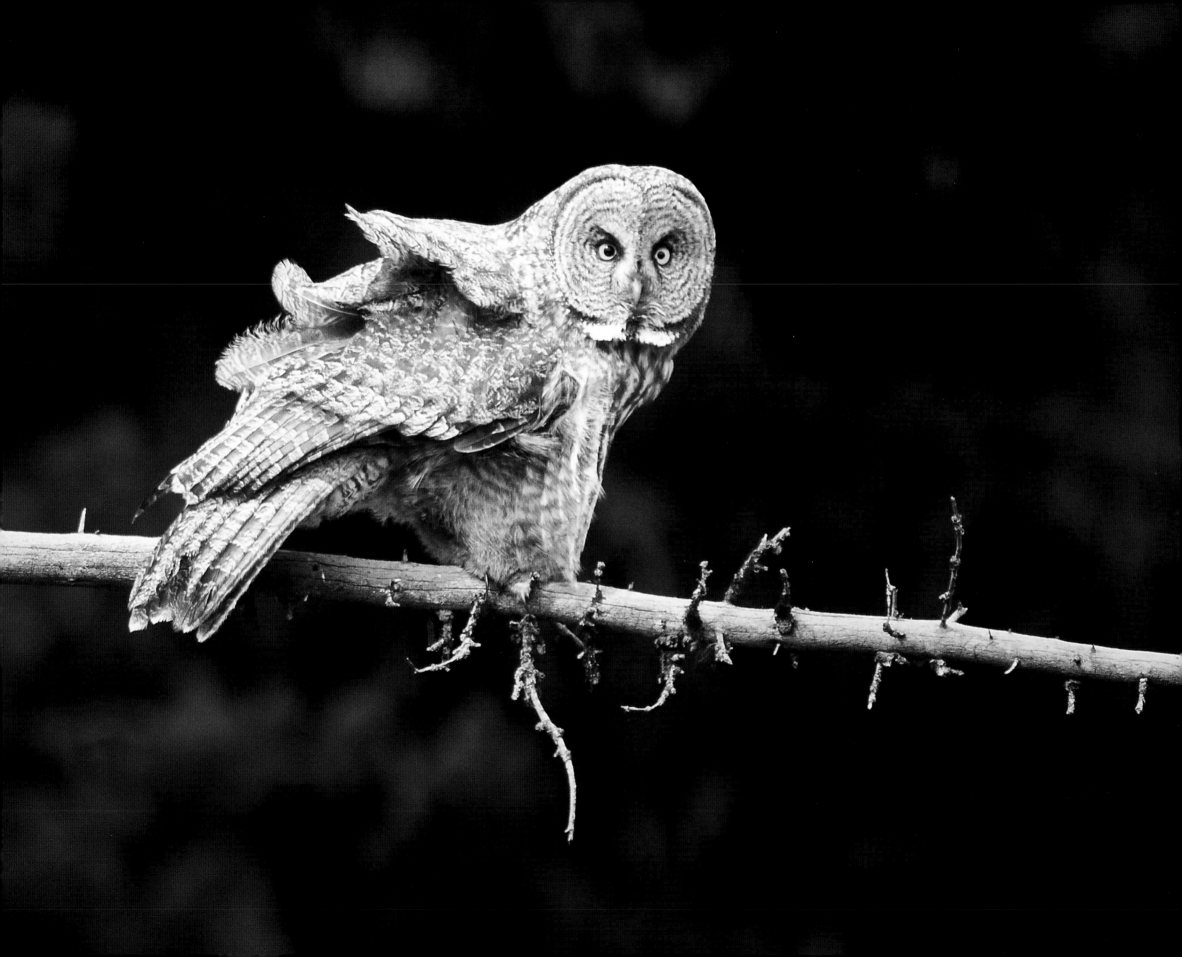

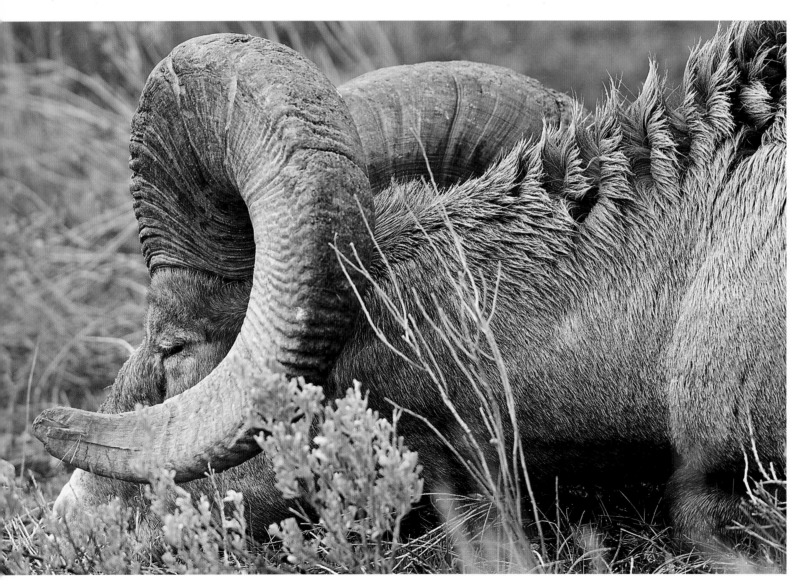

Snoozing bighorn ram near Tower Junction

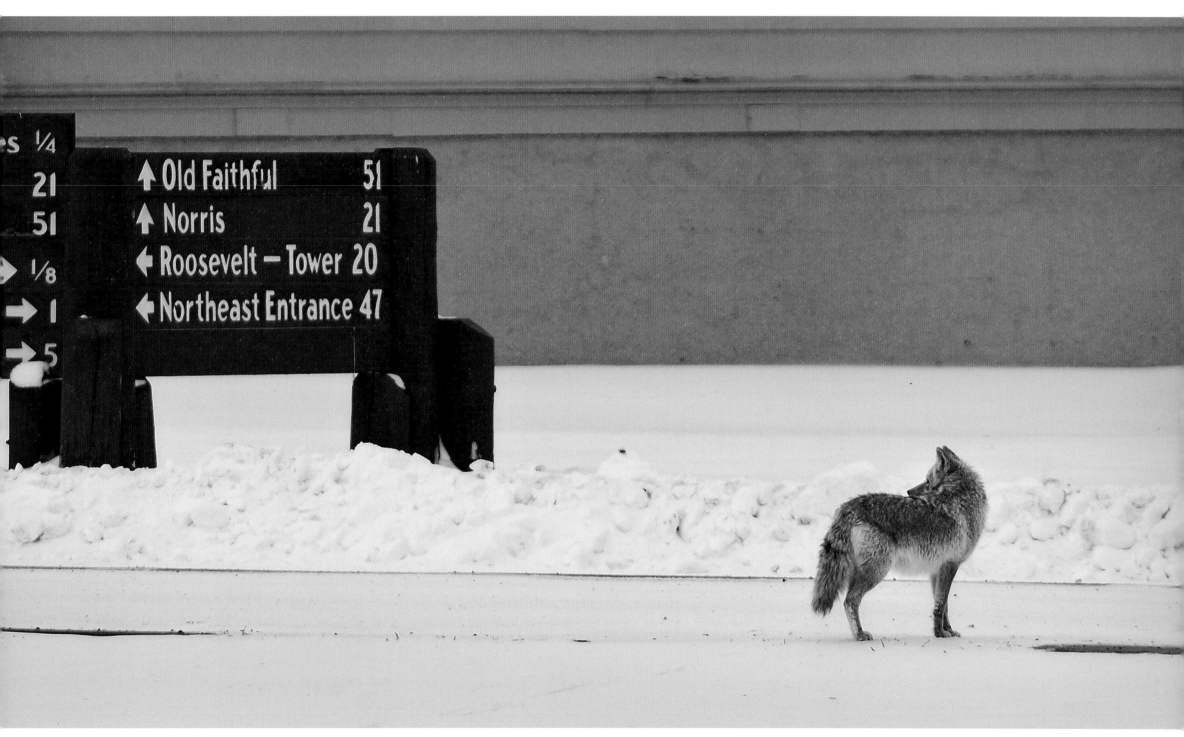

Coyote and signs, Mammoth

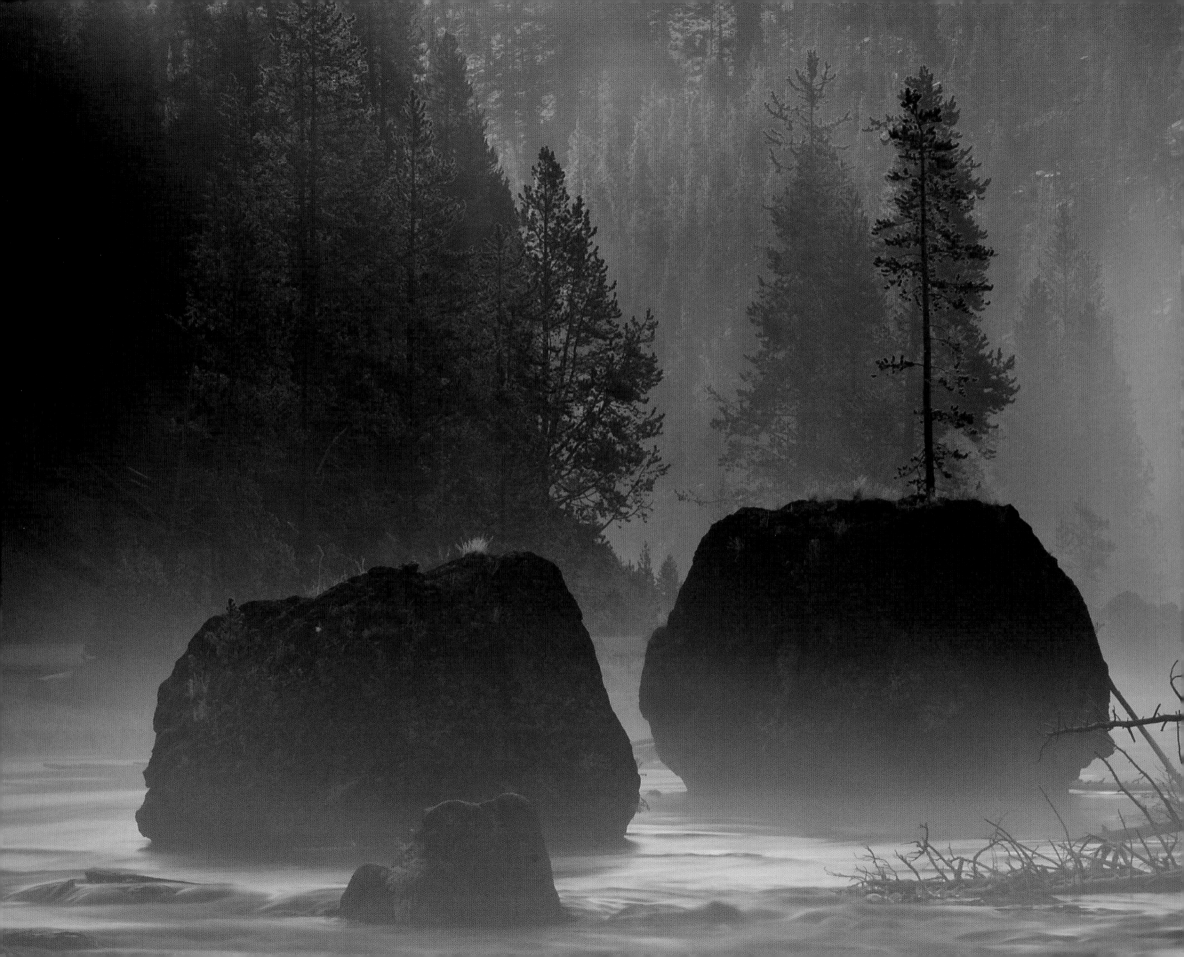

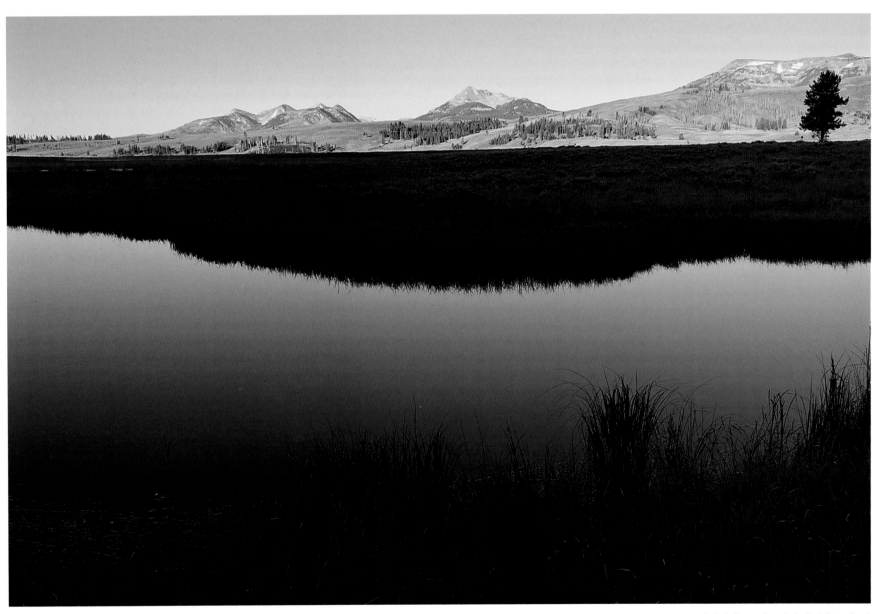

Gallatin Range, Swan Lake Flat, Glenn Creek

Firehole River near
Madison Junction

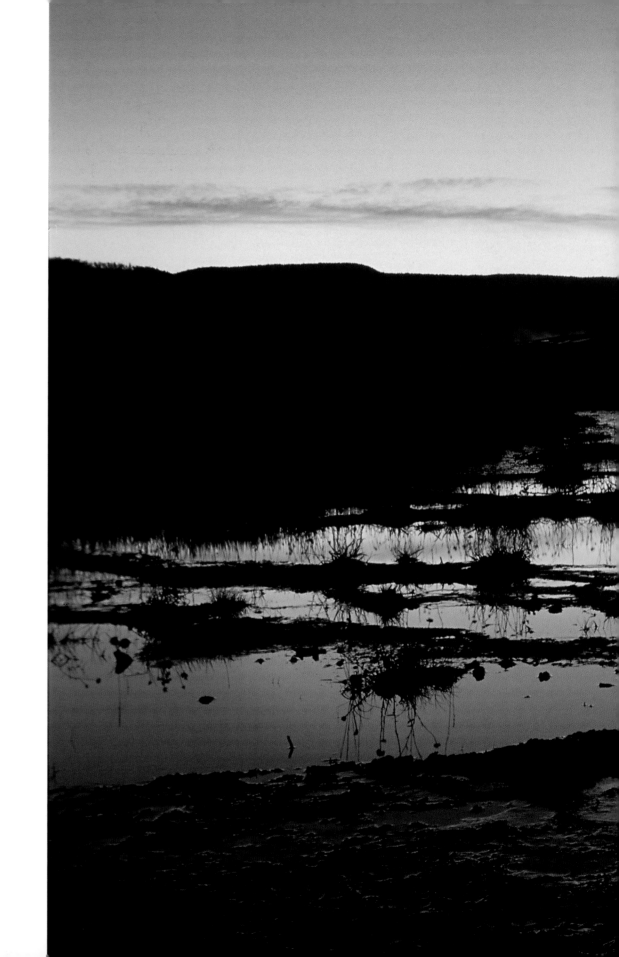

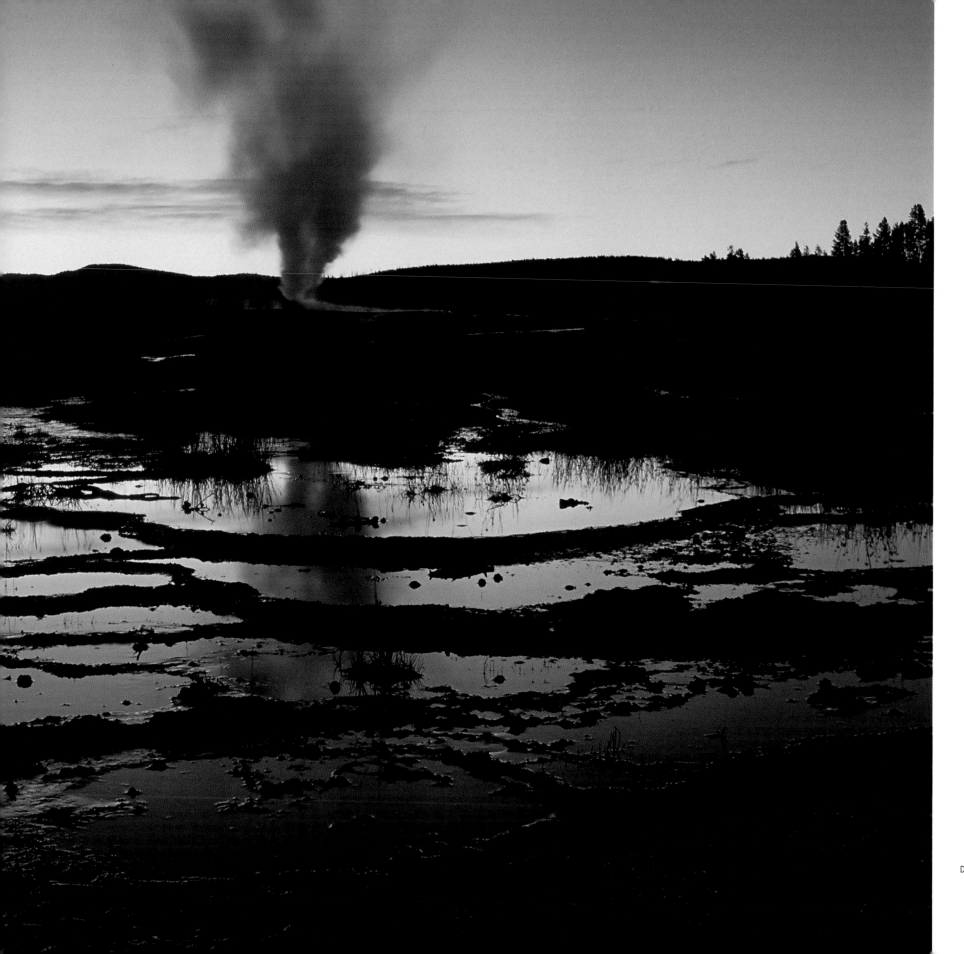

Dawn, Old Faithful

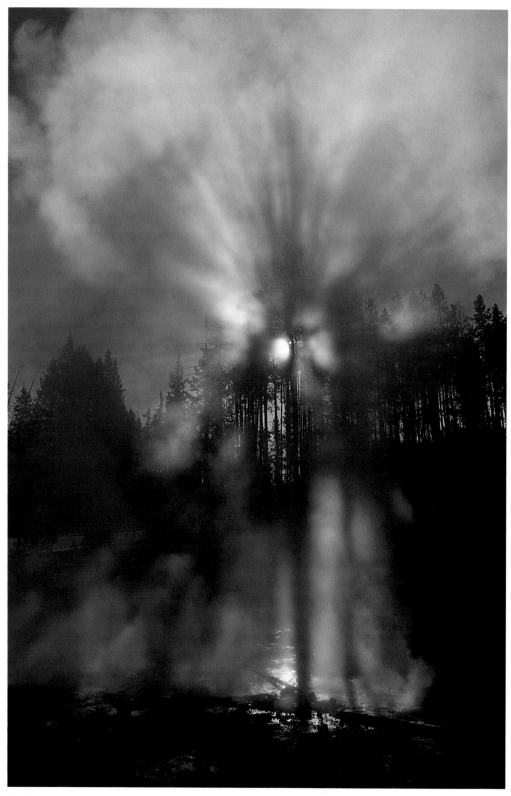

Sun shining through trees and steam, south of Madison Junction

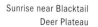

Sunrise near Blacktail
Deer Plateau

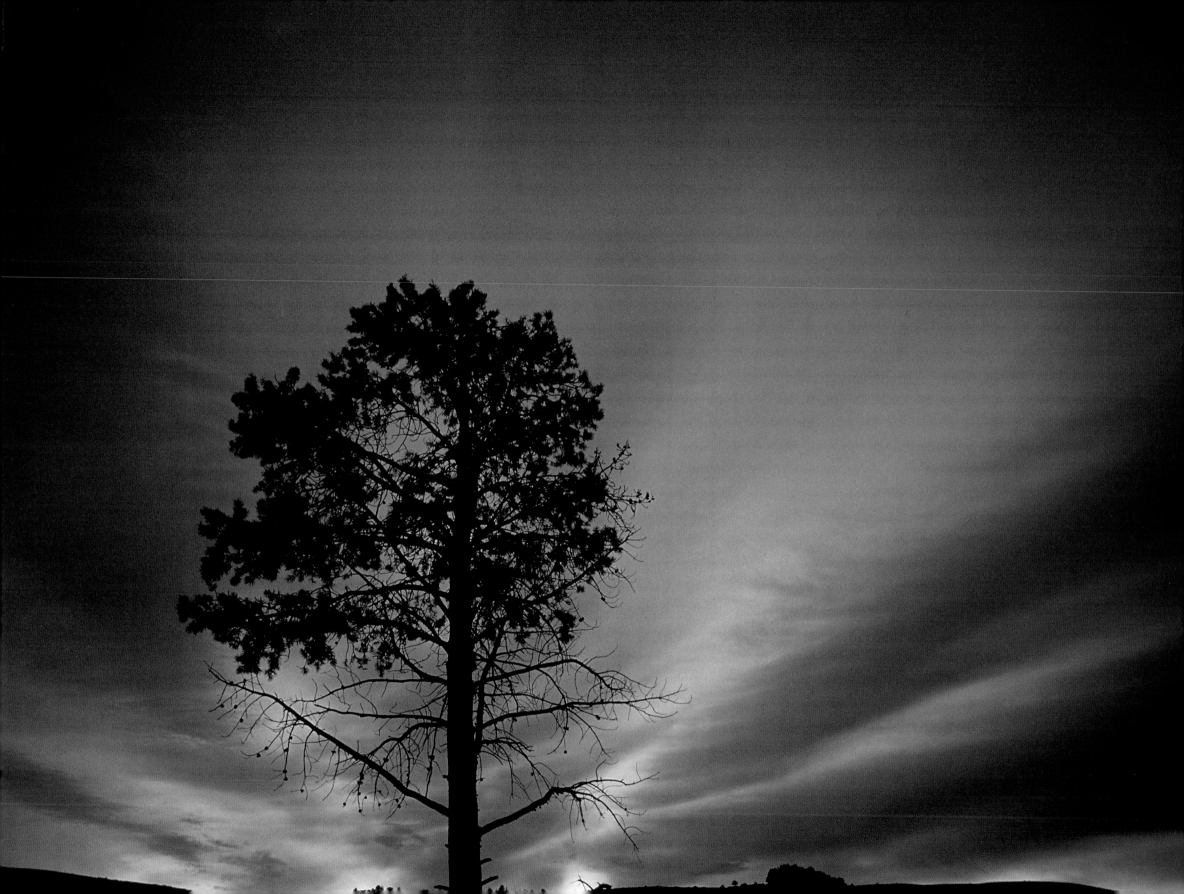

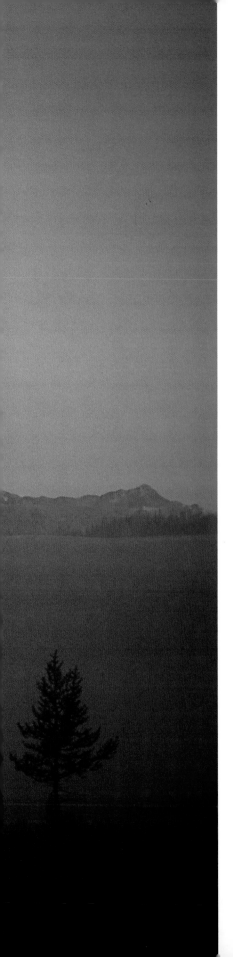

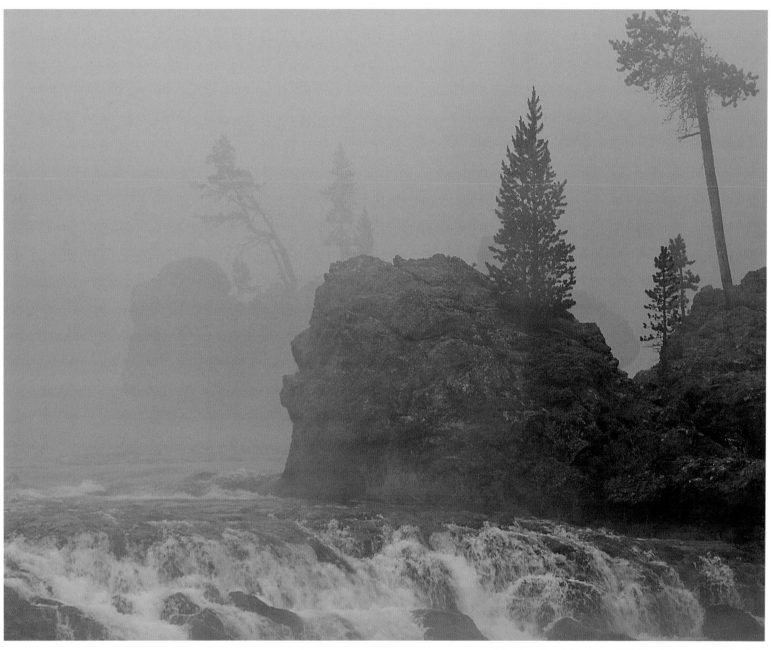

Yellowstone River, brink of Upper Falls, Grand Canyon of the Yellowstone

Swan Lake Flat

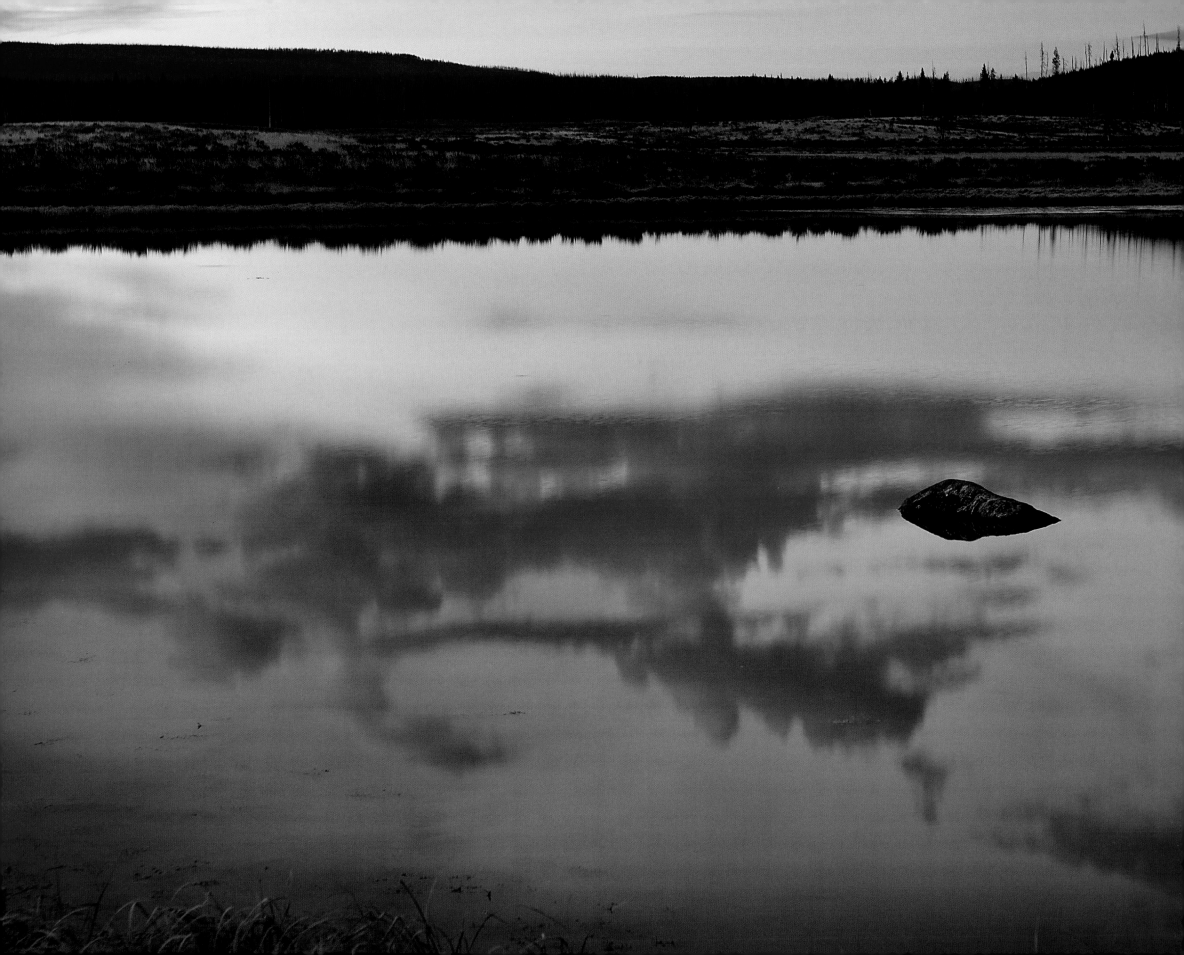

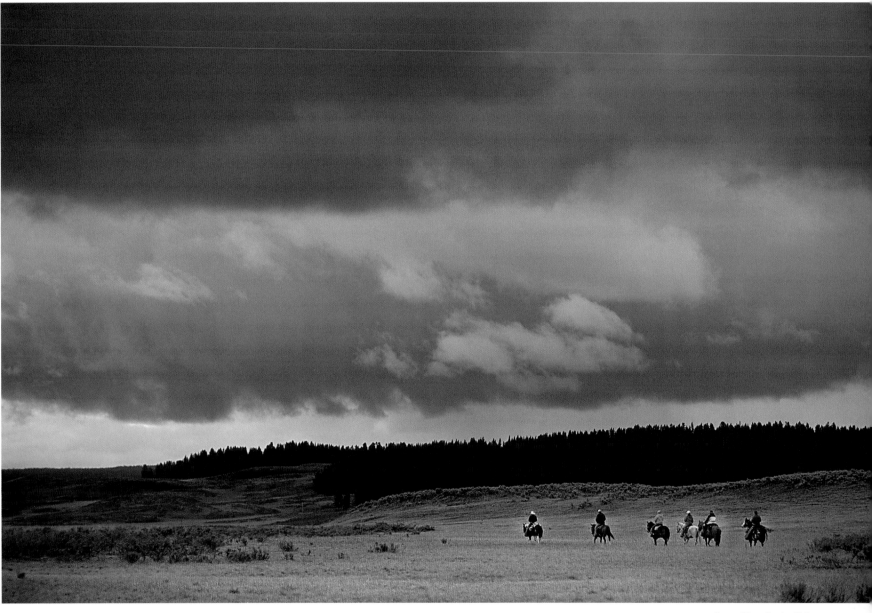

Horse riders, Hayden Valley

Swan Lake sunrise

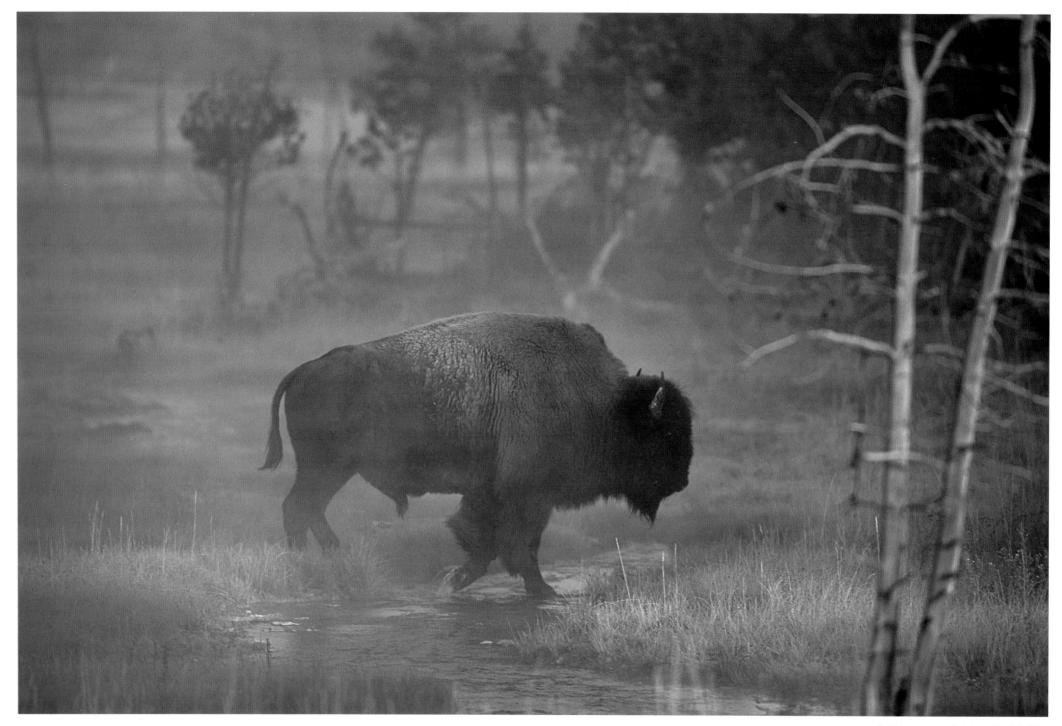

Bull bison crosses rivulet near Firehole River

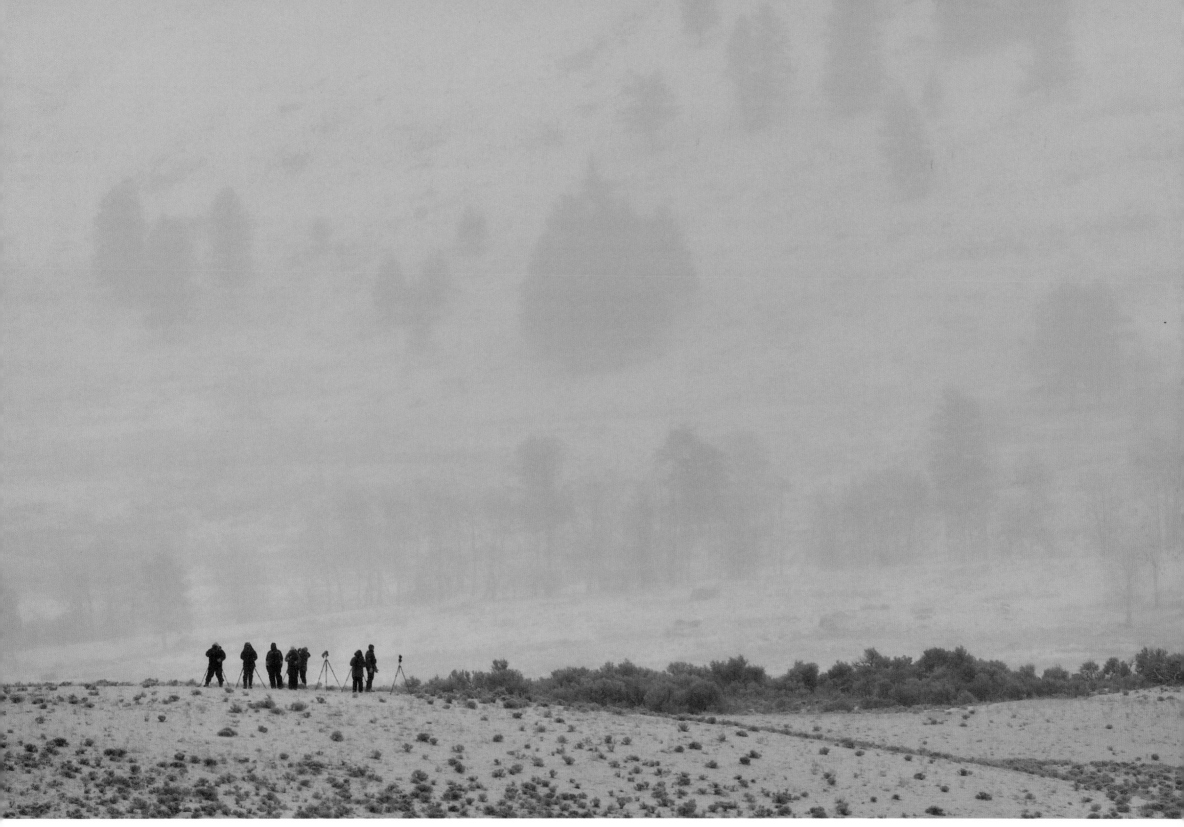

Wolf watchers in winter, Lamar Valley

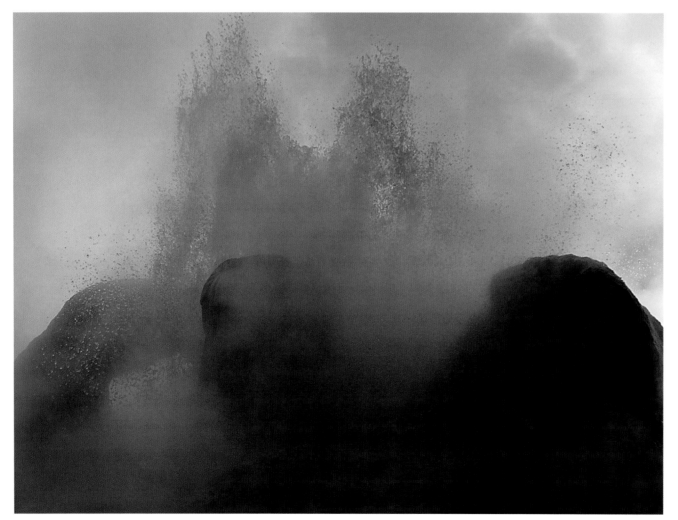

Grotto Geyser, Upper Geyser Basin

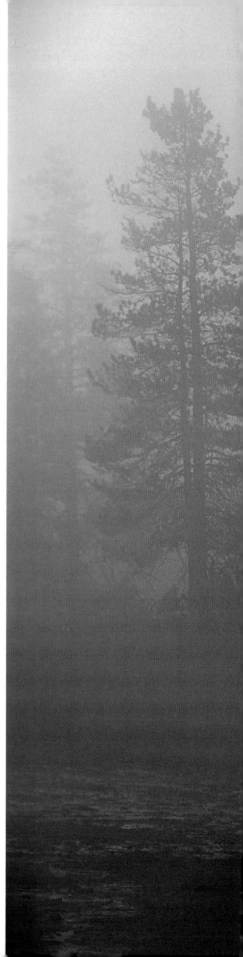

Waiting for Grand Geyser eruption

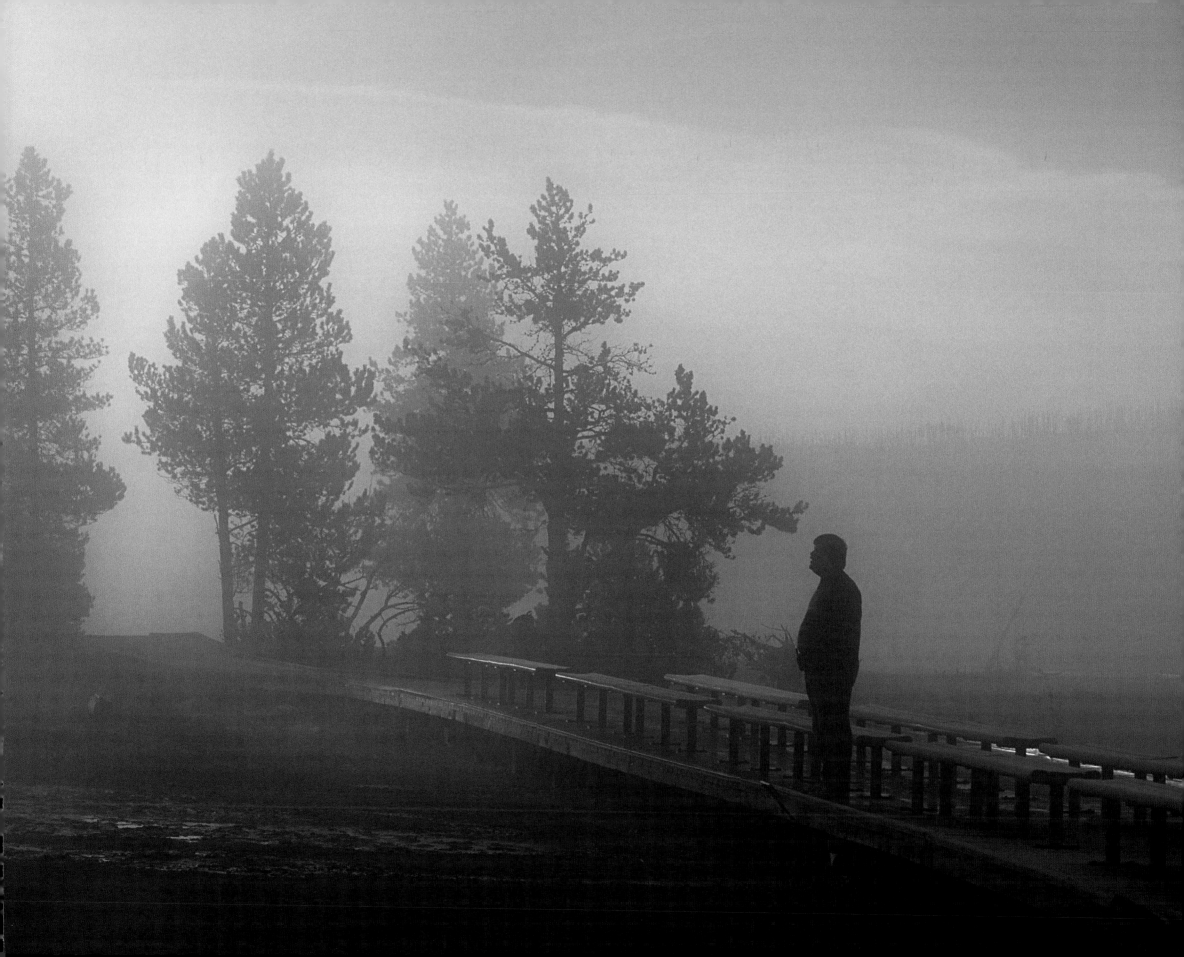

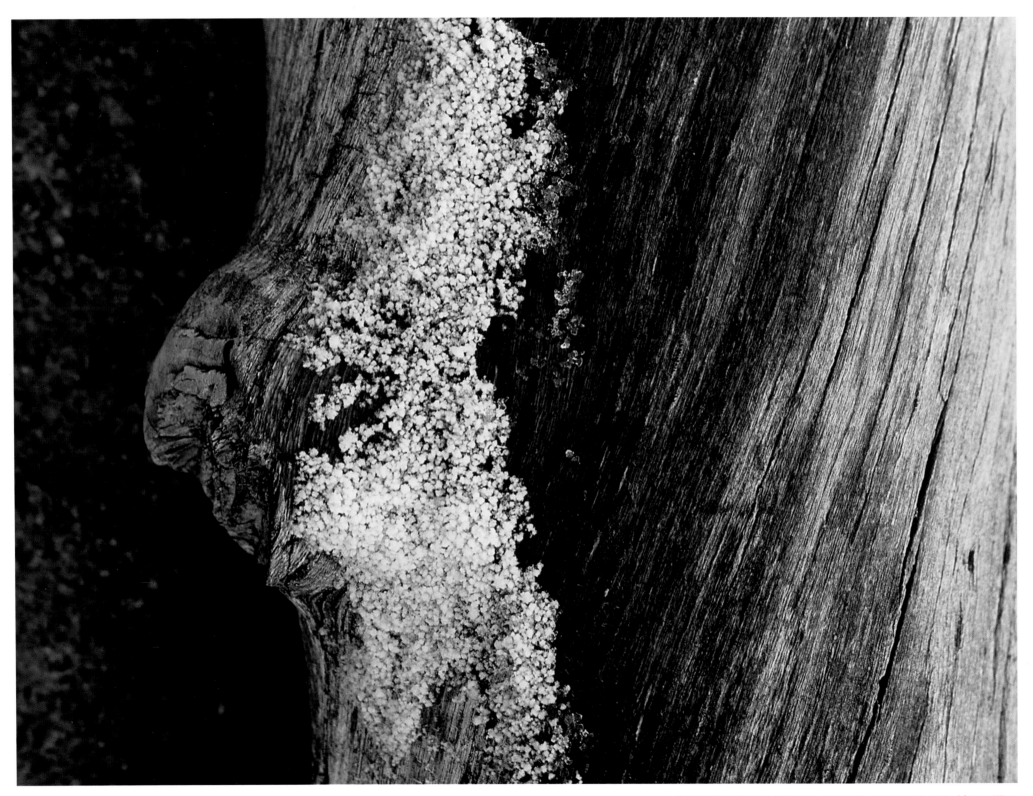

Snow dusting drift wood, Lewis Lake, and at right, great gray owl, south of Canyon Village

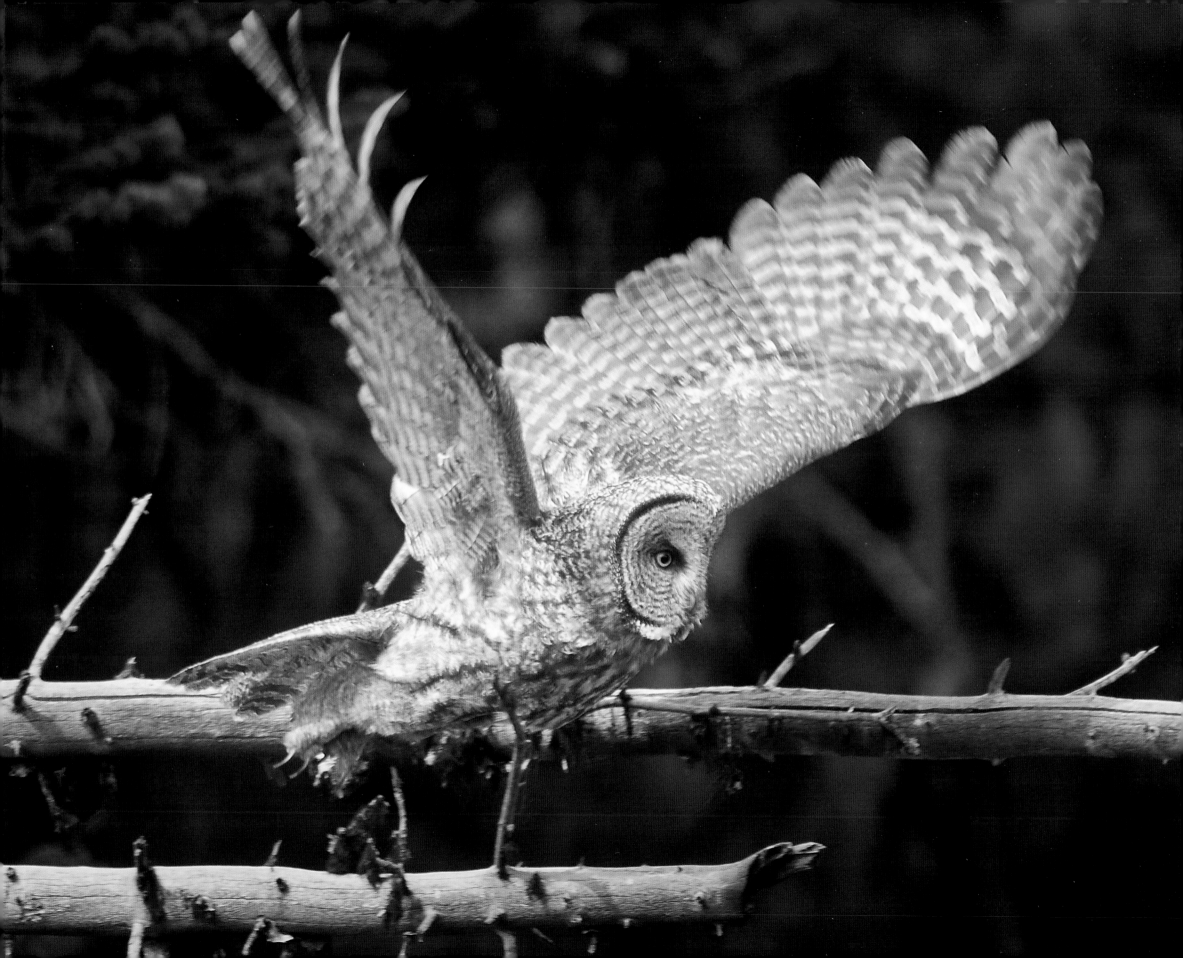

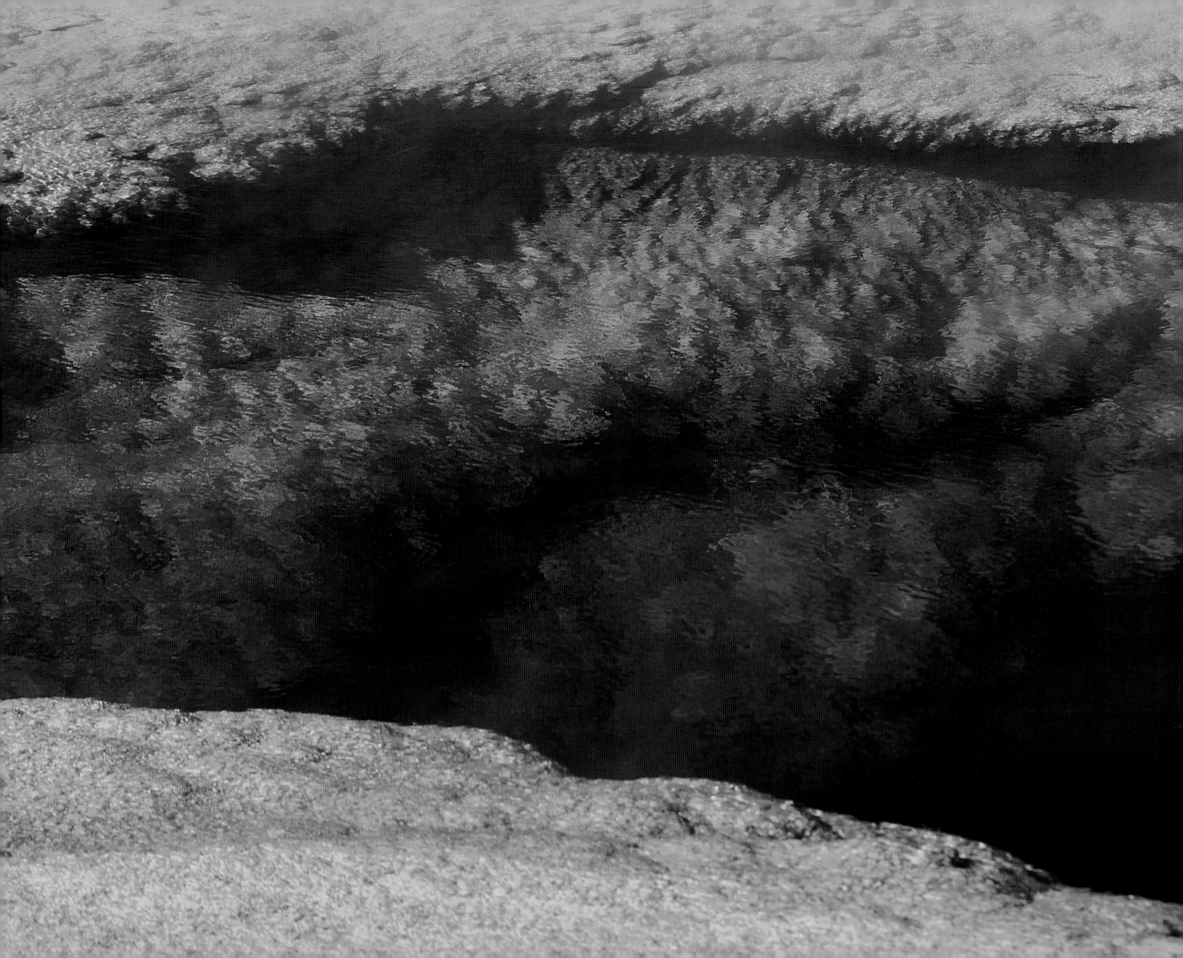

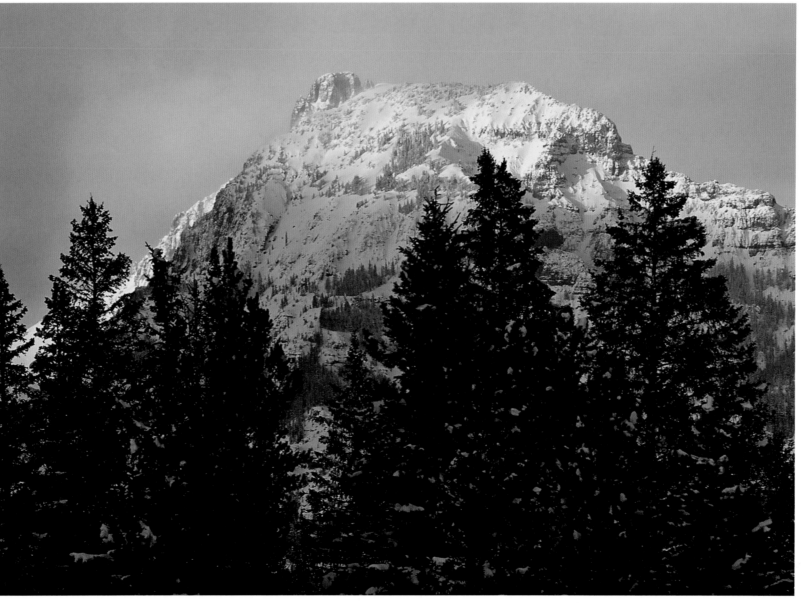

Abiathar Peak

Emerald Pool, Black Sand Geyser Basin

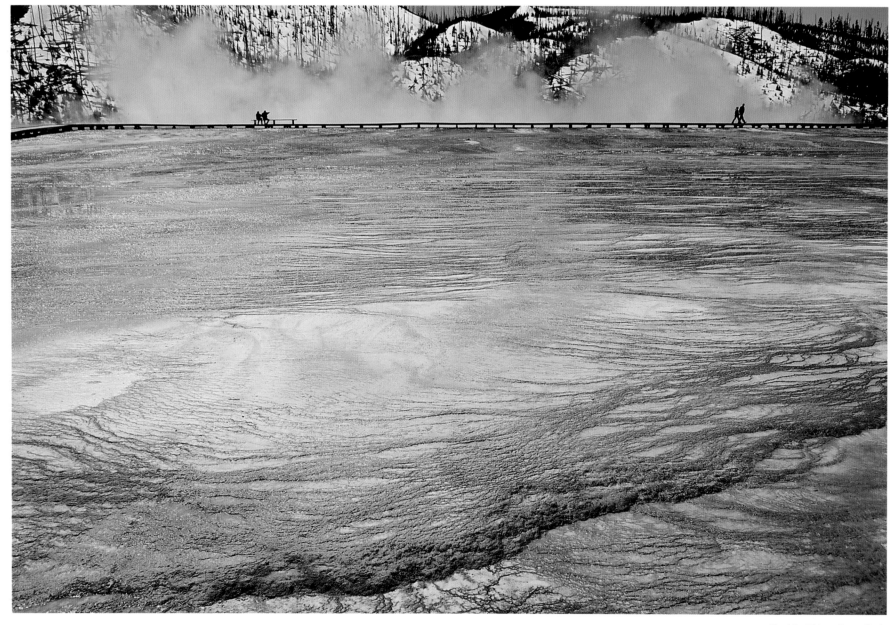

Tourists, Midway Geyser Basin

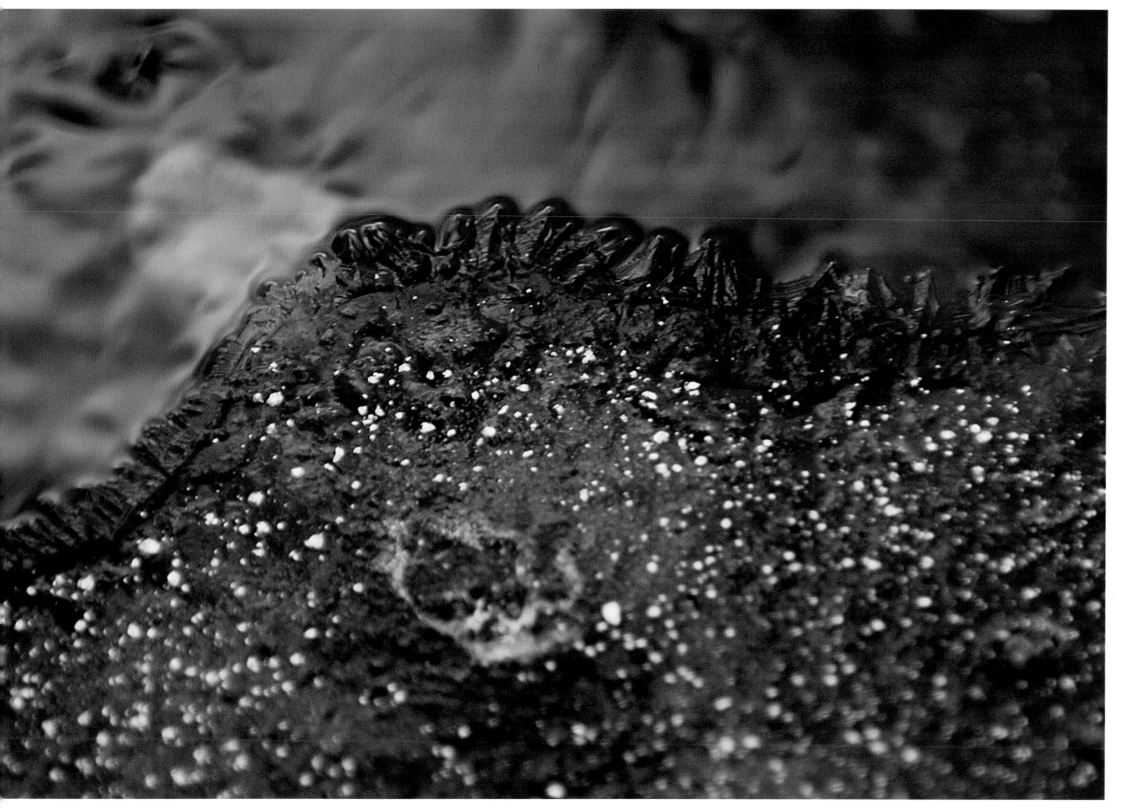

Ice forming, Soda Butte Creek

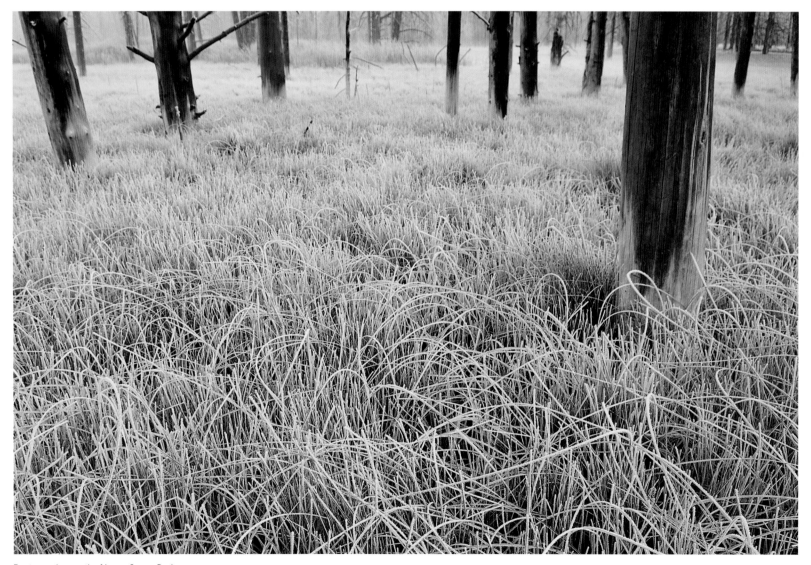

Frost, meadow south of Lower Geyser Basin

Castle Geyser, Upper Geyser Basin

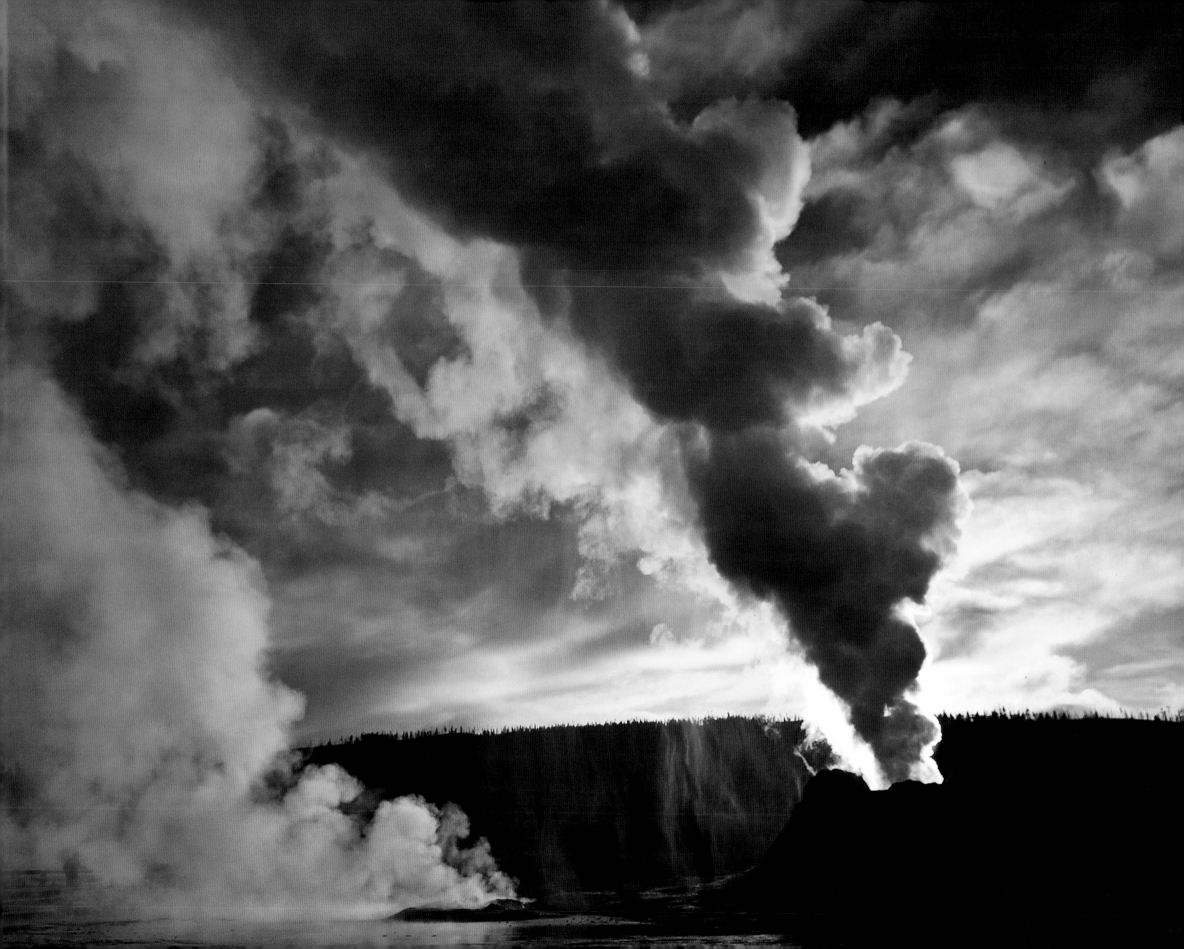

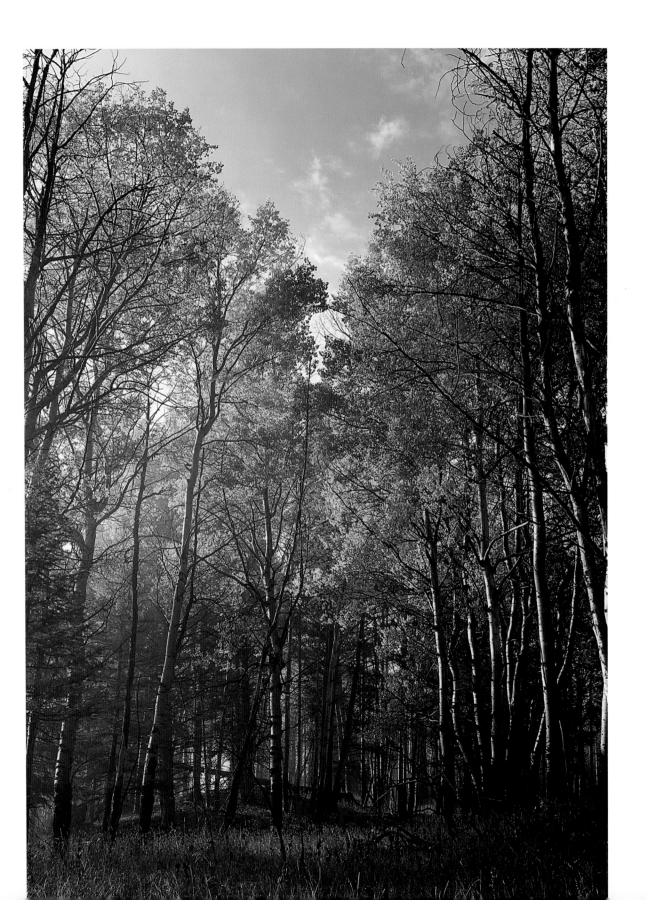

Aspen stand, foggy morning,
south of Mammoth

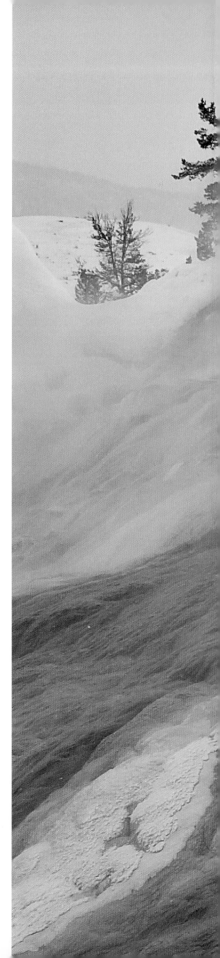

Palette Spring,
Mammoth Terraces

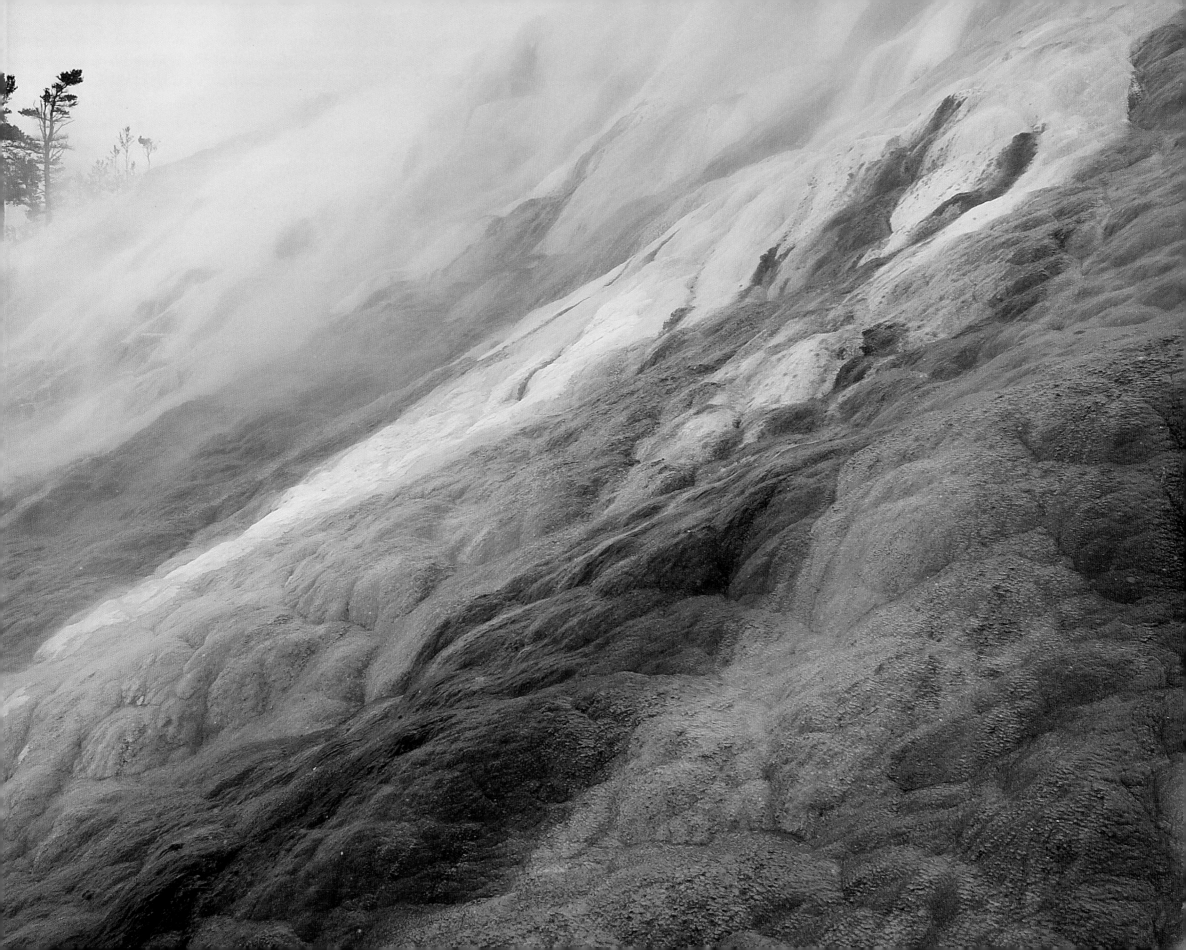

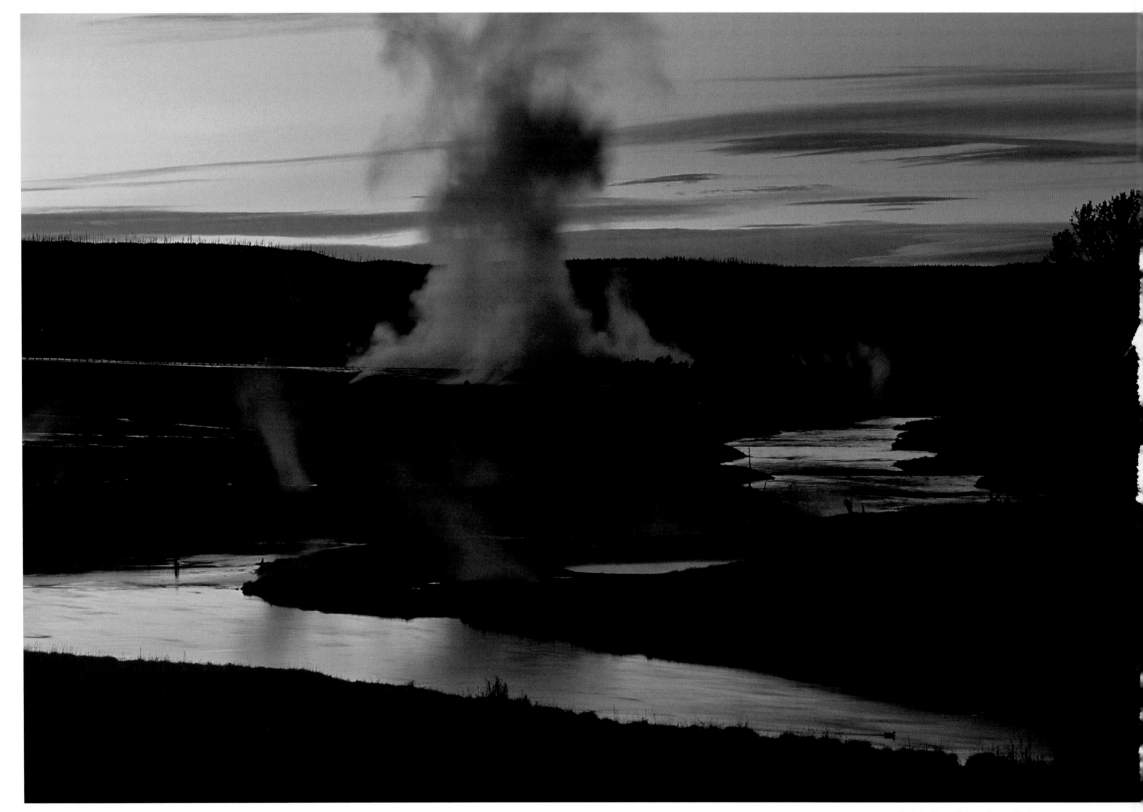

Firehole River, Midway Geyser Basin